Pacific Windows

Pacific Windows

Collected Poems of Roy K. Kiyooka

Edited by Roy Miki

Talonbooks

&

1997

Published with the assistance of the Canada Council, the
Multiculturalism Program of the Department of Canadian Heritage,
and the Japanese Canadian Redress Foundation.

Talonbooks
#104—3100 Production Way
Burnaby, British Columbia
Canada V5A 4R4

Typeset in Sabon and printed and bound in Canada by Hignell Printing Ltd.

First Printing: November 1997

Talonbooks are distributed in Canada by General Distribution
Services, 30 Lesmill Road, Don Mills, Ontario, Canada M3B 2T6;
Tel.: (416) 445-3333; Fax: (416) 445-5967.

Talonbooks are distributed in the U. S. A. by General Distribution Services
Inc., 85 Rock River Drive, Suite 202, Buffalo, New York, U.S.A
14207-2170; Tel.: 1-800-805-1083; Fax: 1-800-481-6207.

Cover stamp by Ed Varney, image digitized by Henri Robideau, from a
video by Michael de Courcy.

Canadian Cataloguing in Publication Data
Kiyooka, Roy.
 Pacific windows

 Includes bibliographical references.
 ISBN 0-88922-378-5

 I. Miki, Roy, 1942- II. Title.
PS8521.I9P32 1997 C811'.54 C97-910951-5
PR9199.3.K46P32 1997

CONTENTS

Art is a Calling a Fool & a Scold: an actual speaking out.
— from *Mutualities: A Packet of Word/s*

o dance a jig on the pear tree's midden heapt
with divers wonderments . language is a fool's fruit
fool-proof pear trees bear the laughter of .
put your ear to its forkt-trunk — hear its sap thrum
— from *Pear Tree Pomes*

"to see is to forget the name of the thing one sees":
to dream is to redeem its unspoke sacral meaning
— from *Pacific Windows*

Kyoto Airs

for Mariko
and Mariko

the sash you bought
for my ukata is
firm around my waist
each time I tie it
you are on one end
& I am on the other.
* how else tell*
of a brother & sister
thirty years parted
drawn together, again?

1 Kyoto Airs

the song is
about tortoise

and not the hare
not the hare

black heads lifted
there sing

sing into the air
walking by sun

in my eye sing-
ing also singing

another song the
air of Kyoto sings.

2 Tokyo Tower

bodies
float-
ing

down

below
the

tower

high

above
Zojoji
temple.

3 Found in a Mound

a hump in
the landscape

grown over
with trees

the voices
the voices

lost in the dust

the word
the word

the lost word
found in an urn

made from earth
to earth returned

the lost voice
returns
in the shape of an urn

a burial urn
a bronze burial urn

ashes and dust
ashes and dust

mingle—
in the bronze burial urn

4 The Sword

glitter-
ing light

shines

on gleam-
ing blade

forged

molten
metal

locked

behind
mind's eye

keen edge

cutting
Past away

I see

blood
on the hilt.

5 Haniwa Horse

Haniwa
a Haniwa horse
found
 in a
 mountain
 mound all
 covered with trees

the mind's
memories

 caved-in
 a cadaver of dust
found
 among
 shards
 intact

only the rider gone!

6 The Warrior

knifed
in the night
his woman
gone

to another
bed did
they lie here
before

the clash
bloodless
hands on
her lash

her pale
white face
upturned
to his

beneath
this cherry
tree where
they lie buried

his brother too

7 Pleasure Dome

the moon
is a paper
lantern
hung over
Kyoto ly-
ing between
mountains
where legend-
ary gods
stalking
the green
summit go
down to
wayside inns
'pleasure

domes of Yase'
sway an
invitation
to dance
tiny cups
of sake over-
flow streets
weaving
pools of song
arabesques
of fall-
ing leaves
round these
loins & aching feet

8 Road to Yase

green
 green
 green
 green
on the road
to Yase
 everything
 is green multitudinously
 green

 green trees on
 green mountains
 green fields &
 a green stream

 all things green

including
the shadows
between boulders
along the edge of the stream.

9 The Street

1
seeking what
pleasure
money can buy

passing one
another past
painted women

moving to-
gether past the
same old jazz

I am among
them a tongue-
twisted alien.

2
how account
for
 his lurching
 crooked tie &
 lascivious laughter

except to note

her indiscreet giggle
behind a small white hand
raised to the powdered face.

10 Dwarf Tree

some-one: long ago
twisted
thin wire
tightly

around tiny limbs

 trimmed others off
 & shaped the whole
 into this thing...
 with
 gnarled roots
 half buried
 in an inch of dirt
contained in a shallow bowl
the size of your cupped hands

'it's a hundred and fifty years old—
imagine how large it would be today!'

11 Coffee Shop

tremor of
cut glass
betrays the
indiscreet
blast from
the air conditioner

or is it
the music—
Beethoven's
7th that
makes it
tremble so…

myriad colours
reflected
on each cut
glass surface
shimmer to
the sound

of voices,
clattering
cups, the music,
all sounds
other than
my own.

12 The Guest

he comes bearing a gift tonight
it is pickles to pay
for the pleasure of her company
yesterday it was candied fruit

he talks business how he
came up the hard way as the young
including his sons refuse to do
how he knew every-one the lowest ones too

and night after night the same
talk always the same talk
the same woman and bottle after bottle
of ice cold kirin beer

o who would not want kirin beer
with another woman another woman
o who would not want another beer
another beer with another woman

13 Prayer

pulling the
tassled cord

he summoned
the god

palmed

six sticks
of incense

then

bowed his
bald head.

14 Waiting Out the Rain

and the rain
keeps coming
between me and
the iron Buddha
sheltered
both of us
under the same sky
only I can see

15 Buddha in the Garden

gone
gone

gone
gone

gleaming gold

gone
 scoured with dirt
 & rained upon, rained
 upon...

gone all gone
 only wood
 to lean upon

16 Sunday at the Temple

to swing
with the crowd
swarming
the great Buddha
one needs
a bamboo staff
tassled with
riotous colours
such as
the guardians
must have waved
in the face
of a swarm of
mosquitoes
on a hot june night

17 Reclining Buddha

hovering
he is
hovering
his eyes closed
feet together
horizontal
behind glass
in front of
a thousand eyes
fingering

crumbled gold
creased
with dust
the painted smile
looks back

18 Stone Garden of Ryoanji

1
they whisper
in each other's ear

eating riceballs
stones in their eyes!

2
the boards
smooth
under hand

no knots
in mind
nothing

but stone
for a face
an eye of sand

3
white sand
shadowed
by stone
mountain

leaves
not foot-
prints in
any direction

4
when
each stone
fills the eye

with another stone
of the inner eye
silence sings
to itself

19 Children's Shrine

small
incis-
ed swastikas
 frame the shrine the
 children's shrine
 near the marketplace

 fishmonger
 picklemaker
 fruit and vegetable man
 the butcher the baker
 & candymaker's

 children

 crowd the narrow alley
 offering prayers
 for the dead and
 prayers for the living

I smell incense burning
the smell of it
 mingles with other smells...

 I smell bodies burning.

 the ancients the living among them
 hammered it into bronze

 burial urns
 for the dead, the
 sacred dead.

I, too, have use of it
to commemorate the living.

20 Higashiyama
A Sequence for Cid

1
kneeling she
brought in the tea
then silently
left me
with a view
of Higashiyama

2
o the white pigeon
on the t.v. antenna
the maid next door
hanging out the wash

a flutter of wings and white-wash
a pantomime played
against your green thigh
O Higashiyama

3
you rise up this morning
out of the mist now
the sun is there too and
I have just crawled into bed

4
she called Higashiyama
a mountain and I said yes
I guess it is a mountain but
I had other mountains in mind

5
small comfort
knowing
the rain coming down
falls on my back and
Higashiyama's too

6
on Higashiyama the gods
do not hear the roar of cars
and I hear nothing else
not even my own voice shouting
for a cab

7
tonight Higashiyama is
not there cannot be seen
does not console this wandering eye
that sees nothing not even
the silhouette humped
against the blue-black sky

8
beyond Higashiyama there is
no place to go where
the mind has not been before

9
put stone
upon stone
plant trees
where
the ground
is bare
put birds
to flight

cut a channel
for water
to flow in-
to the meadow

green!
in the inner eye

10
tell me Cid how
does Higashiyama
look this morning
from your window?

here it
is inverted tangent
to another view
but never the same
twice

11
I have left Higashiyama:
a green protuberance swelling
in my mind

21 The Dress

how to
convince you
that you
do look beautiful
that it
does fit you
that the sheen
of it sur-
rounding you
is the
shape
of intentions
both of us
wear.

22 In the Kitchen

how small you are
heard you put away
three bowls of rice
not counting fish

as if you could make-
up for the hunger of
the lean days when
you bartered clothes

for a bowl of rice
mixed with dry beans
to make a mouthful—
fit to choke on

and now you wear
the dress I gave you
something other than
what you have been given

by others thinking
anything at all
would do for you

how small you are
the cotton frock hides
moments of despair shaped
by fire into something
rare, something rare

23 My Sister Tells Me

why not
speak of it
nothing
can harm you

now that
the wound
has healed
leaving

a thin
white scar
thus the
closed wound

was opened
again
revealing
no festering

no sign of
the grit
ground-in
by the iron heel

24 The Room with a View

what are you
thinking? I
am thinking of
nothing nothing
at all. the
whirling fan

fills the quiet
room swept clean
& bare. voices
rise up from

below. the sea is
there too. you know
it in your way
which is another
wave of the same
sea. we hear.
 "I can write
 my name and address
 and how are you.
 you will write
 simply won't you?"

 from the open window
 other windows
 open out to the sea
 over grey tiles
 as far as the eye can see

 how are you?
 tomorrow: I
 will float
 these poems
 to you 5000 miles
 away. do you
 trust the sea?

25 Departure

I was going to say to you
that it is
 raining, again
 but remembered
 saying it
 before

that
 the scraps of paper
 on the wet grey concrete
 remind me
 of yellow leaves
 fallen
 in the bamboo grove
 —back in Umagi

that
 if it keeps coming down

you may as well leave...

 but I
 had already left.

26 Burning Leaves

I am sitting here
 sun on my back
 Autumn in the air

 leaves are falling here
 and over there, over there

I know where I am
my feet stretched out in front of me
still, a part of me is over there

 where leaves are falling
 falling in the Autumn air

 tomorrow there will be bonfires
 people will be burning leaves
 falling leaves will fall into the fire

I am still sitting here, and she
well she, is over there, both of us
watch falling leaves carried away on the inswept air.

 o mother
 where is the rake?

27 Itinerary of a View

 I am a Canadian painter
 come home to pay homage
to ancestors, samurai among them:
whose honour was the slit abdomen,
whose women hoarded famine rice to
stuff into their children's mouths,
whose children's children gad about
in red high heels, twisting to Ray Charles
and ride together on black motorcycles
to the Chion-in temple, where in the
tall green grass between dead men's graves
they kiss the summer nights away and

the toppled tombstones glisten
 from their sweating loins.

 oh let the semen fall
 and the green grass grow.

I have seen her with a flower
between thin fingers small
in the crowd she moves, as if she
does not see me, does not see
any-one, had no eyes, except for the dead
carried away by the kami-kaze
 strapped to their iron beds.

 oh let the semen fall
 and the green grass grow,
 let red high heels twist
 in the tall green grass.

in the inner sanctum the hidden mirror
reflects all things, impartially:
revealing white pigeons on the red torii
arched high above the guardian's heads,
two priests riding by on aged bicycles,
more pigeons in the courtyards pecking rice
from the children's outstretched hands,
people under tile waiting out the rain,
the endless corridors of wood polished
smooth by generations of shuffling feet,
shaven-headed priests chanting sutras
behind sliding screens, silently opening
and closing on a world of dreams
 unfurling in mind's memories.

 oh let the semen fall
 and the green grass grow,
 let red high heels twist
 in the tall green grass.
 oh let the empty mirror reflect
 the crack in the ceiling of heaven.

the 4th avenue poems

—for john & jos: more than friends

1 tonight nothing is
enough
 night discloses
only itself. only
the mice make noises at 2 am
 even
 the rain
 the rain

 reflecting neon
 has its shimmer its
 shine is
 more than
 mine

2 Dear John: I threw out all your dirty socks foul tin
cans & lousy pulp. you left a month ago...your women even
the fat one doesn't come knocking anymore. the mice have
gone after other crumbs. John: you still inhabit the other
room: I can hear you mumbling obscene syllables strung on
a grave rosary.

3 bent this way and that
thirteen nails
throw thin shadows on
the wall

no comfort knowing
who hung what from which nail
even nails are useless
unless they're used

4 a shelf full of books: pages
from the dead to the living from those
alive to the dying & the dead

o little leaf between the pages
tell the fly buzzing my ear their relevance

5 the color of Death is black & white puked
into a million livingrooms. his death no more colorful
than Harvey Lee Oswald's. or a Jack Ruby's.
when the big quake struck Alaska the Inuits didn't know
what hit them. without t.v. they didn't know
how JFK got it. it wasn't their way. the big storm was
static on t.v. with the power down the lights
all over town snuffed out one by one. Judy's father got it
his way that night. his way wasn't their way.
Death like a burnt-out t.v. set emits weak signals. Death
John is no avenger: vengeance is 3D-technicolor.
are you alive? why don't you write?

6 the argument
again, i fumble
for uncouth words to sear
your sullen mouth

it's always the same fucken
argument: rain or shine
the weather doesn't mean a damn —
what I wanted to do is
shout "FUCK YOU" walk away
& never come back

what I had wanted to say
is "I love you"

7 news item
the rain coming down says nothing about
the old man buried under a tumult of snow: caught
in a sudden storm — "old man, which cheek
did you turn to burn away all the blinding whiteness?"
the land was a tumult of driven snow — it
formed cones-of-whiteness lancing his sightless eyes:
falling through the windlass drifts he saw
the snow children picking flowers:
 their fingers never grow cold

8 Jos has left. John too.
others before them left by the back door
I am still here tied to what they
left behind. what I have made I will also
leave when my time comes
o

gay or drunk: I know
their footsteps the tread of other feet too
so I always leave the door
unlatched the lights burning low...I want
to hear even "the screams" —
next door before...the tide runs out

9 the fly
o how long have you floated
on the grey scum in the coffee cup
& how much longer will this
incessant rain stain the ceiling & the floor

I am thirty-eight today — how
much longer is it going to take to sing a song
without trying — without the pain
of a faltering tongue...

10 for Jos, somewhere in the wideworld
from Turkey, you said
the Messenger came on a white horse:
he came up to you under
a sheltering tree from over the horizon
and the endless sand —
he came with "all the news fit to print"

if you believe in messages —
you'll find this one among the Dead Letters in any
post office even in Nipawin

11 Walt
Leaves of Grass
grow in the parking lots in
the small cracks
of the pavement where my
daughter sings

weightlessly
this poem lies under her feet

in the backalleys
the tenements & the temples
of her dreams
 dancing
weightlessly
 on your eyelids

12 John spent a year on his back in this room:
others have lain here, their arms about each other.
tonight I bed down with them — through the
smoke "we" can see the lighthouse beacon flashing —
the rocks we drift towards...tomorrow,
this bed will be bereft — only these words will tell
how the storm swept away this spare room
 & all the lovely faces

13 already, I
inhabit another room
a bare room
with perhaps a larger window
opening onto
something other than
this billboard
letting in something other
than rain

14 this rain, John
both of us are bored with has nothing to do
with your despair. or my departure:
desperation moves in all directions — the
Trans-Canada leads to either ocean

15 the cherry blossoms in
Nitobe Garden & the dead gull
washed up on Kits Beach:
both bouquets for my departure

16 postscript to the room
"Salut"
I leave the rain for you
to endure. let it nourish your
decaying frame
 let it rain
 "Let it"

Nevertheless
These Eyes

FOR STANLEY SPENCER –

THE SONG THE MIRROR SANG

I am meeting you all the time
and sending my longing for you
into chaos, into the darkness
beyond these walls...

Climbing into the mirror
I sat between her thighs singing

the smell of grapes bruised be-
tween her teeth lulled me to sleep

the dream I had told of a child
borne from the ashes of my manhood

riding the back of a huge bird
black across the night sky and

the lights of Summerland shine
in the orchard where I died. Now

darkness covets the mirror—
night glows from the assassin's eyes

&

behind my eyes you move
in transparencies of pure gold.
light defines the curves of
your breasts your shadow against
the wall is ten feet tall

I will paint your body ochre
simulate diamonds for your hair
count all the days you are
absent & carve your blessings
from a mouthful of air

my eyes my eyes, are they
only a prism a plaything for
dreamers with idle hands?
poised in mid-air my hand
remembers yesterday's colours
and tomorrow's too

&

the image of her
the mirror held held me

and the light,
the moon resisted my embrace.

across the meadow They come
bearing witness to her beauty
they sing her praises,
soft syllables hurting my ears

I stumble after them
mouthing the same old song.

O moon show me the way

&

at least the shape of it
framed her face perfectly

its thickness revealed no-
thing about the shine in her hair

the back of it will tell you
it was all a lie as if

it could see without an eye

&

since you asked me
when you were here—
to take off my mask,
I have done so

again and again I
stared at this face
that was hidden
behind the other one

you thought you recognized
but could not place.
when has the mirror
stripped away what is not

there but present
in another's eyes? since
you left it is
not the same face ever

&

the distance
between an eye and
an eye

reveals
immensities
ready to
leap in
to the space
no tooth can fill

&

Munch stuffed her scream
into a painting
to take it out of his ears

now only the echo is heard,
only the dark surrounding
it insistently appears

&

my hand
covets
what ever
there is

even
the dark-
ness is
almost
possessed

blood
does not
count

&

the other face
that held the mirror
has gone. between

what I remember seeing
& 'who' is looking
back (my own face)

there, is
only
the thickness of a lie

&

turning away from the mirror
my eyes beheld two small trees

the blue sky seen through
green leaves offered possibilities

the mirror had not seen. turning
my head, I saw other trees too...

≈

the mirror
that once reflected
the glory of
her hair this mirror
does not care
it reflects what-
ever solids replace
air

≈

in all this space
no trace of the air
she breathed

in all these mirrors
no trace of
the shine in her hair

in all these words
I trace the presence of
her absence…

the touch of her hand
lies on these words

≈

in a room
full of mirrors
the light from
a single window
gathers the dust
from the corners
and places it
particle by particle
at her feet

≈

it is
the vision of
Her
 become substance

her flesh
more than an idea

the task
is to paint her

 in a thousand guises
 with no more body
 than a ridge of paint
 between two forms touching—

 insistently
her flesh over-
flows the odd numbers
& the even ones too

 the mirror does not lie...

 believe in
 the mirror

&

now other faces
reappear
 out of
 the darkness, they come
 bearing witness to
 the morning star. their ears
 sound each syllable,
 every word is measured
 against

 'the silences to come'
 even
 my own face
 is not diminished

&

Who
among you
can say
what mirror
held
her image
most perfectly?

THE PROPOSAL

there is no saying 'no' in my paintings
all are saying 'yes'

PORTRAIT OF THE BELOVED

She
had a beak nose
crease between nose and lips
eyebrows meeting thick,
long scowling eyes a smear-shaped mouth
with lips in repose.
She had a lop-sided muscular neck
a heavy burden of hair wide chin
dimpled in the center,
tufts of hair on the chin and creases
circling her neck

THE MARRIAGE

We groped our way
peacefully
about each other. the
overflowing
& puddle of you and
me met
and joined, lost
in each

...that is my only memory
the not having to
stop being me when you came

THE SEPARATION

Eat me darling
and let me become you,
in the midst of
your belly I cry out
my love for you...

HER APOTHEOSIS

She stands, wearing
a three-cornered pirate hat,
hands raised in a gesture of
boundless joy. Her gloves
are net, hands spread and fingers
stick out fanwise. Your coat is
the green one with flapping pockets,
you seem like a new kind of
land-fish a flat-fish.
On your slithering feet you
wear your bosnian shoes.
Your lurching movement is
 your essential dance

...about You children are making gestures
of praise with their paper streamers

These four poems are from Spencer's writings.
Shaped from his words, they define some of her
attributes, her relevancy as he saw them. I use them
for the sake of the poems. The titles are mine: given
to define why the poems are here.

&

The grotesque flesh was
hidden from her beloved's eyes.
Her eyes were transparent pools
he could look-in to see his own
imaginings
 nothing she could do
showed him what he did not see...

 she is not
 a collage
 some pasted
 thing hung
 on a wall

Pitilessly, the light revealed
what she did not conceal—
barely able to reach out
to him she showed the scars of
 a thousand encounters...

 words
 will not
 stitch
 her wounds
 together

&

Count every scar
each and every festering wound:
See the thin pink line
across her cheek left by
Caesar's knife. Run your fingers
gently over the welts on
her thighs, the bruises
on her legs...then

 Note the grace
 with which she moves,
 between the living
 and the dead:
 each mutilation tangent to
 her embrace.

&

The Beloved is
resilient bending with
the wind she is
everywhere and nowhere,
she wavers in mind
at the top of the stairs
she beckons to you
to come she will show you
other scars too

&

We had a hard time of it
during the war. I was just twenty then
and every night I went out
into the countryside to steal food.
By day we competed in the market-
place selling rancid food
to the highest bidder. I remember
there was no garbage then,
nothing was left-over to throw away.

He lost two sons
said he needed help
so they sent me.
I did everything I could
to help him but
each night he would beat me
till my tears
stayed his violent hands.

Lying awake
in the shed with pains
shooting through
my whole body
I resented the dawn
another day's work,
the care of his idiot son:
(whose shrill-voice
still rings in my ears)

Still, I regret
nothing, not even 'these memories'
that crease my body.

Like a child I will forget
yesterday's insults
and tomorrow's too. Even the night
has its consolations...

&

Gaston Lachaise you
who knew her by her orifices
sang in bronze the song of
her flesh, would know her tears

Gaston tell them who
harm her, how you made
bronze sing her song. how the shine
in her hair left its traces
on her sculpted form

& Gaston add this too—
that her tears will wash the dirt out
of any man's eyes

&

The women say what I like
about each other. Each woman is
my love-letter to the other.
Down the familiar street I pass
through the unknown land of women

The wind ruffles their skirts.
Their song is not diminished
by the mountains. These words lie
under a cloud of tears fallen
from the beloved's eyes

THE PROPOSAL

in the Garden where
the beloved lies
the unseen wind moves
through pages of love-letters
that propose nothing
nothing about her
the grass does not know:
blessing each word
reflected in her eyes

the Dead can read they
have written love-letters

sheaves of them
bundled against the rain.
They propose you
also write, they pose you
this question—
will you wave streamers
 when she goes by?

THE DANCE

She wears green leaves twined with
 roses in her yellow hair float-
ing above her turning body

 intricate steps twisting and
 turning on the edge of thought

Undulating to the piper's tune she
 wants you to dance with her
her movements make my palms moist

 the light foot rises and falls
 measuring the firm heart-beat

We danced in the hallowed grove
 O where did you go? she danced
after your shadow into the woods

 pivoting on small white feet
 soundlessly the song retreats

HER ADMONITION

 I have offered
my breasts to the moon. Your
arms about my shoulder tells of
the length of your shadow,
its dark caresses my skin

 the fist is
 also a hand to
 hold fast
 to what ever
 yields

We are all
so cheap with what is best
in ourselves as if
it could be stored away

for some other occasion other
than this

as if the moon had a choice

> your hands speak of
> tenderness,
> an eagerness
> flowers understand

> then, She added
it doesnt matter, whose hands...

FIVE POEMS OF RESURRECTION

> the way
they lie there as if
they had always lain there
talking talking
their fool heads off or
saying nothing,
just lying there where
so lately they had come in
to the light of day

> without fanfare
> the procession of angels
> have disappeared into
> the ranks of the living

in everyday clothes
they lie there talking as if
the sound of their voices
had parted the grass,
lifted the compact sod
over their heads to reveal
the shape of their bodies

> without fanfare
> the procession of angels
> have disappeared into
> the ranks of the living

now the shadow cast by
the lid of a tomb invites
the grass to grow, under
their legs and between their toes
it grows and grows

the Fallen have risen—
hand in hand they
board the steamer with
their beloved
have tea and biscuits
under a striped awning
and the song they sing rises
to fall into the water

no one cries
tears won't water the grass,
salt rubbed in old sores
lies at the river's mouth
the river does not whet
their appetites it will not
compete with the ivy
growing over dead men's eyes

you are so lovely
 but the boat moves on

&

the moon
raises
tides in woman

man too
has
his rythmn

head held
high he comes
to raise

the tide
praising
the tide

the moon
praises
his erection

&

Stanley Spencer painted
a sunflower firmly
between a woman's thighs

he tilted her face to-
wards the flower's face
hair and petal twined

he would have us pick
the fragrance of a summer's day
all, for her yellow hair

and the dog at my heel knows
the 'flowers' I pick
are from the same 'field'

❧

The resurrected flesh was a dog's:
his eyes no longer limpid
the fur on his back stands straight up
he is hallowed in the eyes of
the beloved her gaze is more dazzling
than the moon the moon over Cookham
praises his perfection.

Coda

The resurrected flesh is firm
The firmament glistens in each eye.

THE VISITATION

it was
this way & not
how you
imagine it
was
 —the three of us,
 together:

 our different smells
 that confusion of
 whose hands feet arms or legs…

 the thickness of
her thigh equivalent to
our two legs pressed to hers.
the breadth of her belly
more than a thin arm's reach.
nor could his hand or mine
cover the fulness of her breasts,
or clasp her wrist or ankle.

as for her yellow hair we knew
 it could smother both of us—

She in all her substance
breathed a silence neither tongue could span

&

remember
that Silence?
these words
include it
& the moon seen
through the
torn screen. they

 also include
 the tears
 she did not shed
 lying there
 between us, three
 in a bed

 that is the way it was

one two three
pairs of eyes
watching the moon
go down over
the West Bench

 blessed
 blessed
 blessed

 best.

&

what the Beloved said
cannot be recorded what she said
she whispered in my ear

only her breath blows
through these words only
her breathing stirs the night air

NEVERTHELESS, THESE EYES

I am on the side of angels
and dirt...

are to see through—

beyond the clearing
beyond the shadow of a doubt

the rose is a rose.

while you slept

our shadows kept coming
together

do you smell the litter
between these words?

this silence?

gestures, in the air:

a precious concern for plausibility.

lustrous devotions

the smell of
musk-

incense
in a field of heather. night

at the bottom of the well

&

your eyes are
carefully banked fires

pomegranate: each seed

sounds the sense of
what it is the senses come to

ornate configurations

a single strand of your hair

incisive

as an open wound.

your shadow beyond the door,
beyond the shadow the same doubts
forgotten fears,
these words

ghosts of friendly encounters

noisy drums gilded hoops
a monkey on a string then, a bear

Greetings
from No-where—

&

in a single day I gave away

constellations
of desire the fear of

no longer burning,

a sea-swell of promises.

through the open window:
these eyes

the beach swept clean
and bare

all my yesterdays looked in.

sit here, beside me

laugh
make rude sounds then eat

feces! feces!

whose Gods shall I invoke
my father's or a king's?

libidinous dreams…
the liability of screaming

&

for Help!

immense flames a flare

burning chrysalis,

at least
my anger is not appeasement.

to not lie to
the face in the mirror

what face? whose face?

where is
my face?

your face?

the cracks

are not lines of despair

the silver is not your hair

the way your hand moves
up, then down

the sheen of it

&

more than bright.

I am

waiting

for what-

ever pleasure

Love. Go

then
in a quest of a gleam

in an eye,

phosphorescence

in a transparent skull.

I wait

for the flood
the second coming,

angels and dirt

&

I

am

nevertheless, these eyes.

the figure of Her in the poems is his, & mine
the lustre is hers, her dance is what we remember,
the songs are also hers

Montreal, June 1965
Naramata, July 1966

Later Drafts of the Stanley Spencer Poems

—tell 'em Stan How you
fingered her heavy burden of hair and
(in your drawing) You became
God the father & God the son with
happy children dancing around.
you always needed a happy association
to make them come alive.
the gesture, you said, had to be
just right.

&

1st Self-Portrait

lattices of
light

a young face already
knows

&

The Wool Shop

with an eye for precise detail but what's the guy
tossing a skein of wool in the air about?
and have you ever seen a woman her sweater and hair
woven from the same ball of yellow wool?

nobody takes inventory in the cock-eyed wool shop
it's all an invention. even the woman braiding her hair
in the back-room—while her tweedy husband tilts
another pint of beer playing darts at the local pub

&

The Last Supper

it's the rows of out-sized feet
sticking out from under the stiff folds that
lead us to the broken bread. it's

how he painted each brick its own red
that puts the bread into our eyes
& mouths. it's the last supper he ever had

æ

Parents Resurrecting

Old Victorians
Upholstered Edwardians with sideburns
Anglican bishops
Pin-striped clerics with furled umbrellas
Retired naval officers
English professors
Colonial gentlemen & their gentle women
Nabobs Bums & bona-fide
Eccentrics

Beware of Women all Women!

especially Those who keep the Ten Commandments—
have a fat hand in your pocket & love the feel
of coarse-woven worsted. beware of them They'll
get down on their knees for your least indulgences

æ

2nd Self-Portrait

a Don Juan in grey underwear
sniffing the heels of

the woman who called him
a prick and a genius—

making out with many / one
in sight .

æ

Separating Fighting Swans

beak-to-beak—they go at it as
the Christian Science Monitor falls out of her
idle hands into the churning pool

æ

The Coming of the Wise Men

according to Stanley Spencer—
the Wise Men came garbed in white robes
tied with a length of rope. Look!
there's seven of them coming towards you
five with heaven-knows-why out-
stretched arms crowding a sixth one with
a red bowl to his lips. the seventh

and first bless the pink child in polka dot
while Mother Mary hugs a pillow to
herself Jesus kicks up a big fuss

> don't confuse the holly
> tuckt behind the picture frames
> on the pin-striped wall
> with plastic mistletoe. Pleez!

&

The Visitation

An everyday affair in Cookham where
Mary and Ann clasp hands across the threshold.
beyond the front porch—corrugated tin
roofs tell of how an ordinary afternoon tea can
be fraught with sun-lit Consequences...

&

Saint Francis and the Birds

shows a fat man in his dressing gown heading
towards the outdoor larder with all the barnyard birds
squacking and flapping at his heels. he is the
"humble saint" alias his own father "remembered" when
the village thief made off with his one and only
pair of trousers. o hail! the uncouth saint!

&

Christ in the Wilderness

forty small panels: one for each day
He spent among the rocks—painted on a small
table beside the window in the wilderness
of his Cookham living room. forty small panels
showing how He spent each day praying in
the wilderness beyond the trellised front porch.
forty small panels positing a vision S.S.
felt he had to reaffirm. otherwise, it was just
a mouthful of words impaled on the page.

3rd Self-Portrait

wire spectacles—
unkept hair

no light or shade
no profile or
three-quarter view
just the lean

keen-eye looking straight
out, at you

An Unfinished Letter to Hilda

Ducky:
 I've kept all your letters: their glad-tidings
encircle me like the mist covering Widbrook Meadow. If you
happen to believe in dust-bins, my charred remains
will tell you where I am. Where I will have gone is another
letter. Ducky, despair is a smile on an angel's face.
O Sweete Themmes runne softly til i end my song. O let me
keep your musk-scent intact! Ducky: Cookham won't
end with these lackadaisical morning words...

Stanley Spencer's Temple of Love

consists of a Parish Church with 2 private Houses.
abutting the Church Walls tiny Chapels 8 ft. square dot
the church grounds. all the Bedroom doors open into
the Church. along the church aisle 12 Chapels: each chapel
a cubicle with Paintings of Married Couples for, he
said, "contemplating marital bliss." within the Chancel
Angels introduce Animals to their Mates. within the
2 Houses and Passageways: Emblems of Love: viz Clothes/
Scents/ Hats/ Jewelry/ Hair brushes etc. along an
(unspecified) Alleyway large Paintings of Men & Women in
various stages of undress. all this leading into rooms
filled with Nudes making Love and/or simply lying about.
The Whole Schema: more or less detailed as to the
number-of-rooms, walls, passageways, etc.

for Ernie Lindner
who among Canadian Painters
would rehabilitate Love's Temple

```
                D G
              E D G L
            N E D G L O
          O N E D G L O V
        T O N E D G L O V E
      S T O N E D G L O V E S
        T O N E D G L O V E
          O N E D G L O V
            N E D G L O
              E D G L
                D G
```

to Father
& Masako

(for 4 months
together in Kyoto

♦

gathered
blossoms

scattered
a gain

STONEDGLOVESTONEDGLOVES
STONEDGLOVESTONEDGLOVES
STONEDGLOVESTONEDGLOVES
STONEDGLOVESTONEDGLOVES
STONEDGLOVESTONEDGLOVES
STONEDGLOVESTONEDGLOVES
STONEDGLOVESTONEDGLOVES
STONEDG DGLOVES
STONEDG DGLOVES
STONEDG DGLOVES
STONEDG DGLOVES
STONEDG DGLOVES
STONEDG DGLOVES
STONEDGLOVESTONEDGLOVES
STONEDGLOVESTONEDGLOVES
STONEDGLOVESTONEDGLOVES
STONEDGLOVESTONEDGLOVES
STONEDGLOVESTONEDGLOVES
STONEDROYK.KIYOOKAGLOVES

the way they fell
the way they lay there

the dust sifting down,
hiding all the clues

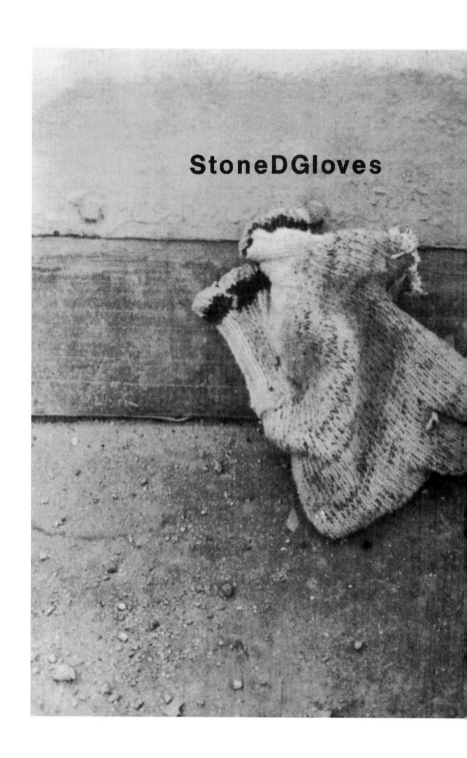

StoneDGloves

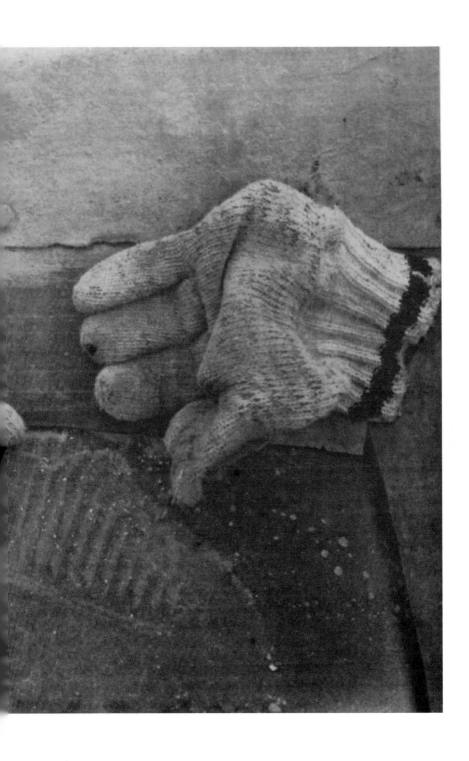

◆

if out of the air —
a piece of cloth falls into your hands
wipe your eyes with it

if out of the ground suddenly —
a pair of gloves suddenly appear on your hands
use them to bury these words

then ask your breath 'where' words come from
where StoneDGloves go

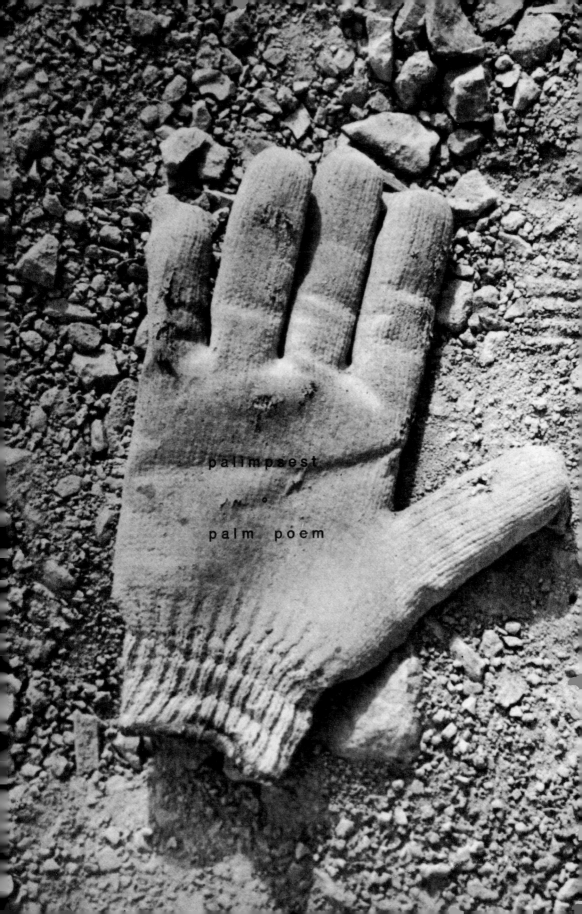

palimpsest

palm poem

this is a poem

for cotton glove, sad, worn-out
cotton glove —the very
heart of the poem. if you put your ear
to its cupt hand you'll hear
his echo re-echo through the poem
like a naked hand —reaching
out for its own shadow

◆

the poem reveals

the thumb pointing
towards the shadow the glove
throws across the dirt
the dirt under your fingernails
hard-bitten evidence

◆

parti-
culars:

one part
cloth

one part
air

one part
dirt

4 Variations for Victor Coleman

I searched another man's painting
intently for the 'glove' & found it when my
hand's shadow (momentarily) fell
across the cruciform 'figure' in the painting

◆

the glossy b. & w. photo shows a heap
of worn-out gloves with the forest unravelling
through moist fingertips. the negative
held up to the light showed a longlost fingertip

◆

thus enbalmed: the finger tip
showed no copy righted 'ownership'
nonetheless: the "glove" waved
to me across the scintillant silences
—pointing to an extinct star

◆

in the Dream: a long Sky Corridor
with numbered doors each door has a 'glove'
nailed over its number. (the number
i'm seeking will reveal itself if i be diligent)
the dream sd. —I'm running down that
long Sky Corridor —lifting each glove to read
its plangent 'number' beyond the very
last door the number that withheld its secret —
a Neon Finger pointed to the EXIT sign...

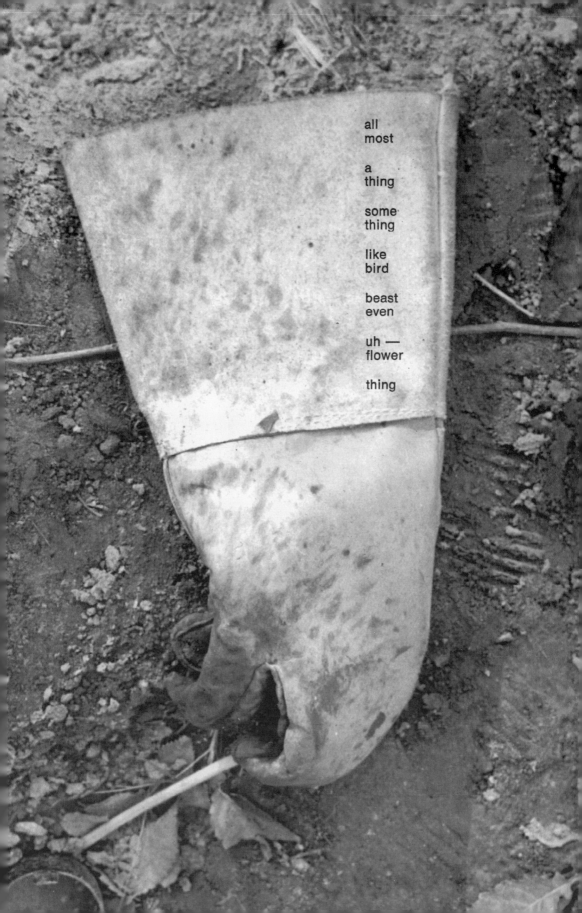

all
most

a
thing

some
thing

like
bird

beast
even

uh —
flower

thing

♦

unbequeathed to any hand

the glove lies flat-out in the dirt
the dirt it's about to die into —
is not the dirt of the poem: its dirt
won't scratch yr eyes. it lies
prostrate on the page —as if it had
been run over by a mack truck.
hasn't anyone told you —you can't be
buried in the dirt of a poem:
 even 'glove' wants real dirt

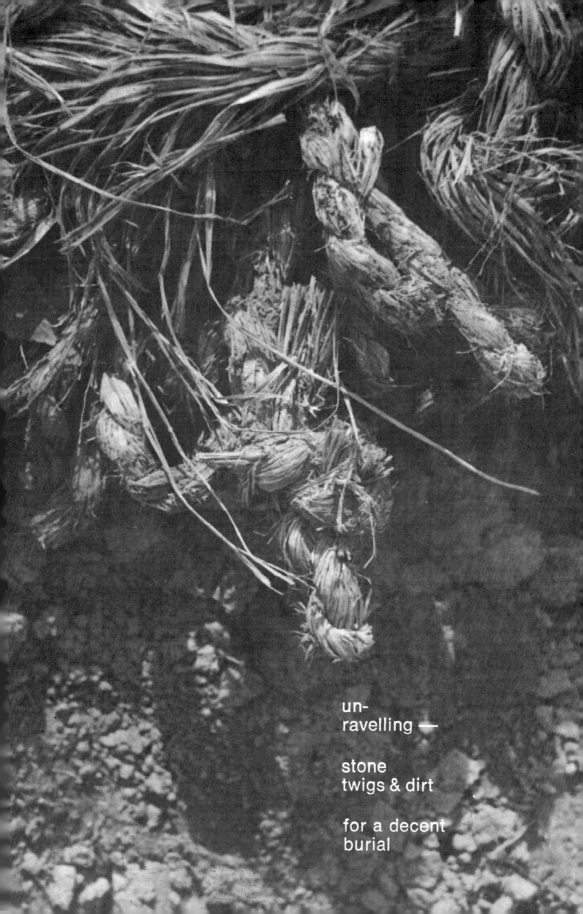

un-
ravelling —

stone
twigs & dirt

for a decent
burial

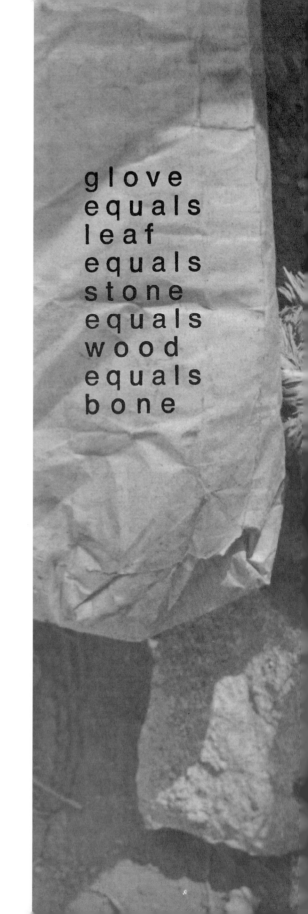

glove
equals
leaf
equals
stone
equals
wood
equals
bone

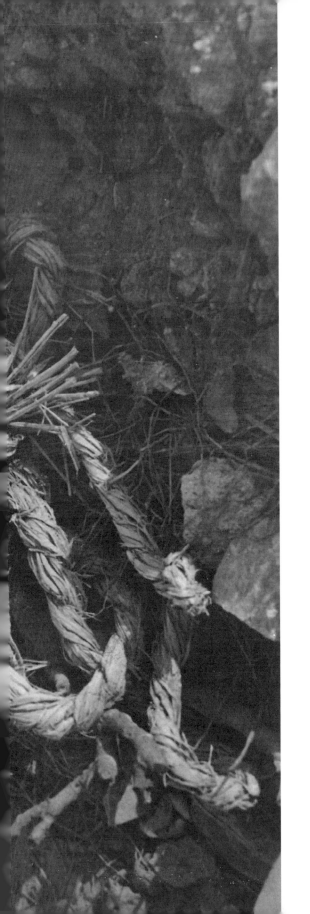

♦

"nobody owns words"
"nobody can put a price on them"

♦

"nobody owns words"
"nobody can put a price on them"

"lip-service," she said —
"for the sake of one small poem"

♦

among a heap of abandoned words:

 1 pair of cotton gloves
 1 acre of grass
 1 pair of broken glasses
 1 dead blackbird
 1 wheelbarrow
 1 pair of ghostly boots &
 1 small poem

 ...hiding all the clues

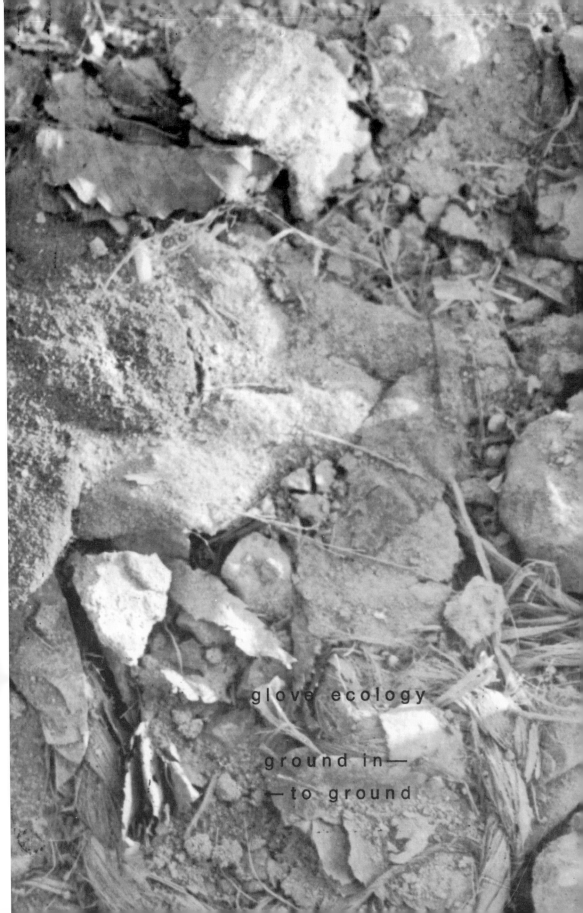

glove ecology

ground in—
—to ground

◆

—if this finger could it
would stick itself up you-know-where
& if it got stuck up-in-there
everyone would shout —Voyeur! Voyeur!
 this finger groping for air

 ...if you
 haven't stumbled across
 a pair of old gloves:
 you won't know how they fell
 into the dust
 palms up

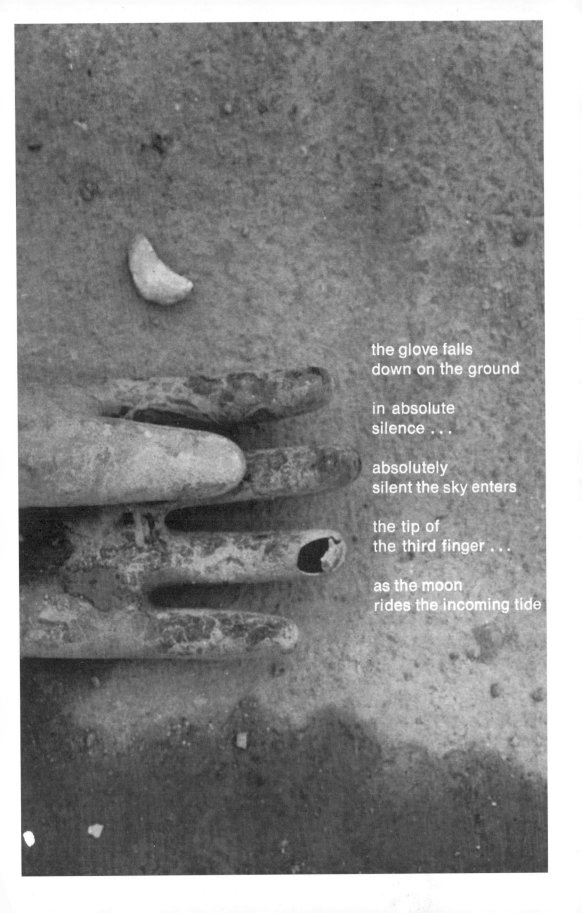

the glove falls
down on the ground

in absolute
silence . . .

absolutely
silent the sky enters

the tip of
the third finger . . .

as the moon
rides the incoming tide

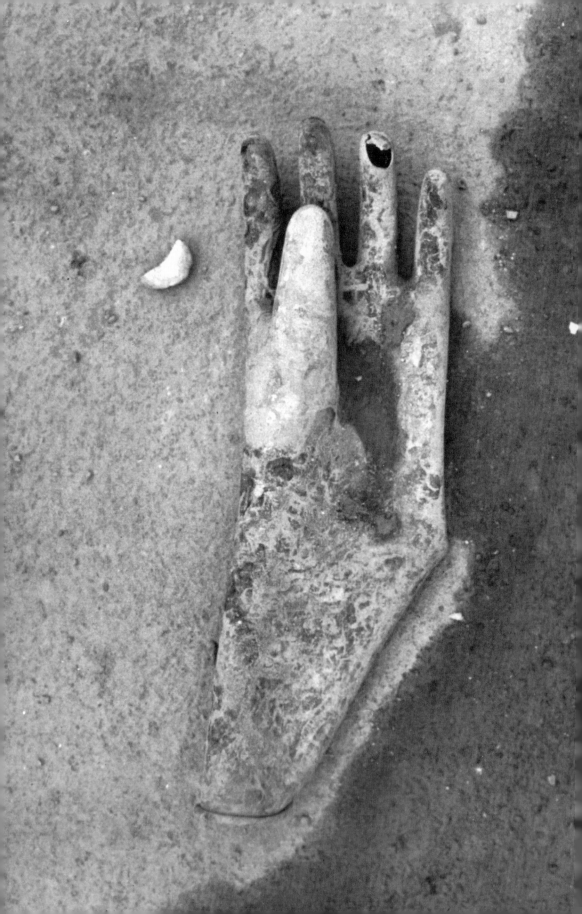

the glove
flat-out on the page
or found under-
foot —the glove you said
you found...

all gloves
scratched in real dirt
fall from the lips
of fools —into the poem
'nobody' owns

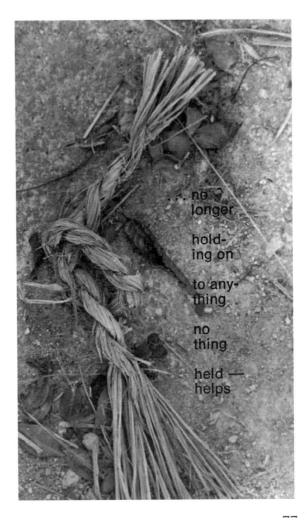

...no
longer

hold-
ing on

to any-
thing

no
thing

held —
helps

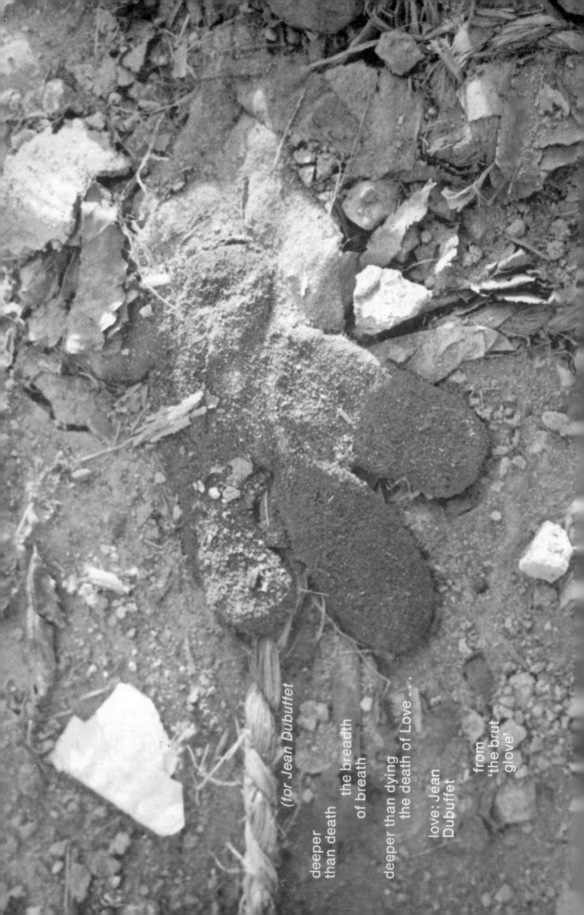

(for Jean Dubuffet

deeper
than death the breadth
of breath

deeper than dying
the death of Love ...

love: Jean
Dubuffet

from
'the brut
glove'

a Psalm for

5 fingers
making a pass at
the moon

♦

the thumb
points to the grass heapt
with gloves

♦

wholesome
night cupt in the palm:
palm'd-light

♦

intricately-
claspt: hand's shadow
foot's print

♦

the back of
the hand invites
the earth

homely earth
hearth
haven / home

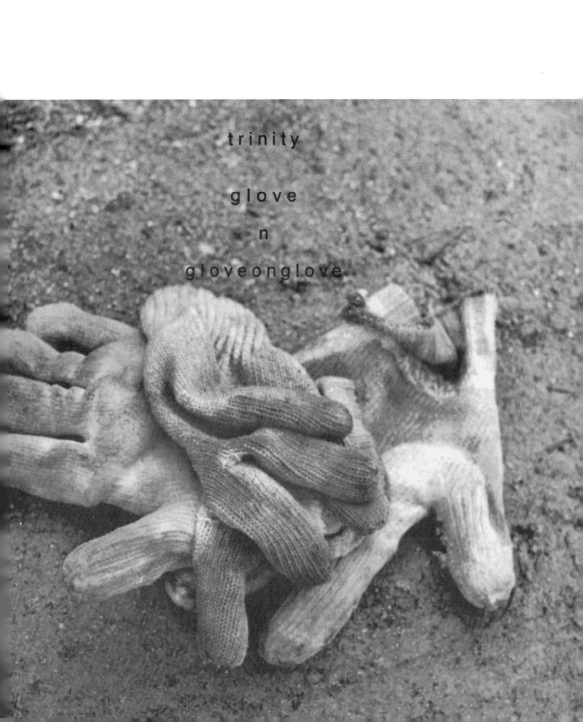

trinity

glove

n

gloveonglove

the words rise out of the ground

 absolutely silent...
 they fall through the air
 into the mouths
of children dancing 'round
 the Tree with
one white glove nailed
 to its trunk
the other glove cupt in the
 topmost leaves

 waves...

 glove
 equals
 leaf
 equals
 stone
 equals
 wood
 equals
 bone

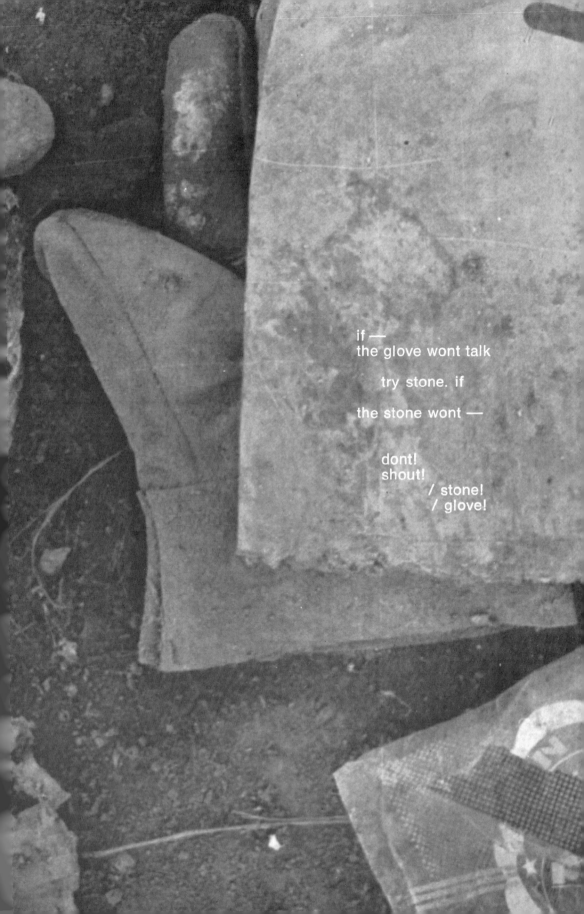

if —
the glove wont talk

try stone. if

the stone wont —

dont!
shout!
 / stone!
 / glove!

glove's dream
―――――――

hands
 hands
 hands
 hands
 hands

hold : held : help
――― ――― ―――

hands
 hands
 hands
 hands
 hands

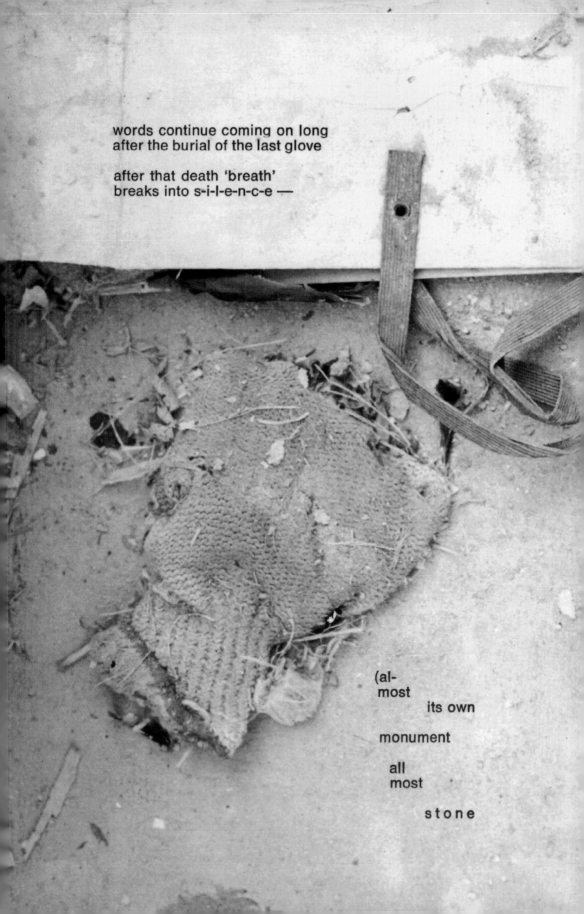

words continue coming on long
after the burial of the last glove

after that death 'breath'
breaks into s-i-l-e-n-c-e —

(al-
 most
 its own

monument

all
most

 s t o n e

this was going to be a poem for cotton glove

the poem that told you all about him:
as if all could be said about something even
my own hand knows nothing about. this
is a poem for "the dirt" the glove lies under

Alms
for
Softpalms

DIRT!

Amen.
Amen.

Amen

light-
fingers

°

radiant
peace:

°

Showa '44
kyoto

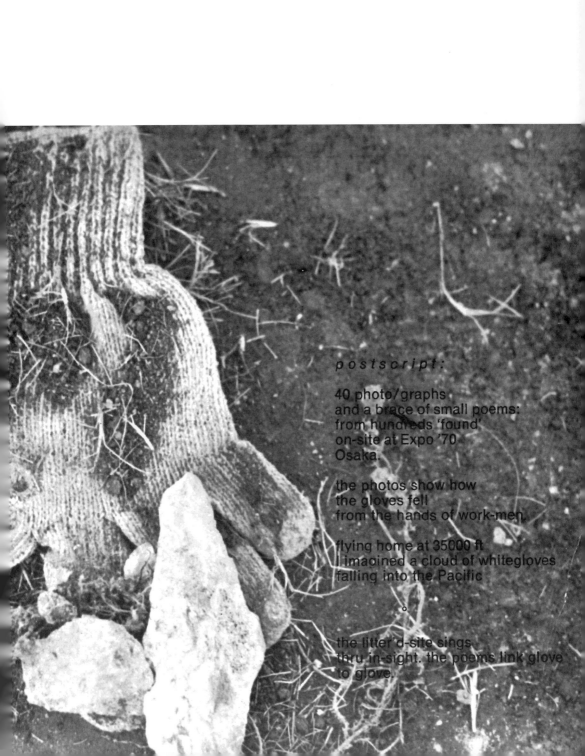

postscript:

40 photo/graphs
and a brace of small poems:
from hundreds 'found'
on-site at Expo '70
Osaka.

the photos show how
the gloves fell
from the hands of work-men.

flying home at 35000 ft
i imagined a cloud of whitegloves
falling into the Pacific

the litter d-site sings
thru in-sight. the poems link glove
to glove.

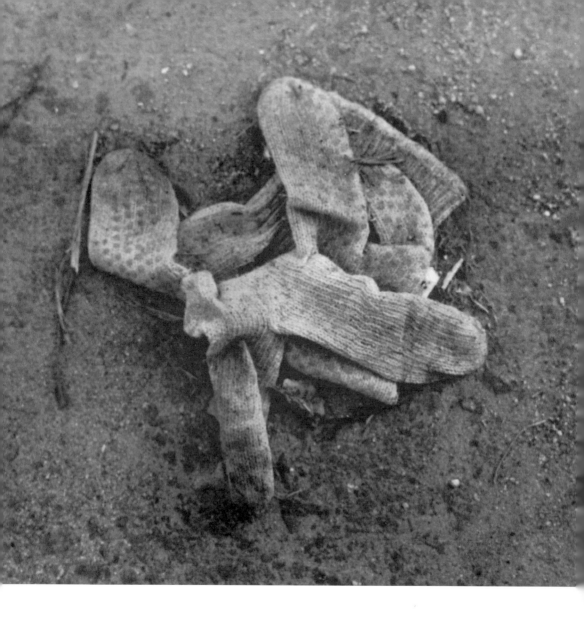

photos &/or poems
may be reproduced by anyone
for whatever reason.
'Copyrights' like worn-out
gloves are obsolete.

"only the imagination is real"

of seasonable pleasures and small hindrances

marginalia
written at the back
of the lot
1408 westminster highway
richmond bc
fall & winter '73/'74

"say it again sam
every lover knows that
I love you *is a vocal*
variable to be interpreted
by the vibrations."

for: richard
linda

paul, xisa
fen yee

mariko
jenny, eric

& ol' peat

&
moon-bow
over the fraser
south of
westminster
highway
east of no. 6 road

walking
behind
my own
breath...
talking to
myself

&
if it gets any colder
I'll have to pull on my longjohns & take my
hot water bottle with me
to bed
 one whole body is only half
 as warm as two. imagine the sky,
 she sd without a full moon

 one house calls
 out... to its clapboard
 neighbour, "hullo,"
 is there anybody at home?

 echo
 answers...
 echos
 always
 home

&

it's almost time for the last big
silver jet to scalp my tousled head.
then, there'll be a few more drunk-
en midnight drivers... before the
early sunday morning birch tree-top
chatter ring of a thousand & one
petite starlings. this flight is for
luis bunuel... listening to the carni-
vore's uproar in his cerebellum

&

ever had
3 red zingers
on top of
a Big Mac laced
w. mustard
before reeling
to her apt.

&

or had
your saucer-eyed
sweetheart
fart in your face
brother

&

everyone buyin' up telescopes to get an eyeful
of *k a h o u t e k* when it hoves into view. & according
to the *Sun* — almost everyone feelin' they've
been taken on another ride to the old Astral Cleaners...
when the "fiery one" fell out-of-sight — like
 a coal-black Cinderella

&

egos
are friable
comets
too

&

he thought he would "go without"
for the sake of "getting it on" — like later. it
was then he noticed how all the lines
incised in his palm bequeathed their intricate
geometry
 to her rotund profile

&

spider in the bathtub
spider in the sink
spider in the marmalade
spider in a *scream*

&

air's
errant
wax-
winged
heir

&

paging Petrarch

fools walk in...
just as the angelic face begins
to erase the traces of
its beatific aura. thus, Laura
w. the laughing face
crackt the mirror w. a wild
grimace

&

tea for two &
two for tea

me for you & a
you for me...
& other top 20
euphemisms

&
... years ago
on a weekend bender
one flat tire one
badly bent front fender
& one pukey pin-
striped suitor without
even a radio

&
caught
without a trace of
her scent he
jerkt himself off & fell
full fathom five
into his own
cum

&
let's not hurt each other further
let's kiss and make up —
must be a 'script' written for other
more providential lovers

&
like the very dew...
his story has something to do
with this o so sodden
peat & these clapboard houses
without a facade

&
midnight bramble

midnight cries...

&
remember...
the herr professor
down on all 4s
pleading —
for more of her blue
angel shit?

&

poems are nothing
but your sere-breath stirring
these 4 am vowels
of all the un-born silences

&

day-break...

the midden
shoulders its way up
thru the mist
into the plenitude of
another blue monday

 un-
 ceremoniously
 bare-arsed he
 divested himself
 of a huge turd

&

fickle
star
tinsel
night
morning
glory
fireweed

horst

&

television & nuclear fission

feces to feces
dusk til dawn if t.v. doesn't
get you trident
will

&

intrepid blue notes

all god's children without exception
bear the familiar *rarities* viz
how venerable sages like fen yee seem
agelessly three & a half. p.s.
you can usually spot them among trees
by their infectious laughter

&
kinky saga/cities

mao's
red peking

nixon's
white washington

&
if you've lost faith in familial pride
you might as well toss the baby out
with the dirty bath water and watch an-
other old-fashioned horse opera

&
yonge & bloore street, circa 1950
for david bolduc

after rossellini's
"bicycle thief" / louie armstrong's
"pennies from heaven"
a neon-drizzle walking back
to 272 parliament street

frederick horseman varley
roloff beny & arthur lismer's
retrospective at the a.g.o.

&
in richmondtown
the japanese keep a low profile
like, there's no exult-
ation, let alone, salmon, without
paying your dues to sit
upright in their polisht pews

&
once
scarred
twice
vigilant

&
viz the watergate follies

stickin' up for his
misanthropo frailties he
shot off a salvo of

maladroit puns — that left
the inner circuits of
the white house gasping —

&
the latest taint of racism

breathe a
little suburbia
plant it w.
a ten foot hedge
dream a
little pestilence...
to keep the
east indians out

&
the new arabs don't fold their tents up
mr. arnold. they're busy building
a gleaming glass & steel "babel" on the
sun-scorched altars of the sahara
as their shieks ride off to the derby in
their bullet-proof mercedes. ah the
new arabs are already moving in across
the street from buckingham palace
w. their harems, kif & luxurious carpets
mr. arnold. remember what you said
about a bedouin's midnight
 prowesses...
the piltdown man meets captain progress

love the land & it'll take care of all your
fallow heirs. scar it up & it'll soon turn into
yet another sahara. ask the stone sphinx
where all that adamant sand came from... &
whatever happened to the lemon groves
in allah's once fabled gardens?

&
capricorns:

richard milhous nixon
muhammad ali
gladys hindmarch
henry miller
charles olson &
yours truly

now that the venerable BBC together with the NBC
& the CBC re-play the official English-Language version
of the Allied Victories & other grim 20th century
Parables... may they all have mercy on Mr. Chamberlain,
Herr Hitler, Maestro Mussolini & last but not least
that lordly munitions-maker Herr Doktor Krupp

viz the same old mendacities: how all
these 'kick-backs,' 'rip-offs,' 'hand-me-downs,'
and 'scratch my backs' *flower* daily in
the punctilious columns of the vancouver sun

... if they open one more karate/
kung fu parlour in the lower mainland
I'm goin' to join the terminal city
lawn bowling club & take out a lifetime
subscription to the Watch Tower

current babel

true-blue tories fondling
their family 'union jacks' think of
the 'maple leaf' as just an
other liberal cover-up job: a new
fig leaf for WASP Kanucks

according to the high potentates
of a Free Enterprise Punitive System: Dope
debilitates the providential pater-
nostrum and resuscitates the breath of evil

suckt-up into the BLACK HOLE of
Intergalactic Space he unwittingly became
the Astronaut of the empty Tao &
promptly got ordained a nihilistic saint

"my country tis of thee"... "I" hereby swear
with my right hand on King James' version of the Holy Writ
to remember all the Disenfranchisements of the
War Measures Act. together with the WASP supremacy of
the Mackenzie King era and furthermore I suggest

100

we let the Pope save P. E. Trudeau from further pedestrian
discomfitures. "Viva la Two Solitudes"... I
thought thinking of myself under a third no less conspicuous
pacific pilgrim's solitude

&
o kanada

hallowed be
thy fame. thy kingdom
befits my own
un-mined *tundra* my
wind & water
hinterland

&
comparative mythologies

mao's
long march

nixon's
miami piazza

&
nemesis
premises &
a pinch of
protestant
piety...

&
remember to remember...
how quiet it seemed on the western front
til the nazis crossed the 'maginot line'

remember to remember...
those inpregnable concrete bunkers
& all the homo sapien ferocities

remember to remember...
how they stood waving fervent 'banzais'
before turning into lethal missiles

remembering all such errant
fanaticisms on the 32nd anniversary of
Pearl Harbor my 15th year

&

'40s screed

"you yellow-bellied
son-of-a-bitch"

&
ask
cain who
killed
his brother
abel

ask
hitler
about
the aryan
will

&
paging mr. aesop

pickle
a president for erasing
a tape
rape a
little orphan annie for good ol' daddy
warbucks

but only a fog can hide
a 40 ft. alder
without any ifs & buts

&
in "quo vadis"
caligula saved all his unspent tears
in sequined vials: thus
proving that even the obnoxious have
their placebos for suds &
heart-break sobs

&
like
over the hump & under
the hill —
without an heir, loom, or
a will...

&

for the Remembrance Day Gathering around the Cenotaph

let's place a Wreath around karmic Catastrophes.
let's call it an unholy Tryst & give the "Living" a break. viz
let's put a conscious break on all future mayhem

&

twice
scarred
three
times as
scared

thank the Tao... "syllables" are the World's No.1
re-newable resource: like, once they're hookt into your windpipe...
you're a dead-ringer Buddy for a bereft troubadour

&

re -
reading kerouac:
flatout on
top of the midden
tracking...
"old angel midnight"
w. stardust
in my eyes

good night linney
good night
jack & good night
midden

&

foolishly-
fated to crack...
he would go
sunny-side-up

for gerry g. & carole i.

3) YESTERDAY
 (burrowed time
 TODAY
 (an impeccable presence
 TOMORROW
 (a lucent slime trail

for) PAST
 (a perpetual inventory
 PRESENT
 (Skies / Grounds
 FUTURE
 (Airs

the) DOOR
 (& all those
 WINDOWS
 (the musical chairs & runcible
 FLOOR
 (w. a bedpan & a Fable

road) f o r e v e r m o r e
 m o r e f o r e v e r
 e v e r m o r e f o r

in 3/4 time)
 "I'm havin' the time of my life"
 "my time is your time"
 "time on my hands you on my mind"

&
no way of re-covering the curvatures of my
yesterdays... but to go on making my
own Home Movies & caught up as I am in each
flickering frame... SHOOT MY WAY OUT!
as the Black Bandit the vile one makes out w.
my blonde heroine. no way out (now) but
thru a Hail Mary Sky filled w. bullets, bird shit,
satellites, & her — ah, swishing taffeta

&
like
love's commotions
curving thru

104

time / ryme could be
my valentine

&
his kind of Tao pun

mating the
proletarian nouns
matching all
the sacral verbs &
letting the
tired dialecticians
re-tread all
the antimonies

viz how the fragile ego
expatiates
its own volitions &
other etcs.

&
mother o mother
tell me the story of love wit
promiscuity & glory.
o mother let's put another 78
on the old victrola

&
air's heir

bearing
it with a grin &
tonsure

Seasonal Epiphanies: for Daphne

blue	spring	wood	east
red	summer	fire	south
white	autumn	metal	west
black	winter	water	north
yellow	4 seasons	earth	center

&
before D-day & after
dancing cheek to cheek round & round the granary floor
with a fearful hard-on for miss susy nishimoto
while the ink spots intone I don't want to set the world
on fire I just want to stop the flame in your heart...

& other consternations. D-day in Opal Alberta. now opal
is minus its 3 tall red grain elevators. its pool hall
& blacksmith shop. its Hawreliuks, Watanabes, & trio of
McInnes brothers. 30 years gone... with the wind-
winnowed blueberries mother pickt every summer of the
war. nothing lasts. not even my outrage: all the un-
tolled human beings incinerated in Hamburg Auschwitz
& Hiroshima — didn't prevent napalm bombs falling
from American Bombers over Vietnam

&

without eulogies:
there's a plangent host haunting
these tongue / tide words.
there's a big black hearse waiting to
drive them to the fastidious
morticians of etymology

&

breathe
a word / dream
a death

&

heather sez fireweed is great for bees,
my man keeps his hives in them.
fingering a silken tuft, sonia sez it's
too delicate to weave alone but
could probably be interwoven. richard
likes the way they stand upright
without giving an inch to the voracious
blackberries. & on acid, my eyes
spun a rainbow w. their lucent filaments

&

"sing about the long deep sleep of lovers
that are dead, & how in the grave all
love shall sleep: love is a weary now."

&

from the back of the lot:
it's taken most of my 47th summer to
refurbish this once derelict
mink hand's shack. now that the small
persistent rain falleth on my
petite palace... "i" the stoned king
wait for the fabled words to
fetch her to my door

&
his kind of firmament

roots
in the aether
grass
on the terra-
firma

&
it's
rainin'
cats &
dogs
while
the peat
& the
midden
both
sleep

&
valorous
———————————
vestments

&
o the lapis
lazuli
coruscations
the heft
of pacifica
it : is : us

&
thanks for all the
heart-felt conundrums loft'd
by your sweet breath o
anna livia plurabelle... my
anamnesis

&
in the eye socket of my netsuke skull
un-
imaginably
small
its delicate
web
its

equally
diminutive
boss —
defining

the
limits of
my
tenacity

&
"tell me sam —
are there any left-over alms
for hand-me-down
middle age lovers of the 20th
century ?

&
of
these
be-
spoke
words
the
midden
wove
another
web

&
tic / toc
thick
stalk/s

tho meant to be its own small book:
of seasonal pleasures & small hindrances got
gathered up & placed inside the trans-
canadaletters published by talonbooks, fall '75.
unbound & re-written at 356-powell st.
vancouver b.c. in the fall of these belated '70s
to please my fickle muse — it's become
that very book thanks to the b.c. monthly & its
editor gerry gilbert
nov. 21st, '78

the Fontainebleau Dream Machine

18 Frames from A Book of Rhetoric

*"over the princes of delirium
over the paupers of peace"*

for
Dave Barrett
Angela & George Bowering
Gerry Gilbert
Carole Itter
Sadakichi Hartmann
Yasuo Kuniyoshi
bpNichol
Wilfred Watson
Phyllis Webb
Georgio Vasari
Sarah Sheard
&
Eva-Marie Kröller

out of the lair of breath the Dream

Machine slipt its moorings
in the Cave of my mouth and climbed the tree
tops of my sleeping eyes up into
the cool blue Night Mother mute mother
of my breath the unvoiced Cry of
the child i am 'rings' the Changes in
your granite mouth

these stones these stones embody a tongue
tied Speech

the 1st Frame shows
Breath (shadowing) Dream (shadowing) Air (shadowing) itself

while the 3 Graces adorn the hem of the dream i fell into

all the dreams breath can hoist go up into the sky!
while the three of them unravel the hem of the dream i became
all the dreams shone on my eye-lids high above the Nile .
then when they began to knit another dream from my unravellings
all the dreams i ever fell thru fell into my Astonishment .
Voila! Voila! the Air of the Andalusian Dog stroking his genitalia

the 2nd Frame shows
all the dreams breath abides betrothed to the Queen of Hearts

the billowing Cloud/Figures swirling

around the Dream Machine's ascent owe their Chiaroscuro
to Raphael and Michelangelo . 'awesome portent —'
or it's that prehensile primate Hero of a Thousand Guises a
Mickey Rooney standing on his tousled head waving —
"Golden Hallelujahs" by Metro Goldwyn Mayer .
"Monsieur, I salute you," acknowledges the Aureole around the Dome
of the Sistine Chapel . the Dream always wins in the end.
"deserve your dream"

the 3rd Frame (hides)

the Morning Star under the Cowl of Breath

at the Portal of a Dream

the great bald Eagle carries a banner in its claws across
the Dreamer's Threshold . the Dream with its
intricate Flotation-System hovers — motionless — above
the Glacial Plains **etched** on the Shining Metal of
your eyes . at the Port of Dreams you never need a Passport
ask the Eagle "who dreamt you?"

the 4th Frame

a Clap of Thunder marking the Distances We Travel by Night

High Noon at the base of

the tall (fluted) S T O N E (breath) Column
— a man with a Nikon F-2 measures the
Lattices-of-Sunlight falling across Broken Statues
of a "once upon a time there was . . ." O
the intricate marble fluted Foliations the inflamed
Lyre . . . kindling
 stone : leaf : grief

the 5th Frame hides
the actual length of the column inside your Inner Ear

the Eye of the Camera Obscura

Lukas Fantuzzi found himself looking thru
an optic-nerve a Verb "to be" —
projecting pellucid Nouns clowning upside
down inside the Dreamer's ah
dormant Machinations . Jewels? well, why
not jewels worth the Heft of a Maharajah afloat
on the cool blue fountain of our
peregrine A B Cs

the 6th Frame exposes

Our Host the Retinal Ghost Dancing in the Dark

how almost elegantly They stand

at their ease to either side of the Dream's Cornucopia
with one hand on their crotch the other claspt
behind a wreath of incised leaves: the ingenuous reflection/s
of their hands and breasts a **navel** among flowers .
how the 'eye' opens and closes on the intricately cut Diamond
of their Vows — as the unseen air caresses the dream up
from under their marble feet . . . i fell into the beguiled air
of their astonishment

the 7th Frame shows
the Hand of the unseen Poet turning into a Palimpsest

sifting the Rune/s for

the Behemoth of Speech: the absolute truth of
those huge white tusks curving in the moon-light marsh
a million years ago, today. searching the Sahara
for the Algebra-of-Awe Rimbaud wept when he stumbled
on them in front of the pygmy king's palace. the impossible
death of Chairman Mao on late night television. nuclear
frisson. Hermann Goring & Separatism. on the
tusk of a dream i beheld the Elephant on the promenade:
his inflamed ear thrums the mammalian silences

the 8th Frame hides

the real pigeon shit spattered on the back of a bronze Napoleon

of the Guardian Mother & her Entourage

of Shining Angels: of such Heavenly Hosts i know nothing
but how they seem forever suspender'd among gilded-clouds
on the back of a hackneyed horse with dangling hooves awry.
lucky or unlucky the Augury they propose lifts a blanket of doubt
from the green morning meadow filled with braying donkeys.
"I would etch a Silvery Horse on the Shining Metal of your eyes"
the Dream whispered, dying into the dew under their cloven
feat . replete replete the Dream dies into

the 9th Frame hiding

the unspent Heat of the solar Belfry, the climbing plant i am

step lively up to the door cut into

the wall the Flaming Wall-of-Figures falling with
all the dreams 'breath enlivens' dying on their forked-tongues.
steept-in the intricate-Gyrations of an imagined Hell
they preside over the diurnal Wave of Fire falling
into the river's Mouth. O Harbour! step quietly but firmly thru
the doorway of your incredulity where all the dreams
'Death remainders' lie in the folded silt under a Mute's tongue.
O the un repenting Snake coil'd in Cleo's brazen hair!

the 10th Frame hides
the fluted (breath) Column in the unmined Quarry
beneath your tie'd tongue

the man tipping his top hat is not Fred

Astaire or Jacques Cousteau.
the Dream Machine ascends or descends according to the precise
calculus of ancient Taoists or Mandrake the Magician
pulling a Tableau of Writhing-Figures out of his adroit sleeve on
Cabal-a-Vision. O the tiny pair of eyes peering thru the
slats of a Venetian blind. The heap of butts we left behind in
the burnt-out Colosseum. "SVB PENNIS EIVS TVTV ERO!" cried
the Angel Maker as the Dream rose out of an acid bath burnisht
in its own Mysterium

the 11th Frame hides
the Butterfly Wing tattoo'd on the Ceiling of your Mouth

SVB·PENNIS·EIVS·TVTVS·ERO·
· I. · PENNIS · R.

Under the charade of clouds the still wind rudders

Disturbed by the Slowly Turning Propeller of adamant History.
Under the intricately-pleated Shroud a Tinderbox of Prophecies falls
into the Fire fuelling the Belly of an Insane Dream. Bestirred by
the slowly turning propeller — "People want HISTORY to resemble them-
selves. Or, at least, resemble their Dreams. Happily, they sometimes have
great dreams." Chas de Gaulle mused. Bestirred by
the slowly turning propeller both Chas de Gaulle and Felix Nadar
are pseudonyms for the un-assailable Ghosts dancing a jig in the
heart of the undreamt dream. At the Potsdam Summit Meeting —
Joe Stalin turned to the stalwart General and sd "Death, my friend
Gall, Death, always wins in the end."

Death is the Slowly Turning Propeller stirring

the 12th Frame
for the un-dreamt Vowel

in Night's Unfolding/s

the Dream Machine & its ghostly twin the un-dreamt Dream
ride the Night Mare Sky above **Pristine Towers:**
Gleaming Thrones of a Corrosive Ekonomicks pitcht on steep
Medieval rooftops — indentured to the Medici with
their Midas Touch. ask the bronze Eagle pointing towards
a labial Sunrise about the unballasted Air trapt
in a dead man's throat . . . the Dividends you pay through the nose
for my permeable Friend

the 13th Frame shows how
obliquely Shadows fall across the face of so-called Sky-Scrapers

Eugene Delacroix noted in his journal

How he felt more like fucking her this morning:
every time this happens another nail is driven into the coffin
of Colour Symbolism . there's nothing new under the sun
pouring through my loft window nothing but getting a huge
hard-on &/or painting her radiant Visage . ask
Amedeo Modigliani What happened? When he drove the last nail
in that awe-filled coffin . the Eye in the loft &
the Tatter Dream **monitor** the **DailyBeneficence/s**

the 14th Frame shows
the Dream's Effluvia pouring into the Gutter of a Song

while the imported Italian sculptor chipt

a Way through the last bits of wood clasping Aphrodite's heel
the spent Dream Machine kissed the cool cobblestones .
when the Air ravishing Her lifted her arms up to the wind all
the Children playing 'hide & go seek' whistled aloud.
O City Fathers giving Caesar yet another statute —
your parenthetical airs leave even these oak tree's leaves
speechless: the Air the air around the Dream Obscene
 / Splendide!

the 15th Frame pre-figures
the Pulp of an Unborn Dream buried inside the Book of Lawes

l'aura of the Ukraine Opal Alberta

the Carboniferous Sky over Europa and Asia: Black
as my horse Sleepy Jim who fell thru the winter sod roof of
our Root Cellar and ate — ate til the snow the snow
falling thru the hole the huge Sky-hole Jim had fallen thru
fell down on top of him. Black as his bloated belly.
his Nest of mashed-up roots. we tore out the whole front of
the cellar to bruise Jim an exit — and chained behind
the tractor we dragged Jim out into the unforgiving cold

> aphasia a cross frozen stubble
> aphasia the drifting snow-mantled pasture
> aphasia down the huge black hole
> aphasia his un deserved famine
> aphasia

the 16th Frame shadowing
the inflamed Lyre burning in the 2nd Narrows

the end of dreaming is the Beginning of

D a y G l o w C o l o u r s spinning a Shiner on
your astonished eyes : Daughters my Daughters
How how is it "i" suddenly see G r e e n : hear B l u e :
smell B r o w n : touch the breath of Rotund .
what the Epithalamion of Bird Songs **throng** my return to
Earth **Beloved Barge Mirage Urge**

<div align="center">

Port of Call

</div>

the 17th Frame belongs to Those
Who celebrate Night's Libations at the Mermaid & the Cecil

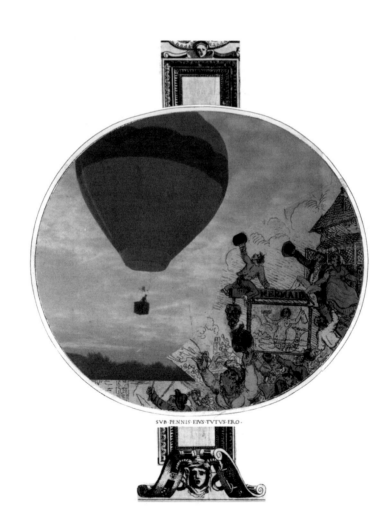

SVB·PENNIS·EIVS·TVTVS·ERO·

the dream dies every morning in the cave

of your Mouth with all the Starlings in the Pear Tree singing
Cantonese . O the Pear Tree in my backyard on
Keefer St . C h i n a t o w n m y C h i n a t o w n .
breathing Thing/s "i" lie under the belly of
the Dream — **a goat-footed Savant** in the Aura of its Commotion/s .
"be me" the Dream whisper'd "be my Daylight ." let
the Seances of another day startle . . .

the 18th Frame

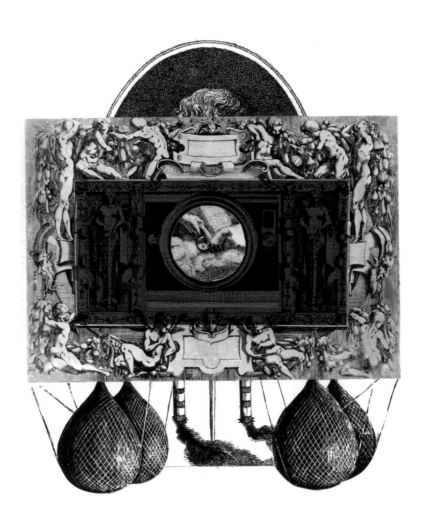

Sodom
Gomorrah &

Carthage
Await

The Sultan
Sunne

the artist/author of
the Fontainebleau Dream Machine
acknowledges the F.D.U.
(Fellowship of the Dreamt Universe) for
their untiring Collaboration
without which these Texts could not
have been written, let alone
collaged

who is really dreaming the dream everyone
one by one, dreamt?

Oct. '76/ March '77
Vancouver B.C.

Mutualities:
A Packet of Word/s

*found folded inside of a shell: for
& abt. Richard Turner & his Painting/s of which he has said,
"if they be 'paintings' they ought to speak for themselves."*

MASSIVE BLACKOUT TURNS OFF NEW YORK CITY:
"We cannot tolerate in this age of modern technology a power
system that can shut down the nation's largest city."

BABY BELUGA MAKES HISTORY AS FIRST BORN IN CAPTIVITY:
"We're not out of the woods by a long shot... but we're
very pleased with the way things are going."

A Baby Beluga makes a big splash in the Vancouver Sun... but
what are We doing, here, applauding, with these flippers
we call our hands. What are we doing standing upright on these
fins we call our feet: We who spent a millennium beside
the salt & silt river's mouth — waiting for some final Blackout — applaud
the miraculous mammalian another Moby Dick.

O Oracular Pacific lave his sleek body & these tongue-tied words

It is the Thing-ness of the Things in & out of the world & our desire
to embrace them that speaks through a man and his work/s

He remembers his first sensation — a savour of strawberries &
a kind of meat-spread. He is about two & a half. I seem to remember
nothing previous to my burning back & the bouquet of sweet peas
underneath my bedroom window. He remembers John Dillinger carving
a plausible gun out of bars of soap & blackening it with shoe polish
to make it look like the real thing. At five years of age the sculptor, painter,
fabulist & grammarian in him already nascent. These words no less than
the Saturday Afternoon Matinees of a long ago prairie childhood. Or the
long hot summer nights of painting (these paintings)
on Alexander St. are Entrances to his work.

His seldom spoken middle-name is Julian:
Julian the once upon a golden age magician and Julian
what's-his-name who was one of his father's
military heros. & a hostage of other irascible Julians.
What's inside of 'our' given-names? What do
our given-names or the nomenclature of known-things

proclaim? Someone said of a golden age & its
pre-eminent hero that "he wore his name like a radiant
apparel." Another piped up, "if you wear yr name
like a shroud, you deserve to die into it, bereft." What's
inside Richard (Julian) Turner's life work?

He shows me the slide of his next painting: Taken
with a 200 mm lens the slide focuses in upon an old man
sleeping under the thick trunk of a sheltering tree
seen through an out of focus frost-fence. That 'fence' as
a penetrable but discretionary screen is one of his
re-occurring minor themes. Now when I go by to see him I
look in on that faceless old man and I note how both
the shadows and the worn grass have grown in around him.
There's someone in a parked car behind that tree.
There's an ominous silence heralded by its unseen leaves.

Whether it's on the slope overlooking False Creek
circa 1960. Or later, in Cloverdale, the Nimkish, Matsqui,
Richmond, or Alexander St. Vancouver the oftimes
breath-taking Thing/s he shapes embody a fulsome Mutuality.

Pretend You Know

Pretend you know why this man is tearing the flesh off
his own face. Pretend you know why this moon-crazed baboon
is shrieking outloud fucking an ecstatic Marilyn Monroe.
Pretend you have suddenly come upon this thalidomide child
undergoing a drug-induced metamorphosis. Or, if that's
too difficult pretend you're that child's daily mother. Pretend
you're the only living/breathing critter left in a concrete
megalopolis after the 3rd World War. Pretend you believe in the
efficacy of nuclear deterrents and that there's a mountain
of invoices to prove it. Pretend you know why even the flawless
face of Catherine Deneuve proposes the unvoiced terror at
the heart of this painting. Then, pretend one last time that you
know why Beauty (itself a pretence) shines with the eerie
light of Thanatos...

He tells of how his mother became a portrait photographer. How
he inherited her 8 by 10 view camera plus a lot of photographic
paraphernalia. I recall a Mr. Iwama in pre-war Calgary who gave us
our first childhood pictures. How even today the portrait of my
maternal grandfather which he printed up remains a guiding spirit.
He tries but can barely recover any image of his own father who
also painted. I remember his uncle Jack who had an art gallery in

Calgary in the 40s and 50s. And we both remember Jack's lovely
daughter. He tells of his recent visit to Edmonton and the time he
spent with another uncle, a retired patents expert & a draughtsman
of the old school. And in all the ways he spoke of this gentleman
I was given the impression that he long ago became his lost father.
But it's in those ways he speaks of his mother that I recognize him
as the apple of her eye: "the age-old son of the loving mother."

Untitled Landscape

of heapt mink-shit mixt with tons of sawdust and runnelled peat:
all carpeted with wild oats, barley, and once tame wheat plus
a profusion of grasses, thistle-down, wild flowers including purple fireweed
— all hemmed-in by straggly pines, willows, poplars,
birch and fruit trees with tangled berry bushes under their branching shade.
all these herbaceous things tapping down into the aged
peat. Here: everything painted has a hitherto undivined history... the
Untitled Landscape resurrects a twice-lived hallowed ground.

because: i won't be dropping by to see him tonight i won't
be able to tell if he has given the old man sleeping under the tree
his own face. because there are these other things i've got
to attend to — i won't know if the grass the old man laid down on
has been tufted & greened. tonight as the offal smell off the
2nd Narrows laves these words: these two men the one who's always had
his own face and the other still faceless have a lot to do
with each other in his midnight studio. because i won't be going by i send
him these mute-signals via that faceless old man & his
penitential repose
 pain, the old man mumbled, sleeps, in things

Equestrian Leaves

Someone, unseen, rides, soundlessly thru these
translucent leaves. Whoever he be, he is one with the
Plant Horse & these entangled leaves wreathing
the I's orison. In the early morning when all the eaves
along No. 5 Road drip into an air-brusht dream I
stepped thru the encircling leaves and beheld the Plant
Horse with its dew-fleckt flanks. Now the late
morning sun sucks the heat up out of the peat and We too
are drawn up onto the Plant Horse hiding the horizon.
Beneath the umbrella of all these tentacular leaves
someone who is one breath with the Plant Horse sleeps
with his ear thrumming the aged peat. These green

leaves flourish as I do with my green thumb. Listen!
there's someone riding thru these drencht leaves.
"he" is not eclectic. he's the assimilative sort. "i"
on the other hand am dazzled with the sheer look of things.
he tends to ingest the whole thing and shape it from
the inside out. whereas i feel i have no mind but what the
beholding eye reveals. no matter. "we" began our lives
unbeknown to each other at the foot of two ladders inclining
towards the same nameless star. and over the years
we have waved & shouted to each other even though we knew
that our voices were shorn of meaning. then there were
those years when he, or i, or both of us vanished into a grey
cloud, seemingly forever. and we've both had the thought
that we had climbed a long ways up but upon glancing
downwards we could still see all the grimaces at the foot of
our ladders: whereas, when we looked up towards that
unnamed star our whole body shuddered even as our ladders
pitched and swayed. at the cross+roads of his life these
words promise to keep, his future undisclosed.

Pluto '79

amongst light air water
earth-inflected leaves rock & motley peat
subtle pelt of purples blues greens
& rust amongst their elemental commotions
a lichen-thatched boulder with soft
black animal eyes beside a swatch of shadow
or a mired pool wherein the humble
mutabilities include a benign carnivore — an
Albert Einstein
 O Astronauts!
 of the vertiginous world

we have talked about 'the knives' we have had in our lives
and what we did with them. he speaks of his long stay in the
wilderness: how during a prolonged fever his whole body
craved fresh meat. how he went out with his seldom used 303
and shot a young buck right between the eyes and dragged
it back to his camp. then sharpening his hunting knife he slit
its warm belly from chest to testicles and cut the quiver-
ing liver out and ate it piece by piece til his fever left him. i
spoke of my midnight shifts working on the killing floor of
a big city abattoir and all the knives i carried at my hip and
what i did with them. and in and through our 'knife stories'

we have come to agree that the hunter residing in us continues
to thrive in the head and heart of the "artist" we became —
and how through these ritual acts with knives we honour him.

2am, July 23rd, '77

... it is the Thingness of the Things in & out of
the so-called World and How they come to cohere within
The Language of Form & Colour that startles — the
unquiet silences folded into the throngings of his paintings.
it's in the breadth of their unmitigated silence/s
that our conversations have their twist and turns. tuned to
their chiaroscuro these words fall back into breath
knife clay wood air-brush camera stone and paint — to
illumine
 the Imago Mundi

Trans-parent-stairway

whatever these two people with their backs turned to us
are about to do. wherever the bronze sea leaves them
after the tide goes out — there'll always be these 'hands'
enclosing and disclosing gestures of aqueous benediction.
afloat on the shoals of an ancient reef I've listened to
these eddying waters swirl through my city's angry traffic
... Atlantis might well have floundered on an ordinary
afternoon like this. Suddenly, i see myself as that pale old
man turning away from these hands, his daughter & the
throng of trees washt over by the bronze sea calling to me
with its ancient kinships. whatever these two be about —
these hands clasp their diurnal affinities to the pagan sun

the sun shines brightly on men who have had loving mothers

... the endless birth-onto-death Processional of their,
from the beginnings of time, Otherness. their ah pregnant
coruscations: their Hosannas. We have talked about our
mothers the host of other women including our many daughters
til we were dumbfounded. And we know in our very bones
the ineradicable tracings they have left on our life's work. and
we have agreed time and again that we are as much 'them'
as we think we are 'us.'

Art is a Calling a Fool & a Scold: an actual speaking out.

Trans-parent-stairway

... and I come back to this painting
or rather it's the stained 8 by 10 colour print
taped to the wall above my desk. after all
these months of staring up at it. I am beginning
to see how — it's their undisclosed faces
that reveals even as they conceal their solemn ties
to the bronze sea & these gesturing hands.

Cast Off

... this coat this cast-off bituminous coat
with one round button leaves a hole in the mind the
size of a coffin. can you feel as if it were a
dead-weight upon your own back — the inexpressible
shudder hidden within its labial folds. or, if
you have the nose for it — smell its rain-soakt puke.
cast-off it hangs on a blue utility pipe where
it makes its own covenant with the sun falling across
the concrete wall the arabesque of pipes & the
motley grass. this cast-off overcoat/ cloak of
an 'ancient covenant' knows the humble pie world and
its bereavements.

'Beauty' lies unspoke inside its abysmal folds.

These words for & about his Painting/s
come from the unfound Ground beneath philosophy.
They attempt to reclaim the Mutualities
together with the Mutabilities that inform the ground
of our common bond. And though it should
be implicit, let it be said that these words fall back
into the interstices that lie fallow in any
man's work. His paintings especially.

*"for a painting to 'mean' it should catch
a moment of time in the space of a man's life, entire."
who said that? — was it him, or a remembered
echo from another man's mouth? no matter where it
has come from, I would make use of it to tell
of how an artist & his work/s are twinned — though I
would add that there is nothing adamant in
that fact. "nothing personal."
July/August '77.
Alexander/Keefer Street, Vancouver, B.C.*

WHEELS
WHEELS
WHEELS

A Trip thru Honshu's Backcountry

the moon's phases
the faces along Kawaramachi

Kyoto City
446 - Hachi-ken Machi
Furukawa-cho
October '69, midnight

tucking paper napkins into the brimfilled food basket
Masako said, I guess I will have to wait til my next life before
I see as much of Honshu as you three will on your trip.
on nights like this I feel I am living inside a dream that stops
short of Furukawa-cho's precincts. eat the sushi first.
I'll make sure you're up in time to catch the Backcountry Train

 "good night"
 "good night"
 "good night"
♦
with Masako waving to us
from the curb outside Furukawa-cho
Father and I hang on — as
our cab careens through Higashiyama's
grey-dawn streets towards
Kyoto Station & the Pine/Wind Train

 Syuzo our intrepid guide
 & fellow traveller said he would
 meet us in Matsue — an
 afternoon away on the San-in Line

◆
 Backcountry is
an open window on a slow train
 bags full of mail
boxes full of fresh veggies

 Backcountry is
a slow train with open doors
 obento with tea
a velour seat with a wide view

 sniff the air
 feel the rain

 pelt of solitude
 humming wheels...

father has his suitcase filled with Seagram's VO:
each bottle carefully wrapped inside his change of clothing.
i've got my faithful Canon & 20 rolls of Fujicolor film.
nobody noddin' off on the Pine/Wind knows our 'family name'
or 'where' we hail from... i thot, taking a light-reading

 — comin' into Fukui-yama
 father askt if the conductor sd, "Fuji-yama"
 "it's Fuku-chi, not Fuji," i replied
 without taking my eye off the view-finder —
 gleaming a viridian landscape

father opens his suitcase and takes out a small white cup.
unwinding a sweater from a bottle of VO he uncorks it and pours
himself a tall one. "here's to the Open Road ahead of us —"
father sd, lifting his whisky, before downing it. i, pointing my
Canon out of the rain-streakt window, heard a dutiful son
reply — "here's to the snapshots of everything surpassing our sight."
"i'll drink to that," father replied, pouring another tall one

 "— this is my first time in these parts
 though it's only a long day away from Shikoku it seemed
 thousands of miles away once i got to NA
 ah, but now we're travelling through it it's almost
 textbook familiar. rice is king around here."

 miles of harvested fields
 under us these turning wheels

... how come we have so little to say
given all the years we've travelled separate ways.
... how is it we seem to have spoken of all
manner of things cast-up in familial nets.
... o the assuaged tongue/s of a father & son
riding Pine/Wind train thru Honshu's Backcountry

 ... pictures-of-the-floating-world
 pictures-of-our-passage-thru-it...
 i thot, winding the film up

 resting his head on his suit-
 case father nods off his empty cup
 jiggles on the window ledge

"ah could this be
Nippon's number one Rice Bowl?" i
askt myself as these endless
rice plains clickt by my view-finder

♦

without rime or reason
this rain-dappled Landscape becomes "us":
'lineage' must have something
to do with these precipitous rock ledges —
this serpent river follows
 towards the China Sea

 it's raining! it's pouring!
 cats and dogs and cascading fields
 "inside or outside we're 80%
 water anyhow," father chuckled,
 pouring another VO

Kinosaki

mere name on a map where
the Japan Sea sat upon brown tile roofs
aloof as only the sea can be

by the time father turned to take a look
it had vanished behind a tangle of
pine branches on a red rock promontory

140

's d u n e s:
grit on a 35mm lens
a cup of scotch
neat unbespoke s a n d

> Backcountry Time is 'local'
> : locate each Whistle-stop — place
> its earthen goods its weather
> on the horizon line... doze off

— out of Yonago
there's only 7 of us on board
comin' into Matsue —
it's STANDING ROOM ONLY!

> Syuzo our intrepid guide
> speaks an off-beat 'inglish'
> i a comparable 'nihongo'
> father our equal in either tongue
> lets the silences hail 'us'
>
> how do 3 Backcountry
> Travellers abide each other?

> > don't ask us what Matsue was about
> > it was veiled in a dank grey shroud when
> > O'Hash came to fetch us to his home

> > noted for 'maga-tama'
> > green jade beads fingered by
> > long ago Shinto priests
> > & these well-shuttered Spas
> > lining the cobblestoned
> > street & for us O'Hash &
> > his family
> > > whom father

befriended in Edmonton
where a young O'Hash came to complete his
medical studies. now O'Hash is just one

of the many House Doctors in Otama who spend
their days fingering rich men's pulses &
prescribing the proper mineral water treatment.
"it's a limited use of my skills. I'd leave Otama
tomorrow if I didn't need their yen to set up
my own practice back home," O'Hash sd,
pouring another round of sake. we talkt abt Kanada —
how Nippon could be tuckt away in one small
corner of its immensity. & round & round
the sake flowed while the incessant rain applauded
our plenitude in the heart of Otama

o

 one mountain
 stream
 strumming a
 wind harp

 two shadows
 pirouette
 in a 2nd storey
 window

o

at the far end of the aforementioned cobblestone street:

 huge
 gap
 in its
 sod
 roof
 for
 Demon
 Sky
 to fall
 in
 to

♦

o niche! who?
put the long-stemmed faded flower behind your rusty iron gate

o

then: it's 3
tired travellers in a neat row
til sleep annuls —
the million-darted rain drummin'
the low tin roof

Otama's Dream

beads
of aqua
beads
of jade
suave
bodies
falling
thru
a natal-
dream

lave

♦

head thrust inside the cab
O'Hash gives the Punk Kid our Driver
last minute instructions — like
he's to bring father back here after he
has put Syuzo & i on the afternoon
train to Higashi-hagi. now the O'Hash
family wave to us from beneath
their dripping doorway as we drive off
into the unabated downpour
°

sodden ochre fields slant
towards the brine sea on our left.
more of the same drenched-
terrain as far as cloud-mountain
on our right
°

 which hand
 pleasure?

 which hand
 pain?
°

like
providential
Guests
on a Tour of
Sacred
Precincts

We bow
to the Wind & the Rain God/s who

long before breath
got baited

upbraided
Life
°

these school girls biking single file towards us
include my 3 daughters from another life
i thot, as the rain pelted my homesick thoughts

◆

on the Road to Izumo-Oyashiro, Hinomisaki & the Japan Sea

no hard-times hereabouts
with lots of fish at the back door
these rice fields up front,
father said, making small-talk
°

Do you see how all these farms have their backs up against the monsoon
winds which sweep these fertile plains with a rough broom all year round?
See these tall cypress trees sheltering each farm well I've often been told by
those visiting from other parts of Nippon that they have never beheld such
stately trees — do you agree, he asked, wanting to include us in his proud
consensus. Now every farmer here knows how wealthy his neighbours be by
the height and breadth of their wind-break trees. Plus the number of Li lying
fallow between them. Those over there belong to the top half a dozen families
in the whole region, the Kid said, as we veered towards them — their tall
cypresses tousled by the brinegale. And as you might have guessed all these
farms only change ownership reluctantly and then it's usually due to an un-
foreseen catastrophe like a derelict husband or a once in a lifetime drought
that wipes the slate clean. Now their Legends tell how they had sprung from
the seeds of an unnamed couple from down under who got ship-wrecked on
these craggy shores. "Rural aristocrats" I call them — they've lived on these
fertile plains so long their own past is but a dim memory. As for me I'm just a
mountain-village boy who made it down to the City of the Plains and got
himself a diploma in auto maintenance, the Punk Kid said, making small-talk
and swabbing the fogged windshield off with a sodden cloth.
°

only the Punk Kid knows
what mean-bend lies around
the next slope. only a Trio
& their chauffeur know how
rice fields crumple & slither
down the windshield — as
drencht tarmac unwinds itself
inside our dank forebodings

144

♦

... the old tale tells of how prospective Bride & Marriage-Broker walked around the Groom's Family Trees, tallying each and every tree. It's these very Trees that told them how large a Dowry a capable wife with a fertile womb could with impunity fetch. The old tale tells how these tall cypress Trees have always been a weather-vane & a ladder to climb up into the heavenly realm. Ah but it's always been one of my pet beliefs that there was a third Party involved, namely that old thief "Kuroi-Kasei." Afterall he alone knew exactly where his family had buried their vilest secrets and he was more than willing to show her the exact tree the Cache-of-Secrets lay buried under — if she would pledge with a prick of her blood to let Ol' Windbag curl up beside Her whenever her husband-to-be went out to sea. Thus this triangular tale based on a guileless marriage lasted the three of them a long lifetime, the Punk Kid concluded with aplomb — knowing he had a firm grip on all the local legends as well as the steering wheel.

He's at home with us enough to take a sly poke at his big city cousins: those who fly down to the Spas in his part of Honshu to cure them of their big city ailments, their fettered IQs. He's at home enough to pass the sodden cloth over to Father to mop up his side of the windshield. Hmm something hay-wire with the defrost — I hope you don't mind the limited view. O the weather bureau predicts clear skies on the South-West Coast tomorrow, the Punk Kid said, as if he anticipated our desire for something other than this incessant drench.

 Izumo Oyashiro

grey, wholly grey, the curving cobblestone street
squat grey buildings, unplummed trees, veering towards us

Here: the Kid duckt into a shuttered souvenir shop to borrow umbrellas for us. Driving to a side entrance he leaned back in his seat and sd, you have an hour to take it all in — I'm catching a nap. Meet me back here.

♦

in Izumo Oyashiro
the Gods gather in October "the Godless Month"
with Marriage on their minds for
all the Sons & Daughters of the Rising Sun. ah
but it's really November — "All Frost
Month" the sweet rain tapped
upon our umbrellas

HUGE

Sacred Rope
over the
Holy Entrance

EVIL KEEP OUT!

how
tell how
high
ridgepole
goes
to clasp
sky

when
underfoot
small
grey
stones
float

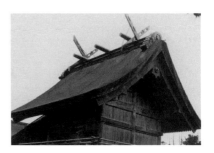

up/down

wood : temple : body : gate

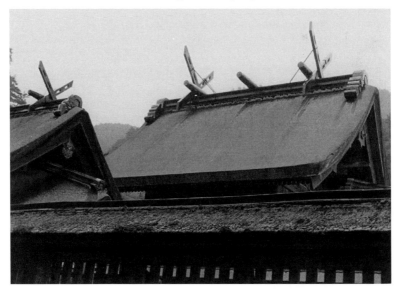

it's how they fitted wood-to-wood with simple tools and
an eye for plumb and precise detail, the sculptor in Syuzo sd
unabashedly. as usual, father didn't say a thing the sweet
rain didn't hail for him. i'll never take snapshots of Izumo like
the glossy postcards, i thot, clicking the shutter again

◆
amongst
gleaming swords
unsheathed
daggers
medieval armour
embosst
containers
& death
 poems

amongst
a hostage
of Hungry Ghosts
& their
memorabilia

one high-prowed river boat to float a cargo of dreams downstream
two slender sticks to kindle a flame for the holy pyre
°
there's a shadow of a carnivore dancing at the foot of the temple
there's a Mountain God clapping his hands like thunder

◆

 tessellated with paper dreams
 the Aged Tree sings of longevity/brevity
 sings through tessellated leaves:
 this moment, this moment will never be
 all all there is to apprehend...

Dear M:
 Let this postcard tell you 'where' we be. Let it
fill in for our Backcountry silences. If the rest of the trip has
more of this in store — I'm looking forward to further
Astonishment/s. p.s. it almost feels like I've come this way
before but that's another pilgrim's odyssey.

 Higashi-hagi coming up

as for Izumo's Beneficences —
there're at least 3 pairs of thoroughly soaked feet
imprinted with its Splendours

father turns to have one last look... then it's
back to our car to fetch us to Hinomisaki and the Japan Sea

148

from under
wind-bent pines
out — onto
precipitous orange
rock ledges...

with nothing to hang on to we clung
to brother Tree

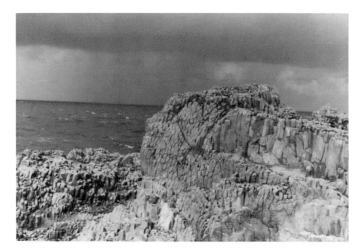

shock
of wind a
brazen
glad tiding

hearth
of breath
unending
brine

♦

 no horizon-line demarcates sea from sky
 no boat in sight to placate our i's ... nothing — but
 a tall white lighthouse, the sea & the wind
 blowing the 3 of us into a Trinity with the 3 of them

°

this is as close as i'll get to China, father yelled —
but the brine-wind stuffed his words back in his mouth

°

then, it's back to Izumo Oyashiro & the Souvenir Shop
to return our borrowed umbrellas:

 i offered them a token sum but
 they said no — given the fact we were such
 inopportune guests the kid said

 °

 though he said he wasn't really hungry
 the kid ate 3 bowls of noodles and washed it down
 with hot sake before dropping Syuzo & I
 off at the local train station. see you in Hiroshima
 in a week, father said, as the Pine/Wind
 blew its whistle and let out a cloud of steam

◆

we've got a whole coach to ourselves!
we put our feet up on each other's seat, smiling
we let the Backcountry surpass our i's

Taki

the
brine
lips

Nima

of all
these
small

Iwami-gotsu

towns
pass-
ing be-

Kokufu

neath
the
brine

Misumi

skirt
of
mother

Abu

sea

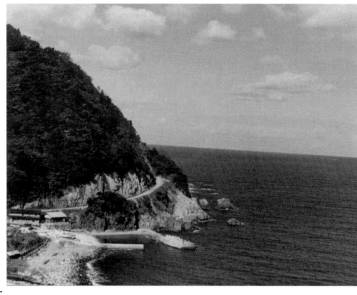

nothing but a mouthful of syllables to posit an ocean's breath
nothing but brine and a rind of air

SCHOOL'S OUT!

WHISTLE-STOP platform a hive & a swarm of school kids
heading home aboard the Pine/Wind train

now more of them clamber aboard — they wipe the rain off
their faces with big white hankies and there's lots of hanky-panky
in the aisle on their way to their Backcountry stops
now some of them are jumping off while —
their fiendish friends going further down the line W A V E !

o

nonce nonce
another coal-black tunnel
annuls all nuances!

o

your multitudinous "i's"
i am also also the shape of
stare thru my back —
thru brown eyes i am
blessed with the burden of

Higashi Hagi

to the Rakutenchi Inn

round
the whole sweep of
Hagi Bay
its humpbacked Islands
via the one
and only cab in town
with
 HURRAH! NO RAIN!

♦
nothing
like a hot ofuro
followed by
cups of hot sake
to soothe

nothing like sleep to consecrate
breath

♦
last night when I asked her to please 'pour' me
another bowl of rice she giggled behind an upraised hand
over a 7am breakfast of last night's left-over fish
she re-peated my silly misnomer with a pinch of asperity
that left Father & I chuckling over our morning tea
°
these small fishing boats putt-putting out to sea remind me
of fishing boat on the Great Slave Lake, circa 1940s

at Tokoji Temple, 9am

without missing a single leaf
she looked up at us and cheerfully said, good morning

a penny a leaf: yesterday, today & tomorrow
her swishing broom seemed to say

◆

"Dating from the 11th century
Tokoji Temple is one of the purest examples of
indigenous Nippon Architecture,"
the brochure said, as we looked up to behold —
the aged grey-wood rising tier on tier
to touch the lapis lazuli belly of its old kin Sky
o

nothing
left of Hagi Castle
but this
cut-stone moat
afloat
with lily pads o

where have all the valiant warriors gone?
what am i doing here?

with Death clicking the shutter —
we mugged for each other on their sun-dappled tombs

"it's the graveyard of an old Hagi clan"
"these tombs here belong to the clan leaders and those
over there belong to their kinsmen and faithful
retainers" "these rows of lanterns are lit in perpetuity —
to light their way back through the underworld"
"think someone will light a lamp for the likes of us when
our time comes?" i ask, clicking the shutter.
"only if we have it in us to commit honourable mayhem"
Syuzo shot back, sunlight dappling his shoulder

"— if you can't find the right japanese word try your English on me," said the Keeper of Hagi's Meiji Legacies. Point to any thing and he will hand it to you. Handle it and he'll tell you 'who' held it last and 'what' happened to it before it came into his collection. "Now some of the most brilliant men of the Meiji era hailed from Higashi Hagi. They were chosen by the Emperor Meiji to go to Europe and Amerika and bring all the marvels of Western Science home to boost Nippon into the modern age." He named some of the illustrious ones and citing their accomplishments showed us their artifacts. He proceeded to show us other things including a small scroll by one Tomioko Tessai. Having been told by Syuzo that I was an artist he asked me what I

thought of it. I said I only knew Tessai's paintings from an exhibition I'd seen long ago in Canada but that it was my surmise it was a youthful work. He concurred with me and added that it could be worth a fortune one day but I won't be around to squander it. One object led to another and we found ourselves marvelling over a rumpled watercolor of fierce 'blue-eyed' men-of-war striding ashore. Though rudely painted the WC depicted the astonishment & fear of seeing white-skinned foreigners. We'd promised ourselves we'd catch the late afternoon bus to Akidaiyoshi and promised to send him a copy of the snapshot his assistant took of the three of us with our backs to Hagi Bay. Poker-faced, he said he would find it an honourable place in his collection. We chuckled at his humour and bowing again we took our leave of Higashi Hagi. "It's nice to know there are places like Hagi where history & the picturesque conjoin," Syuzo said, and I agreed, thinking of other westerly paradisios.

155

°
purchased a raku vase
& a box of sweets at the local
gift shop and had them
sent on to Furukawa-cho. don't
ask us about Higashi Hagi —
it seems to have always abided
here beside the China Sea

Dear M:
 Though I take pleasure speaking it — my brand of nihongo is to say
the least an abomination. And i'm nothing if not self-conscious inside its
subtle nuances. O how I wished nihongo fit me as snugly as these suede
walking shoes I bought in Kawaramachi which have become my very feet.
Thank goodness Syuzo is beside me to ease all the proprieties: it leaves me free
to be the "I" of my camera and not just a tongue-tied tourist. One day I'll
travel the length & breadth of Nippon just to be father's heir... I mumble (in
inglish). Meanwhile there are all these home-spun dialects crouching in
these terraced green mountains. I'll tell you all about the ambiguities of travel-
ling through Honshu's Backcountry when I get home.
 written on the bus to Akidaiyoshi

 Akidaiyoshi

out of the Green Rock Mountain's
maw — blocks of squat Souvenir Shops all
hawking polished Figures hewn
from its green flanks — ever since the Gods
cried out for their own graven-
images, their stone "i's"

chip chip chip
the flaked greenstone releases
the pentup chlorophyll
distilled in ancient Gods & a host
of irascible Demons

 polished stone
 bearing the marks of a mountain
 for the folks back home
 polished stone
 for an "i" to behold
 °
 water
 shaping words
 shaping a
 stone cathedral

156

shaping
itself

water
shaping stone
shaping
monstrous
shadows shaping
something

like 'fear'

under the mountain soundless aqua
erudition

♦

on top of the Green Rock Dome the sloping
Greensward — a persistent drizzle
soaks into. under our umbrellas, Syuzo said
"— it would be clammy, if not creepy
down there, if you're not water stone or bat."
given the iron cage we rode up through
tiers of weeping stone — given the timeless
coruscations, i more than agreed.

HURRY! HURRY!
your bus leaves in 10 minutes...
& Autumn's a scarlet-shine inside
your mind's blue-flare lit cave

 all the way across the ankle of
 Yamaguchi — her thick black hair shone
 across the aisle of my indolent
 stare: is this the way to Uda-onsen?

Dear M:

The View from our small window in the Inn is nothing if not the usual tango of grey t.v. antennas on top of grey corrugated roof tops. All these pallid greys & a hank of bright colour sumi'd across a thick grey soup sky: Why even the locals hurrying along the street to escape the drizzle seem attired in the same grey cloth. Ah but come twilight little "Uda" let's her work-a-day drab fall off her back. She takes a good hot soak and a cat-nap to freshen herself before she wraps herself up in a bright kimona. Then as little Uda paints her moon face with bright red lipstick & orange rouge — all the red, violet, pink, blue & green neons drive the abysmal shadows down 100 crooked alleys. Taking one last look at her face and patting her upswept coiffure little Uda steps out onto the Night Street. Though my own bod knows how soothing mineral waters can be, it tells me again that spas are not its cup of plea.

> p.s. wish you were here with all your alacrity.
> toss a kiss at the blue prairie sky for a belated son.

♦

 arms tuckt
 into flutter-sleeves
 Syuzo glides over
 the wet cobblestones
 I wobble upon
 nothing quite like a pair of
 high getas to sniff the air of an
 unquiet equilibrium. nothing
 like a patch of Pleasure Domes
 to scour our empty bed with
 all the
 intrepid flea pit
 bars petite strip-tease
 dens las vegas style pachinko
 palaces soothe-your-brow
 sake pits tiny tea
 for two pews
 souvenir & gift shops
 noodle carts & little Udas prowling
 neon cobbled streets

"I saw her give you the sign —
why didn't you take her up on it, Prince Charming?"
"and leave you stranded in a strange town
besides I dislike paying for venerable diseases, ok."

night-wind up our arse
pie-eyed grins pinned to wry faces
we bow to Lady Moon for
lighting our way back to our inn

Two on a Cold Tatami Dream

Steept in the prolonged silences we hail each other across: Father and I sit
side by side swaying through the long fetid night with all the litter heapt
under our feet our midden heap of unpledged familiarities. Father has his own
face. Mine, the Dream sd, lies half-buried in the cleft between his shoulder.
Then I'm running running through clouds of steam — my footsteps echoing
FATHER! FATHER! WAIT! WAIT! FOR ME! — down the length of the
empty Station platform. The Dream sd, Father waited waited patiently as I
came running up to him. Waiting til I caught my breath — he sd, "Son, this is
where I take my leave." "This is my last stop. I'm thankful We were able to
share a seat." Then, the tenderest smile I ever beheld brushed his thin lips
before he turned his back to me to begin his long descent: Step by steep
darkening step I watched his small bent back turn into the dark pit EXIT.
Back aboard the Midnight Train I stare at his empty white cup stark against
the night sill... my swaying body, un-comforted
o

"O-go-rii"—
in the early bird morning
a cup of hot coffee
then a U-DRIVE Toyopet
to fetch us North

♦

trackin' a post-industrial Tokkaido Road at 70mph

sure a lot of sob songs on is it the all nippon hit parade?
uh you know how one small sob turns into a bucketful of yen
 congeries of
 heavy industry oil
 refineries to
 grease the pallor of
 the Inland Sea
o
... we don't seem to have any more to say to one another,
than we had to say to father. or father said to us:
how translate 'breath' into miles without driving through
silences? how do two intrepid travellers presume

o

Shiki
& father's
Shikoku
a stone throw
away

wish i were that very stone or the god who heaved it
across Iyo Bay

o

somewhere: between Kudamatsu & Hiroshima

Ray Charles wails "you'll never walk alone..."
for all the home-sick GIs in SE Asia
with "Love & Kisses" from the Girl next door
in good ol' USA. (RADIO FREE AMERICA)

♦

Stars & Stripes a Big Bandaid over our bruised pride. it's
why all the Leftists lean on Sato to get the Yanks out

does that explain all the militant students we watched in
Kyoto? does it, for instance mean, Asia for Asian/s?
o

terrifying —
the raven's beak Ya!
thin-ice

o

do you think the next wheel will have uranium spokes
attached to a nuclear hub?
me i'll take fossil fuel & aluminum hub-caps anyday

o

o gimme a home where the buffalo roam
where the deer and antelope play
where seldom is heard a discouragin' word
and the skies are murky all day...

Kintai coming up on your side.
watch for turn-off

Dear M:
 — if you believe as I tend to do
in the magical efficacy of Picture Postcards you
too will believe in this View. If it doesn't
turn you on — you'll have to hold it in your Mind's eye
and fill in all the details. Hopefully, my own
Snaps of Kintai will show how its intricate underbelly
supports its soaring Arcs. For what it's worth
we've had nothing but all sorts of rain since we
left and it's a good bet it'll keep comin' down til
we're back in Kyoto.
 p.s. has the endless winter covered
 Edmonton with adamant snow yet?

 good, ah good afternoon

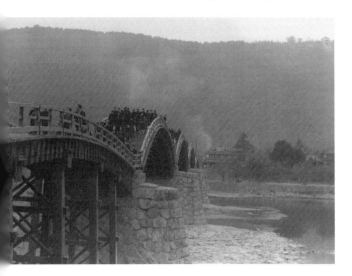

hailed by the slant rain —
bus loads of high school kids stomping
across its prodigious arches
hoot and holler heel to heel hallowed
by this ah Sudden Rainbow!

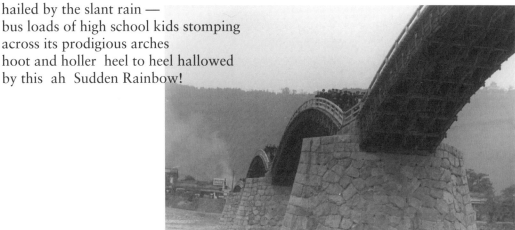

♦
could this be The 101 most magnificent View in all Nippon?
or does it all depend on where your feet are planted?

you could ask Hokusai how to sumi it in a single brush-stroke
Syuzo replied, laconically, eyeing its architectonics

o
Pictures
of the Floating World...
Portals of
our Passage through
it, i thought...
winding the film up

o
Good-bye Kintai —
you flung a double-curve across my lens
once and once is twice as
much as i can handle at a single glance

don't ask why Kintai threw a double-curve across the sky:
ask Sky.

"on a clear day you can see 'it' soar all the way across the bay"

1 bright blue datsun from Kochi City, mother's hometown
3 mini-skirt secretaries turn backs to the squall on upper deck
1 grey gull tilts into a gust of rain across our silver prow

like the nickel ferry-ride past the Statue of Liberty to Staten
Is. — i'll only take this trip, once. NONSENSE! hissed the
keen wind slammin' a white-cap at the feet of my adventure/s

♦
o rub a dub dub

3 drunk fishermen shout
obscenities from the stern of
a fish-eyed wooden tub

o rub a dub sog

2 sodden school buddies
proppin' each other up slip & fall
into a puddle laughing —

o rub an old rubby

1 old man pissin' against
a tall stone lantern —
flashes us a toothless grin

o rub a dub drab
pennants postcards
& the sweet rain's epiphanies o
who would want less
o
we step out of our sodden shoes into a pair of straw sandals
bowing — we make our way through a windy maze

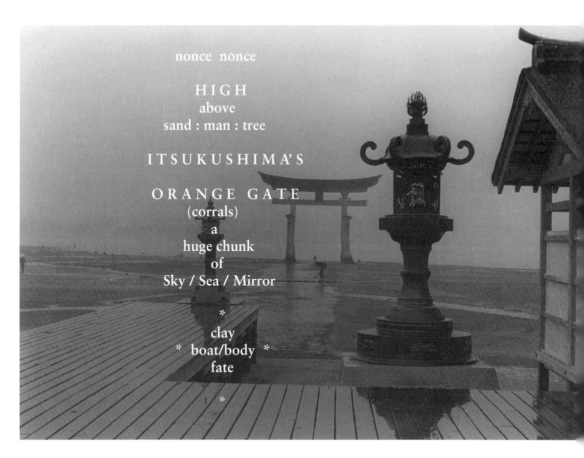

nonce nonce

HIGH
above
sand : man : tree

ITSUKUSHIMA'S

ORANGE GATE
(corrals)
a
huge chunk
of
Sky / Sea / Mirror

*

clay
* boat/body *
fate

*

♦
100 bright
watercolors & empty
bird nests

feathering
corridor after windy
corridor...
°

 father's un-voiced
 admonitions...

 mother's sun & water
 concatenations

°

 tied to wind-swept
branches sodden wishes
abide the downpour

 mud on our keel
rain on our brow we avow
the demon 'nouns'

o
the exits
and
entrances

o
scow!

o

scoured-beggars at a wind-fest —
we slip out of our straw sandals into
our wind-dried shoes & bowing
put a handful of change in the pot and
tracelessly leave Itsukushima

through —
foreshore's downpour

Itsukushima
soars!

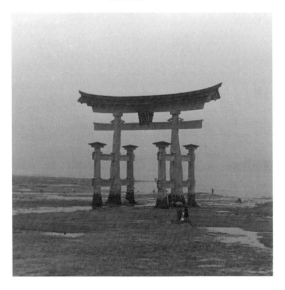

Dear M:
 Ah! Itsukushima: The Gate magnificent
Gate through which the Mind 'alias' the Wind blows —
on its way to becoming a huge Sky House, callit
the "Celestial House that breath built." We both know
what Breath can build — breath can steal away.
Meanwhile, why not embrace a Hiroshima a few hours
hence
 p.s. have you had your share of
 Air/s today?

through the altogether sudden fog
 daemon dragon boat —

what news have you from the Gods
 of the Inland Sea?

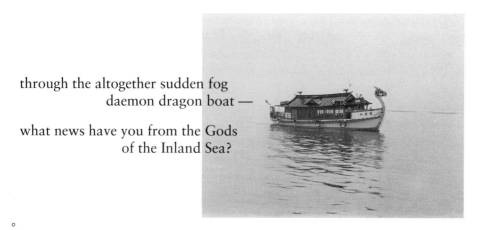

○

when the 3 rascals caught us cocking our shutters —
they came running over to gawk at our made in nippon cameras.
then when they saw we meant business — they mugged
for us all the way to Miyajimaguchi. "bye, see you, sometime"
they chimed 3 times before running up the ramp and out
of our view-finders. these enaka kids can sure be sassy, Syuzo sd
as we got into our Toyopet to take us to Hiroshima

Hiroshima

 aki no hino maru
 over Otagawa, 5pm

they saw us coming a mile away— they
bowed perfunctorily and said, ah it's too bad but
a travelling salesman from Kagoshima had
just reserved the last room moments before you
stepped in. we knew what they wanted and
because we were tired offered them more yen than
commonsense and moved in — knowing we'd
been taken to the cleaners. at least their steamy
ofuro offered up its abundant warmth

Jazz Club Hiroshima

all the best un diluted request/s:
from Bunk Johnson to Sadao Watanabe til
the grey dawn/yawn gulped up all
the forlorn-decibels & haplessly drunk we
hail a cab to fetch us back to our
 Grub Street Inn
○

met father at the local airport. he said
he enjoyed his stay with O'Hash but the incessant rain bored him

166

it's "black crow" versus
"white heron" on rice straw mats
beneath a wan winter sun

it's a motley of old men
playing GO under bare limbs planted
sunday after the A Bomb...

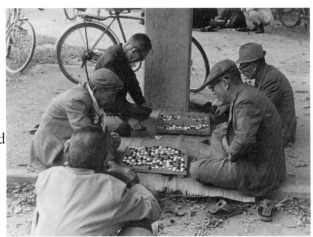

there's

a
tumult
of
singed
hair

falling
thru
the
offal air

in
front
of
my lens

there's
a conflagration
inscribed
in these words

tall glass cases with pallid '40s mannikins
attired in somebody's ashen clothes
 (click)
an alarm clock with arrested hands anointing
that awe-filled moment when
 (click)
the shadow of a man taking his ease on a granite
step was all that got left of him
 (click)
heaps of domestic utensils made in purgatory
bicycles shaped like pretzels
 (click)
rows of unimaginably charred, children's and
grown up's plaything/s
 (click)
panoramic photos of a vast rubble plain which
had proudly called itself Hiroshima
 (click)
o the bronze angel with a charred hole for a face
o the lurid, lopsided, sake bottles
 (click)

 which hand
 pulled the trigger?

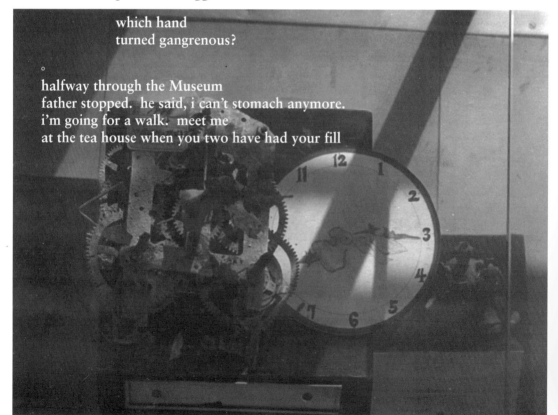

 which hand
 turned gangrenous?

°

halfway through the Museum
father stopped. he said, i can't stomach anymore.
i'm going for a walk. meet me
at the tea house when you two have had your fill

300.000	300.000
Prayers for	Prayers for
Bereft	Un tolled
Children	Trees Plants
Orphic	Reptile
Birds and	Unborn Child
Mired	Insect
Animals	Buddha/s

♦

from the 2nd storey window overlooking the Ruined Tower

... it could almost be any day of the year you care to name.
name it. name the time and place. put father there beside a child
in green velvet — the two of them feeding the holy pigeons...
while all around them the greensward hides a once-charred Hearth

24 years : 3 months : 1 hour : 31 minutes ago...
BANZAI! HIROSHIMA! BANZAI!
♦

there's a charred-hand reaching out of my abdomen to
inscribe my 'name' in the Museum's Guest Book:
there's an acrid taint to all the consonants & avowals
of a hundred-thousand (faceless) Signatories...

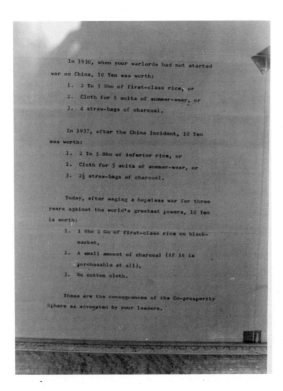

♦

nobody can live inside the Monstrous very long
without becoming one father said,
as we sipped our tea and bit into our sandwiches

♦

on the pedestrian overpath in front of Hiroshima Station

 nothing left to expatiate —
 but the killer behind the wheel inside each of us

 nothing much to rave about —
 but the healer tied to the fiery wheel turning us

♦

Dear M:
 no postcard/s. no images: though i took my
share of pictures of mute things inside the museum i won't
belabour their visual paucity, how they inevitably
leave out the stench of searing flesh and yes, all the offal desecration/s ad
nauseam. John Hersey's "Hiroshima"
stands word-for-word behind these perambulatory thoughts...

 i remember "JAPS SURRENDER!"
 i remember all the flagrant incarceration/s
 i remember playing dead Indian
 i remember the RCMP finger-printing me:
 i was 15 and lofting hay that cold winter day
 what did i know about treason?
 i learned to speak a good textbook English
 i seldom spoke anything else.
 i never saw the 'yellow peril' in myself
 (Mackenzie King did)

& even as i'm writing to you this teen-ager
with a mop of black hair saunters by with a transistor
attached to his ear. o how the wobbly pivot —
spins us around to face (it must be) 'ourselves' in all
our Contradictions: our callit, Heaven / Hell

 ersatz personification/s
 bombs of pitiless annihilation falling
 through the chagrined air...

perhaps the photo/glyphs i took
of abandoned work gloves on the site of Expo 70
will negotiate a tryst for my sense of
an un-embittered, well-being. what's the price
of clasping one another's hands ?

 Kawaramachi a long night ahead.
 Hiroshima buried inside us

 5pm Night Train
 Kobe/Osaka/Kyoto

 via
 the curve
 of
 the Inland
 Sea

 via these wheels annealing fitful sleep

father said he only had four bottles of VO in his suitcase:
he said he drank two of them up on the first leg of the trip but left
the other two with O'Hash as a Gift from the three of us. now
his small suitcase is stuffed with take-home gifts. Syuzo nods off beside him
his All Nippon Train Schedule Book packed up in his haversack. blindfolded:
Backcountry lies inside a black box on my lap.

O the invisible 'ties' we ride tongue-tied
thru the traceless night... O father
what do you see out of the night window?

 the stale exhalations
 the coughing air

o ain't she sweet! ain't she got such dainty feet!

she's one of Masako's kind of imperturbable
Heianji women the kind who can put a Watanabe or
a Cohen in their place with aplomb. staring
at her profile in my night window... i imagine the
full moon cupped in my vagrant hands.

o sleep! thou gentle hinge —
even on public transports you monitor our hapless libido

♦

somewhere
behind us
a child cries
cries itself
to sleep
 somewhere
 in the night
 the Inland Sea
 deciphers
 the algebraic
 tide

o

rose-hued cloud-bank up ahead could be Kobe. yup, it's
Kobe alrighty — next stop, Syuzo's Osaka

o

 father's white cup sits on
 the night sill gathering
 the fetid air up into itself
 utterly emptied it cups
 itself in its own pale light

o

almost as if he had been counting the tinder ties all along —
Syuzo lifts his head as the Night Train pulls into Osaka Station

see you both in Furukawa-cho, soon. thank you.

 good night

 good night
 good night

a scattering of lights along the night plain towards Kyoto
a Higashiyama looming on the horizon

o

nothing nothing left to tell
these iron wheels annealing my midnight blues
don't don't insistently wail
love me love my halcyon days my errant ways

172

◆
Backcountry
lies

folded map
inside

of us
folded

inside
her dream

lights
of Kyoto

all a –
round us

Backcountry
sleeps

inside
us

<div style="text-align: right">

446 - Hachi-ken Machi
Furukawa-cho, 12.50am

</div>

Masako got father a big bottle of vintage Suntori
she tidied up my small room & filled my heater with petrol

over one last nightcap father lifted his cup up and
plainly said, the best part of leaving is the Welcome Home
°
his bod
beside mine
dry husk
breath rasps
thru

mine
a bent reed
clasps
'all ending month'
wind —

my small
brass bell claps
wildly in

Dear Family:

I want to tell you about Father's Leave-taking Party at the famous Unagi-House high in the mountains above Kyoto. You know the one I mean with its rustic tea house set off from the rest of the Inn by aged cypresses and a large eel pond. O I want to tell you how Masako used all her Heianji skills to be both the High Priestess and Father's very own geisha — by pouring his sake and singing him the old Meiji songs: her gestures weaving a garland for his Rite-of-Passage. Meanwhile the Hostess and I agreed to be their gnomic attendants by putting on our best know-nothing-smiles. Even the surly Winter Wind held his breath to be a proper third party Witness.

We are gathered here tonight in honour of your arrival at the Gate of your Eighth Decade. We the duly-elected Savants of the Rice God welcome you to the portals of the Great Gate. We've been instructed to do everything in our power to assist you in your Libations but being mere mortals we are in no position to accompany you. Afterall it's your immortality that's at stake and there's no way that we can fake it for you. Otherwise it's your second Childhood Coming out Party and needless to say you better make the most of it because a second Childhood only strikes once in a blue moon and it only strikes those who arrive at the Gate hale and hearty. The Mistress of the Rites intoned with a tease in her voice to tickle the fickle man in him. And round and round the sake flowed and none of us wanted a single drop of it to dwindle. Even Old Surly sent a blast under the shoji to show that he approved whole-heartedly.

°

Now in order for you to have sufficient zest to carry you upright through the portals of the Great Gate — you will have to partake of the Ritual Sake which will be placed in front of you. Now listen carefully to my Instructions as I have been sworn never to repeat them 'cause repetition depletes their magical efficacy. Now there are three simple steps. Each step a prelude to your 'last' walk. This walk has nothing to do with measureable distances. Or those pratfalls everyone has their fair share of. To put it bluntly these steps are mandatory if you want that dollop of rage to sauce if not sweeten your immortality, the High Priestess concluded with a toss of her well-coiffured head. Whereupon, She clapped her tiny hands, twice — for the Hostess to fetch the ritual bowl of sake.

First you must close your eyes and take a deep breath to centre yourself. Then, you must bow deeply over the brimfilled bowl and inhale its salubrious fumes — before you show us your baptismal face. This is called the Moment-of-Purification. Once you take this step you make a pledge to leave everything behind you. If you cast a backward glance everything you behold will turn into stone. Like there's no 'satori' without getting rid of excess baggage, the Priestess concluded.

174

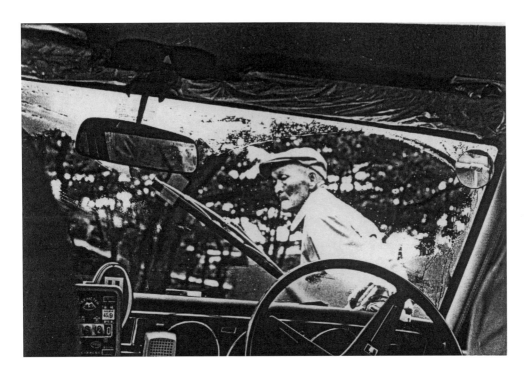

Secondly you will take up the brimfilled bowl and place it to your lips without spilling a single drop because every drop lost will lob a moment off your eternity. Need I say your ability to hold your own in any company won't be half enough. This is known as the Moment-of-Challenge. It's the very moment the venerable Rice God extends his hand to assist a near-immortal through the Deathless Gate, Masako added, filling everybody's sake cup.

Thirdly you must partake of the eel of longevity bottomed in the ritual bowl. The more eel you eat the longer you will keep that old dread "senility" from your door. Otherwise the Rice God will have to put your name on the bottom of his list for second hand wheel chairs. Now in a few moments the Sun Goddess' Mirror will illumine your passage... are you ready for the Rice God's Beatitudes?

°

Father nodded, nodded with an eagerness that belied his age. Then the three of us lifted our sake cups up to the Rice God to bless Father's becoming and Father began. He began by closing his eyelids. Then taking a deep breath he bent over the brimfilled bowl to inhale its plumed fumes. He inhaled & inhaled his florid face wreathed in pungent sake fumes. Then he swooped the ritual bowl up to his lips without losing a single drop and drank. He drank and drank the hot sake dribbling from the corners of his mouth down the front of his plaid shirt — while the three of us cheered him on. Red lobster red Father almost let the emptied bowl slip out of his hands as — a delirious smile washed over his dripping face. Then he picked up his pillowed

chopsticks and pincered a fat piece of eel and popping it into his toothless mouth he gleefully gummed away. He repeated this several times — each time washing the eel down with sake. Then placing the chopsticks back on their tiny pillow and smacking his lips he said, with a cackle — now i won't be able to complain about my thirst or hunger when they come to put me under — an instant later Father's head hit the cold tatami. He was out like a light. Tucking a blanket around him and turning up the petrol heater at his feet our Hostess said, he wears the smile of one of Sakiyamunni's blissful ones. He will be fine after a nap.

While one old timer slept beneath the eaves of the great gate and the other old wind bag who never had much use for man-made curfews threatened to make chopsticks out of the eel house walls Masako turned to her dear friend the Hostess (of a 1000 Assassignations) and told her all about her recent bereavements. Don't ask a middle-aged attendant with thick bifocals whether the venerable eel house had large ears. Don't ask the three of us if Father heard the 'all ending month' wind howling outside. Then, as the last of the patrons wobbled off to their taxis in the arms of their hostesses and the thought of winding up the long Night Scroll to let it unfurl in our sleep passed through our watery minds... a small perfectly clear country boy's song rose note by clear bell note up through the dripping bamboo. O I want to tell you that all of our derelictions got suckt up the flue when that small psalm touched the topmost leaves — to rustle the hem of mother sky. Then, as sudden as a summer-cloud covers the sun the song faltered... its last grace-notes dying overhead. From some distant place far beyond the edge of our littered table we heard an old man sobbing, "it's gone gone for good." And we three who had been blessed by that country boy's 'air' sobbed aloud for it must be our own lost innocence. Looking down on a quieter than quiet old man and wiping his cheeks our Hostess said, his eyes sleep here but his breath abides in Umagi-mura. It was the Eel House Keeper's son who drove us thru the morning fog to Furukawa-cho.

let father tell you his version of our trip when he gets home.
let mother know the gist of this family letter:
let her savour its unbespoke Tryst.
<div style="text-align:center">Good Good-Night to all of you</div>

176

♦

home is a throng-of-voices

 tide/s
 sieved thru familial
 nets

 fish fish

 untied
 knot/s an ocean
 wheat

 unspoke land

 brine
 on a cleft-
 tongue

 silence...

o
i heard his song : i cried my tears : i will follow him
with my own small song

no
word
left
un-
said

no
echo
on
michael
mas

3am

*With much gratitude
to Daphne Marlatt and George Bowering
and Others for their Appraisals
during the many years of its writing.*

Struck from the Heat of a Cold December Sun

i have wrapped my body in layer upon layer of words
to keep the pitch of me swathed these cold december nights

toucht with hoar-frost these unbidden-syllables track
the lineage of ice encapsulating her earthen vernacular

&

love on ice a plainsong for gordon lightfoot and joni mitchell

"once upon a tusk of time..."
l-o-v-e in the guise of a pellucid-microbe nurtured in
an astral greenhouse fell... through
a millennia of time / out of mind / empty / dung hill mind and
falling burst—into an indigo skyfull
of perfect 6-pointed snow-flakes and everything—
it husht and melded into turned
the Mad Cartographer's Dream of a Vestal Newfoundland
into tiny silver vials full of 100 per cent
toxic M-o-o-n D-o-g C-r-a-z-e

> some got it obliquely
> like a snow-flake tattooed on their cheek
> some got it like a swift kick
> in the genitalia by an unkind karate-master
> others pitted their wills against
> its crystalline-powers and
> lost everything including their bleu-chip
> divertimentos

&
ask an inuit
how many ways 'snow' leaves its imprimatura on a tongue
ask the tundra
what turned the brine tide into an adamant wall of ice

 this vintage
 slash-heap of unquiet passions / flaring
 across the middle east

 these midnight
 'figures' cavorting in an ice flambeau
 across the tundra

o the diaboli of
these mid-winter insurrections
born of the scorcht-
citadels of the middle east

o the migraine
heliotropes christened in
the olive groves
planted inside an old testament

there's a fresh pair of snow-shoe tracks
across the crenulated snow drifts after last night's storm
and according to the vancouver sun a handful
of siberian peasants un-earthed a giant musk-ox lockt in mid-
stride inside a 100 foot cabinet of sheer i-c-e

 o the black ice ovulates a horst of
 bitter consonants

clad in thick layers of frost-bite hide and fur
her black hair caught at the nape of her neck with an ivory comb
she takes her stance—as i imagine her—a tilt
and a fearful glance away from the arc of those huge white tusks
pronging the b-l-a-c-k i-c-e V-o-i-d

 o the black ice vowel will split your anus
 and make you h-o-w-l

flip channels while you lie alone on
your redoubtable double bed in a hilton hotel somewhere
this side of the kremlin wall. flipt-out
on a shimmering desert replete with camels and oasis you'll hear
a high-pitched c-r-y splinter the technicolor
skies over the crenulated roof tops of hollywood and vine
that subliminal cry you heard... escapt inside
a pod-of-earth—just as the black ice congealed and

split your air-conditioned nightmare wide open
the myrrh between her breasts tinctures these vaporous words

borne aloft—their rotund silences propagate
all things, unheralded

&
these tell-tale bones miss her brazen sun

the cold-draft of her sudden dismay flaring into outrage
everytime these slit-eyes glimpse
a comely broad striding through the crowd on main street
they bulge and brighten flare and ember
there are long winter nights these reptilian lids never
snap shut til sun-up . o eyeless on
the gaza-strip—ript on coke and perfidious dunes—a
delirium of whirling dervishes spun
a carapace of perfect figure 8s on a snow-white glacier
in ellesmereland: mocking the midnight sun

&
these nihil-words have had
their heads tonsured by an avalanche
of pure paleolithic snow...
head and tail-less—
they scream at you inside a prairie WHITE-OUT
laser winds lacerating snow

their thin-nosed pontiac seemed to be hurling
through a swirling snow tunnel totally out of their control
the whole wide prairie suddenly an uptilted wall
in actual fact the young couple's 1st car clung precipitously
to the frozen shoulder of a Nowhere Saskatchewan road

 visibility
 'zero'

 impossible to tell which finger or toe froze first
 impossible to tell whose tears shaped these vowels

 dumbstruck
 numbsuckt

they pulled the old buffalo pelt that cobbled their seat
up around themselves and hugged each other tightly
inside their hide tipi inside their snow-impacted pontiac
cum frigid tin igloo—they smuggled an ancient fire
to outdaunt the cold. this mouth: these words: this ice

o the black ice ovulates a horst of bitter consonants

o the black ice vowel will split your anus and make you howl

&
these hands that have twice
cupped the perfect cone of her breasts: once
upon a nursery rime inside a
fabled childhood book and once in maladroit manhood:
these hands that once forsook
an agile fingertip—sculpting cedar ellipses seem
to be waiting, albeit 'callused'
if not 'callow' for their third handful of that
perfect cone with a painted rose-bud
unfurling on its tit. see how
they alight on these keys as if the whole prow of her
brown body the thick black hair
still caught at the nape of her neck by the ivory comb
he had carved for her *moved* imperceptible
as breath... through a snow-white
tundra beneath their haunted promptings

see how these words tingle thrice

&
o you, pie in the sky, proletarian dreamer
twirling the ol' boob-tube dials for a gossamer bite of
cool bleu fright you benighted two-bit lover
of 40s horse operas you elongated purveyor of kanadian
follies—didja catch a glimpse of those ah
prismatic skeins of iridescence turning cartwheels
across the skies of the midnight tundra on CBC?
i did and let's just say that i had my eyes reamed out
incidentally, the glittering sequined wardrobe
belonged to none other than Miss Aurora Borealis and
the sound-track of shattering ice was re-recorded
from an echo out of the last ice age . nothing
like the tundra in early manhood to grace the 'apparencies'
of middle-age rage . nothing like a quotidian memory
to thaw the improvident i-c-e... he thought, talking to
his several youthful selves, before shelving them

&
they said: he had swept armfulls of snow up around himself to
insulate his body from the bitter cold. they said: they had to break
his limbs to lay him flatout on a stretcher before flying him
to fort smith. they added: that they found a perfectly shaped hollow

the size of a large fist left in the frozen embankment by his
once warm breath. and so he had let himself go and froze to death his
quest and his pride intact. nobody knows the number of i-o-u
notes he left strewn across the tundra or the valor of his selfless act.
that night he took leave of his frozen pelt and his spirit flew
to the side of an ice-age maiden and a vengeful musk-ox and thus placated
a Northland fable without once mentioning the Roman Catholic Church
or the Hudson Bay Company brand of colonialism. they say nothing

&
ask a Canticle-of-Breath why
the Black Ice gript them in its millennial thrall
til Bride Groom and Hairy Beast
were released from its crystalline grip by a burning
pod-of-earth that auspiciously pummelled
out of everything's Heaven into—
his own vexatious mouth

ask his first Holler how come this paleolithic keel
of warpt-words harkens to the Tundra

o the black ice ovulates a horst of bitter consonants

o the black ice vowel will split your larynx and make you howl

&
like
the prodigal
descent
of a norse god
these
buckshot-words
pellet
the brine
under
the polar ice
cap

&
be kind
sd the shamanic fog

like me
be indubitably wet

incontrovertibly
weather

The Ace of Hearts

purporting
to be a cycle of love / songs

"the last sweet night
of fortune's attitudes"

o the convoluted spirals of a fickle man / sickle woman dream
o the lapidarian lover polishing up another pair of jade ear rings

&
—if this S-p-e-l-l really takes hold
these bitten-words ought to unconceal themselves
tracing the arcs of her presentiments and
how they foreshadowed his: 'riddled' it lies under
the dome of her oracular mouth—an un-
diminished portent of psyche's confabulations

&
a toss of words in a midnight salad on keefer street

i remember saying to you how much i got off on our Vernaculars
even in your seeming absences i listen to us on tape—
talking talking our fool heads off: you in your kansai-ben lilt
and me in my blunt kochi-ben—the two of us revelling
in the folds of a parabolic lingo of parsed-syllables with
our beguiled touch leading us on... wanting to be wholly
present-tense 'these' words scrunch-up into your afternoon *knock*

&
you

sang your way into my winter lair
and need i say you left me quarried. 'i' who talk too much
but seldom sing, found an unvoiced
blues lying unbidden in my cantankerous throat

you sang with your whole body. we walked
the blue mule together on the banks of the winter fraser
i listened to you, over and over on tape
i became mesmerized by your mellifluous vertigo

in the early morning rain i hear you
in the 5pm traffic uproar on hastings street i listen for your call
leaning into the wind of your throat
my whole body learned how the blues was born

if we never sing together again you'll always be imprinted on
this moose jaw kochi-ken bod—the very blues it wails

&
—if i told you that
my real pelt and my fictional hide collide
in a headlong leap of joy
would you think me a foolish middle-age goat?
for instance—my whole face
crackt into a huge grin—thinking of your
lips easing its surly creases.
'you' came and claspt my winter-wrath by its
unbecoming tail and you sang it
back to mother / mirth

&
my oldest daughter tells me that she and her young husband
have been attending classes in pre-natal child care and
among the many oddly matched couples there was a man my age
with his very comely, very pregnant, young wife. i thought
of the two of us... how you could be one of my own daughters
yet—when we woke to another dawn i felt my age, halved

&
unfound noun to dumbfound stone

what's the name of that indian goddess
she with a skyfull of arms—all tracing the arcs
of our sentience: all the phantasmagorical
hullabaloo 'psyche' is blessed by and yes—prey to

 what's the name of that arcane flame
 we kindled with our tinder limbs ?

those long ago indian sculptors versed in the kama sutra
who carved an endless processional of copulating-stone-figures
across the intricate facade of a plumb maharajah's dream...
i suspect had their fair share of a union such as 'our's'

 what are the names of the inflamed stone couple
 wearing our delighted grimaces ?

body to body we be one uncleft whole til that wily surgeon
herr doktor thanatos deftly severs the 2nd umbilicus...
i thought, thinking of the long scroll of lovers we hailed
and in our hailing—praised beyond, all holding onto

what's the name of 'the breath' we hailed
and blew back in a pod-of-song ?

 the triple umbilicus:
 1 the pre-natal one we're severed from at birth
 2 the paradigmatic man/woman one
 the ying/yang thing
 3 the long fibrous one binding us to the universe
 'mirth' its true narrator

&

your delicate touch tingles through these words

all i need to do is sit quietly at my late night cup of black coffee
and let my thoughts rekindle your touch and all of a sudden
your equally delicate scent assails me completely. o do drift my way
if the pacific current fills your sail. unspent / unrepentent—
these migraine words climb into a middle-age lover's midnight hearse

&

while a frail sliver of moonlight cradles your sleep

my lithe-fingers led on by their own surmise toucht
each flusht eye-lid, lightly—"good morning" before gliding
down the slopes of your momotaro-cheeks—to brush
the sun-rise across your dawn-beguiling lips. for thou
art fair, love—thou makest my winter bed unenviously green
as the late spring bamboo in the hills above totsuka

&

the 3 red roses you brought me, saying
it was the first time you ever bought flowers for a man
stand parched and unremarked beside my bed.
when i asked you, why 3 red roses? you quickly replied—
well i could mean *you* and 2 could mean *coupled*
but 3 is 2 un-completed loops that doesn't leave anybody
out in the cold. all this, she said—brushing
the 3 red roses across the tip of his ah! cat-nip nose

&

with all the doors and windows
you still have to fling open to vent a petite air:
i am a pane of glass / a door jamb—
a netted voice wreathed in the air you suck
eventide's flask of brine silences

&

something in him said
put your predelictions aside and
so they fell asleep o

i had such a lovely nap
did you catch a wink, too? she asked
looking up at the alarm clock

o dear me it's time for me to leave—
why don't you give me a hug,
or better still—let's fuck, again

&

he thought
in a few hours there'll be nothing but brine between us...

she knew all along and for her part had
never stopt listening—

i'll remember that coal-black winter crow cawing us awake
while we laughed and fucked

she said
tuning each vowel inside his riddled ear

&

in a lull in our love-making
an unslaked laughter
spilled out of your contagious
mouth—into mine . i
caught a sidelong glance of an
old hag sobbing sobbing
her wizened head off—and i
echo'd echo'd her vile
laughter

in all the hallowed
hallowed parts of our body where
we touched completely
i felt the knot of an ancient groan
thrust up through your
writhing body and my own
indented body moaned...
it moaned for the old hag you had
turned into. it moaned
for the young husband sleeping
in the room next door 'i'

became your fretful child crying
mother! mother! where
are you ?

 faceless
 faceless i clasp your shade
 and 'i' die die
impaled on 'our' palpitating
O-u-t-c-r-y

'you' and 'i'—Diagnosticians of the Heart's Aplomb
"the ribald laughter etcht with silver pain"

blind as a bat in a winter cave i veer towards you. how many
dawns will i awake to without the least thought of you?

ॐ
listing towards her side of the bed—
he barely filled half of the scented cave she
left in her wake. his own side lay
flatout—an unrumpled shade. with his tousled
head between her breasts he assumed
a foetal position and an occult / outcry gasped
in his plenary throat: mother / earth—
half-sister / daughter songstress / sickle lover
rune! one whole half of 'me' is cleft
from thee. the 'other' stern half is permeable
skin and bone. "i discover that wherever
eros goes, something psychological is happening,
and wherever psyche lives, eros will in-
evitably constellate." haplessly entwined—
i sing the divinity of each / our whole being

ॐ
what she really thought
of their piquant love affair was
in his mind inseparable
from her lovely discretions.
it was afterall the way
her whole body trembled beneath
his delighted hands that
told him with what care
they spoke to each other
in their variable foot vernaculars
how how shall i apparel
these meagre-words this midnight saucer
full of puddled english

188

⅋
listening to mayumi's heart thump in my wet dawn ear
listening to myself mouth inept 'love' words

o there's a twittering of starlings tailing a high wire
o there's an old fashioned 'ode' to the way i float

listening to trudi warble a soulful sumeric-summer
listening to howard tap out an intrepid tin-pan-alley tune

o hear it toss a february morning weir into the fog
o hear it sob a sodden lament thinking of your sayonara

there's a lady i know who sows the seeds of sorrow in my brow
there's a lady i know who cracks men open to let them flow

i coach my addlepated-tongue to caress each syllibant moment
i have a catch-in-my-throat for her to float up through

⅋
waxen these words dream inside
the scented tent of your thick black hair. cindered…
your face spirals up into my crazed-stare
startled startled by your 'komatamon' 'komatamon' laughter
me feels like a tattered coat / me feels threadbare
if i never behold / never behold your bright face again
these tallow words will burnish the Ace-of-Hearts
on the Shinto glass. under my hands these words shelter
an un-wavering flame. see how it illumines
our Signature/s and brazenly consumes 'us'

⅋
it's all a conceit of errant-images—
all a young succubus' fraught midnight madrigal
he thought, thinking of how her breath
had enlivened his. how her bright face held up
an ancient mirror: an air-filled fugue

⅋
—like any man who has had a door slammed in his face
i tend to gather nectar and grace where i'm permitted—

i am my mother's son. 'me' is your dumbfound child/man

⅋
thronged with
the 'passages' of all her
nocturnal lovers

189

these words lie
in the brine tide of her
shamisen-throat:

intoxicated
vestiges / a carapace
of hauntings

they float me
home to the throne lodged
in my own throat
°

homesick
these words unmask
thronging/s

&
this mouth misses her breath
this mouth misses her
this mouth misses
this mouth
hers

The After-Midnight Heeby Jeebies

an arse-end of the 20th century
ideological exorcism

i've spent the whole winter mole-like
in an astral hibernation . i've stooped over an
oracular bone washt in the river jordan

see how its incisions lace fingertips and toes
into a perfect 6-pointed star for you
to pin on the indigo sky over the wailing wall

see how the three wise men from the far east rein
their camels to a halt under its effulgence

&
nothin' quite like the sunday morning worshippers
of a sacrificial lamb on a.b.c. to impugn a self-righteous
peace-keeping mission in the muddled middle east. punk
kids from iowa and pennsylvania in camouflaged suits catch
themselves doin' the ol' biblical dipsy-doodle 'cause
the mean ol' HEEBY JEEBY has blown into town to tool another
round of midnight misanthropy. o the savage HEEBY JEEBY

&
will all true-blue idolators purse
their fat lips to the ancient wailing wall

 of an unrepentent fundamentalism

will all true heirs of breath press
their parched-throats to the black ice altar

 burning petrol in a concrete casbah

will all the knights of christian brotherhood
tilting at windmills in the holy land

 since "the holy crusades against islam"

take their orders from the good *white house*
'cause the ol' jube-jube is wirin' up

 another lethal batch of HEEBY JEEBIES

to scour islam of all your "thou shall not kill"
commandments. o the ark on mt. ararat!

&

on the stroke of midnight—
the coal-black jube-jube tosses the old year bone into
a sepulchre-of-fire fuelled
by stacks of no-tread goodyear tires and pulling
a brand new bone out of his
gold-embroidered sleeve he rubs it in his sulphuric palms
to burnish a no-name Spell before
passing the spell on and exhorting the ashen pyre

o the ol' HEEBY JEEBY will jabber
in your nightmares if you don't renounce your lethal stockpile

&

hext : vext : prehensile :
and perplext : the ol' midnight HEEBY JEEBIES
gonna scorch the whiskers off
one end and the bushido tail off the other end
o the chromium plated wurlitzer—
spinning the ol' angst-zion

o the orion of an anwar sadat

&

o the ol' downhome cowtown blues wanta place
a sepulchre of black oil in your tepid hands . o the ol'
cold december numb-numb blues wants to dissemble
you to corrugate another clone . o the ol' down and out
doldrum blues wanta pull all the taps and screws
out of your noodle head and implant a microchip computer
in your ah so shiny platinum-pleated skull . o
the ol' HEEBY JEEBY will turn you into an electronic
pariah... if you don't mind all your Ps and Qs

&

no direction to fall . no pawing
the ol' astral turf . no mauling the rungs
of the angelic ladder . no smoke
hole or wispy cloud . nothing but
the prehensile Vow 'cause nothing is all
you got and all you'll regret—if
you don't exact a plenum of its quantum
loops... intoned the jube-jube man

&

hush little baby
don't you cry 'cause your mom
has scurvy and your
pa got a mouthful of dune

hush little baby
don't you bawl 'cause CUSO is gonna
spoon yum yum pablum
into your puckered mouth... soon

&

how does one grease cain and abel's palms without
dropping napalm?

&

born of
a pod-of-awe
our song/s
renew an
ancient spiral
dance
o

don't let 'our' tomorrow drown in abysmal ideology
don't forget our entrancements

&

what's the name of the breath we borrowed and blew back into mirth ?

finding himself hungry in more ways than he could spell

he got into his toyota the day after new year and drove
south on main to broadway then west to heather for an afternoon bite at
the dar lebanese restaurant. over souvlaki and black coffee
over the tousled heads of a motley of hung-over patrons—the ah jasmine
and myrrh strings plucked the shimmering viridian leaves of the
tall cedars of lebanon. this music insinuates itself into
my new year doldrums... he thought, lighting up another camel.
driving home, ear and belly full, he wondered about his hungers and all
the ways of expatiating a brand-new enchantment. —as the apple
tree among the other trees in the woods so / is my beloved amongst all
of pharaoh's comely black-haired daughters / i sat / delighted in
the clover beneath its brimming shade / —her tart fruit had
an unsurpassing bite / now / she's left me to be with a man half my age
her body floats like a summer cloud above my winter dune... he
caught himself—crooning an improvisation of the song of song/s—
just as the lights turned green at main and prior. home at last:
he put her song/s on his cassette deck and danced a lively fox-trot with
the old kitchen broom wrapped in his thin arms. mad-cap, his perk
of providential pain... his ol' heart thumped. his words, proclaimed

be ahead of all parting, as though it were already
behind you, like the winter that has just gone by, for
among these winters there is one so endlessly winter
that only by wintering through it will your heart survive

from *Sonnets to Orpheus*
Rainer Maria Rilke

Struck from the Heat of a Cold December Sun
is affectionately DEDICATED to
all the denizens of our untolled tundra
mayumi honda in totsuka
and the charred ghost of Richard the Lion-hearted

written between Dec. '83
and August '85 at 648-Keefer Street
Vancouver, B/C and printed
in an edition of 11 copies on a
Canon NP 155 Copier

PEAR TREE POMES

ROY K. KIYŌOKA

ILLUSTRATED
BY
DAVID BOLDUC

The Pear Tree Pomes

illustrated by David Bolduc

for Daphne & Kit

a tree becomes a nest the moment a great dreamer hides in it
<div align="right">GASTON BACHELARD, NESTS</div>

credences of summer
now in midsummer come all fools slaughtered
and spring's infuriations over and a long way
to the first autumnal inhalations, young broods
are in the grass, the roses are heavy with the weight
of fragrance and the mind lays by its troubles.

now the mind lays by its troubles and considers.
the fidgets of summer come to this.
this is the last day of a certain year
beyond which there is nothing left of time.
it comes to this and the imagination's life.
<div align="right">WALLACE STEVENS</div>

≈

tall as a telephone pole and as old as the oldest house on
the block the pear tree lights up the whole sky above our alley
every spring and every fall it's a pear a day for every kid
who saunters down the alley — something round to bite into some-
thing ripe to splatter the nearest garage door with. i haven't
said a thing about its viridian summers or its charcoal winters
but as i sit here writing its virtues down on paper i can see
call it the 'real' pear tree just outside the study window.
inside or outside of anywhich door or window there's at least
one pear tree unfolding the verities of all four seasons. intact
these words cling to each fragile blossom fruit bug and worm
the old pear tree exudes. if you listen closely you'll hear a
creaking branch with 'me' clinging to it without a ping of remorse.

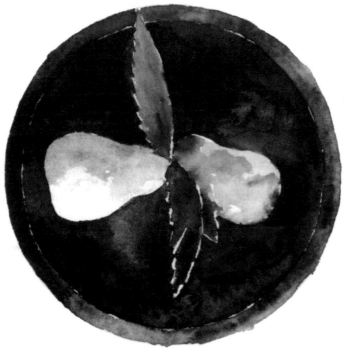

≈

these bent rusted nails embedded in
the pear tree's trunk : these broken cleats speak
of a processional of school-children
barking their shins while skinning the pear tree
shimmying up into its leafy hideaway .

long after the very last pear on the last live twig
falls earthward 'these' frost-bite words
shaped from a handful of dried stems will recall
their boisterous covenant. these bent words
embedded in my own trunk bespeak 'other' plangencies

given the gift of its white blossoms the small yellow pears

to come 'these' words want to spell out an old story of
how two lovers sat a round-of-seasons up in the forkt branches
of an old pear tree . like the birds the assorted birds percht
in its candelabrum-branches they would re-enact the magic
of each unfolding day up in their air-stream lair . given
the divers ways they were paired these words want to finger all
the silences that fell between them before each fell out
of its parasol of leaves in an unmitigated heap . given all
the time in the world only language never stops listening 'to'
and 'for' the other . only an 'i' cries — havoc!

&
since you and i forsook the rites of marriage

intentionally without facing up to the signals of mutual
disenchantment — we found ourselves side-stepping
each other's nakedness to fall asleep in a heap of mired feelings
til the early bird traffic on prior street summoned us
to another 'good morning — did you sleep well' breakfast
on the run . there's a lady with a champagne voice on co-op radio
singin' the ol' after midnight blues and whoops! — there's
that ol' heart-ache again . what i want to know is how come you
with your bright gists and me with my pointed beard didn't
make the perfect match . how come we ended up playing
that ol' deaf and dumb game when it was as plain as this prose
that the pear tree's forkt branches foretold the truth .
since you left i've been taking a hot bottle to bed
 how about you with your tepid toes?

&

love the aurora of these late september nights

as i write this lovely suffusion of twilight colors down
it changes before my very surmise from rose into translucent amber .
by the time i get to the end of this petite colonnade of words
all the amber will be stained a deep violet and in a few moments ...
the pear tree's branches will have knit the night-sky around
themselves to catch a falling star . such as they are these words bear
a testimonial to all the weather we lived through together .
not even your leaving me for a woman will erase their intrepid
measure . love, the night-wind is winding up the spindle of another
dream ... where o where do you think it will spin us?

೮
the pear tree's white blossoms tincture the night air

i remember turning away from the ah of that lovely stain
to place my head on your bare white shoulder . these words mime
the exactitude of your scent — even as they reach out to
cup the ah cool tingle of your pear-shaped breasts . last night's
sudden shower draws all the fragrances out of the grass .
i remember those other nights we stained with our unbidden tears
'tears' i later thought we had wrung from the riddled depth
of the pear tree's corrugated trunk . 'into each life some rain
must fall ...' the ink spots wail on am radio and so it's off
to my small bed . any fleet whiff of another bod turns out to be
an unexpected wind-fall these dwindle-down rasp of days

೮
given the gift of ground the pear tree shaded every summer

there will always be pears to look up at and pears to preserve
pears to bite into and toss and last but not least there'll
always be pears rotting into the ground to nourish the seed of a
small pome . — would you believe me if i said i want these
very words to turn into that pear you're biting into . believe me
biting into a ripe pear doesn't bear the same consequences as
biting into an apple . — just ask jack our cantonese neighbor .

&

since i wrote the night sky down i've been out for a late night

bowl of barbecue duck noodle soup at kam's garden and since i got
home i put the ol' blue mule band on and yes — i've dreamt up
this 6am dawn just for you . i'm just an ol' night bird ready to do
the lindy hop with any ol' hurdy-gurdy man or woman . 'birds'
who don't invest in the same dawn tend to end up sharing a different nest .
since you left i've been keeping an early morning vigil .

&

if i had known the number of hours i would find myself mute

til the early morning wind off the tip of ballantyne pier gently
stirred every leaf and all of a sudden these words, these votaries of
incandescence and all the awakened birds startle the incipient
breath of a small pome. if i had known it would take 56 summers to
divine a plain-song i would, given another spin of the wheel chant
each new-born syllable aloft and watch it haunt the combustible air.
in this way the felicitous way of nouns and their attendant verbs —
a small pear made its compact with the sun to become utterly rotund.

'i breast an ancient syntax heaptup long before speech bore fruit ...'
trilled an orange-crested pear tree bird before heading south

&

how to qualify a pear tree without pointing at the sky

i lean out of the study window to sniff the clear october night
there's one two three half-bitten pears hanging in mid-air

under skeletal branches a motley of bruised pears toll the end of
another summer, another fall, flagrant heat, heart and all

up in the air or down on the ground all creatures large and small
begin by biting the air these bitten pears bear the flesh of

&

who knows how long this small psalm to an old pear tree

and your preserved pears will sing into the so-called future.
on this the last friday in the month of october i am ravaged by
its gist of autumnal silences and everything it unconceals.
what i have been given to accomplish borrows something dark,
barely apprehensible from it must be its original shadow.
planted in the rainforest of my image of a pacific nation the OM
of primal silences blew a pear tree the size of a dwarf's fist
into the forebodings of a sentence, which, believe it or not
flowered into, this bitten flesh, this beak of mirth.

p/s caught a glimpse of jim the ace mechanic of our alley
biting into a ripe pear while over his head a bunch of starlings
and a robin you know have awful belly-aches.

 ask a fallen pear about winter omens

æ
since we stood on the back porch

wondering if the old pear tree would survive another winter ...
i've been sitting here where you used to sit writing its
diurnal virtues down on paper and every time i look up i can
see how it prevailed over our solicitudes by lofting yet
another plangent spring . with or without you i am clearly
intent upon sharing its equinoctial visions . riddled by
an awed phosphorescence : the old pear tree and i sit quietly
divining the lattices of a frugal winter light ...

æ
in my book of sacral nomenclature

the pear tree bespeaks all the unimpeachable days
we savour'd under its green umbrella .
'pears' kisst into existence by the sun will nourish
compost and bury every lover . given
its seasonal epiphanies i would be a fool indeed if
i didn't turn inside its ring-of-seasons &
yes sing my adamant self alive —

æ
with his waterman fountain pen poised wallace stevens
meditated in front of a cut-glass bowl full of ripe pears
and the language he mediated mirrored their rotundness

i loved the whole smell of the morning world from the back
porch of 1008 third street east when i was a foothills' child
i thought, thinking of all the spells i had before i could spell

ask wallace stevens if an ode to an old pear tree sounds too
trifling to thrill the air of our well-being . ask mrs stevens how
come she had two green thumbs and eight brown fingernails

permit me to add that this bright fall morning enthralls each
pear left dangling from the old pear tree's boughs . ask 'pear'
about the midnight arias sung in allah's scented lemon groves ...

&

a persian miniature for gerry and marlene

planted at the foot of the pear tree their endearments
curve towards each other on stamens of silences .
if you put your ear to its scarred trunk you'll overhear
the pizzicato of their least perturbation . nothing
you can dream up equals their exquisite forays
and scented rebuffs . if i had to do it up in a pear tree
again i would hide a tape deck in its lustrous leaves
to record the least tremble . given a tongue-tied
poet sitting in a pear tree with his beloved these words
are but a faint echo of their original betrothal .
planted at the foot of the pear tree their every endearment
composts love's etymologies . ask 'adam' or 'eve'

&

o
little
bird

chirp
pippa's
song

into
my blue
ear

&

love the subtle ways the weather occurs and reoccurs

in the bodies of men and women . love all the intricate ways
the world has of disappearing into their forbodings .
love there is no discourse left in the abode of language no
ecstasy or outrage left undesecrated no unconditional
'yes' — yet there's something unborn in me that wants to be
the 'verb' of that longing my body feels when it feels
the actual touch of your breath . an appall'd lover bends his
ear to the pear tree's trunk to hear a lost rhetorick .

what lay under the midden the
mound of hair between her gated thighs
toucht his deepest presentiments .
permeable as a summer rain and twice
as penetrant she stroked the small
of his back til he curled up like a child
in her ample lap and wept himself
to sleep . in the air-borne nest between
her speckled-breasts the pear tree
sang a psalm to the long-legged bride
and her goat-footed consort who
together with a gnomic child dwelled in
an all-weather pear tree house . it
sang them the salmon-haunted song
of all the lost nuptial bodies come home
to dye the birthing river scarlet.
what lies unsurmised 'neath a midden or
a mound of hair ignites the verity
of all distaff phenomena ... it added
in a telling parenthesis . it was then
he awoke and peering thru the leaves
beheld a giant red-breasted robin
pulling an earth-worm out of a topaz mountain .
what lay under hand toucht blue sky

i had meant to write about a pear tree i knew as a child

when i lived over the mountains in a small prairie town but
the language of that pear tree belonged to my mother tongue . it
bespeaks a lost childhood language one which the pear tree
in our backyard in chinatown has a nodding acquaintance with .

how many languages does a pear tree speak ?

i am still sitting here trying to get a handle on my childhood
pear tree but all i can hear in its 'ukiyoe' branches is
the voice of my mother as she bends over my head delicately lifting
tiny spoonfuls of wax from one pink ear then the other .
how many languages have i lost losing my childhood pear tree ...

and is it that loss that makes me the tongue-tied lover i be ?

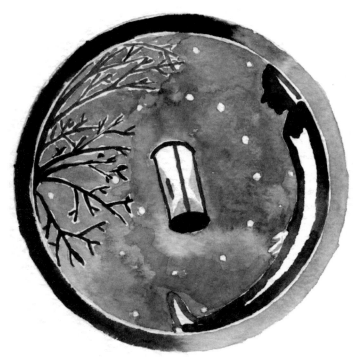

&

what i am given to 'see' lies half-hidden

under the burdened keel buried in the pear tree's midden .
ask king solomon how he increast the pear tree's
yield by singing all night long up in its leafy branches .

in my book of hours : one forked branch wraps itself
around a giant hour glass . while the other equally twisted
branch clasps our thronging bodies . what i am given
to 'be' flies out of its midnight leaves ... utterly unseen

&

the pear tree a siamese cat named cooper and me

seem to have made a compact with these autumnal days —
one which has something to do with an improbable stiffening
of the ligaments and joints plus an oftimes acerbic-
laughter sandwicht between thin slices of callit-a-wanton
hunger, you said, put a pallor on our relationship . unlike
the other two 'i' didn't want to admit to my infirmity . thus
the old pear tree basks in the rotund sun striking my cheeks —
while stroking the fur of the paws-in-the-air siamese cat lying
on the light-struck carpet at my feet . thus language —
mirroring the eddys of our indiscretions deposits the trio and
their common ailments at the foot of the heapt-up midden :
 crumpled bent unrepentant

ह
dear lesbia

i'm thankful i didn't have to choose between you and the pear tree
though i must admit i didn't think i'd have that choice made for me :
nor did i think of it as a deliberate intent on your part til the very
end when it became impossible to tell 'who' fell out of synch with
'whom' let alone 'why' . bird bird of my once fabled pear tree —
there's one less song haunting the morning alley since you flew off
to another nest in another neighborhood . do fly by if you have a
spare wing and share a pear . you know that i know a pear tree isn't
anybody's property . and if i may say so, neither are you . nor i .

ह
thin sliver of november moon over maclean park

... i want to hang a thought on its silvery horn i want
to illumine these disparate words : *words* i once thought
'you' and you alone made visible . incarnate in its very
origins 'we' are the breath on which they fly . fly out of
the extremity of our winter solitude into another ear .
listen — 'breath' bears the brunt of all the unstirr'd
silences to come : breath is a calling an actual reaching out .
ask the ode of an old pear tree 'who' stoppt listening ...
 — can you hear me from your tree?

&

just the other day i ate up the last bowlful of

your preserved pears and wasn't it just the day before
'yesterday' we stood in the back-alley looking up
at its array of white blossoms and under our breath say
how lucky we are to find such a splendid clapboard
house with its own tall pear tree . eight brimfilled years
spoke to me as i put the last sliver in my mouth and
suckt up all the sweet pear juice . from here on in i'll
have to go it alone if i'm to compost another spring .
i'll miss your preserved pears your paring knife and son .

p/s there's a dozen pears rotting on top of the camper

summer came and went leaving its traceries on his fall

if the pear tree didn't stand so tall outside the study window
he might well have gone off to bed thinking he had invented
its midnight-presciences for a small clandestine pome's sake.
but given the gift-of-sleep with all its inchoate portents —
the pear tree crackled with forebodings nobody in their right minds
would think twice of repudiating. prophetic in its mastery
of all the seasons since the beginning of speech it thinks with
its whole being. given the gift of its haunted syntax these
words rehearse the music of "the last day of a certain year beyond
which there is nothing left of time." "nothing left to decline
but the divinity of air ..." i thought i heard a bitten pear pray

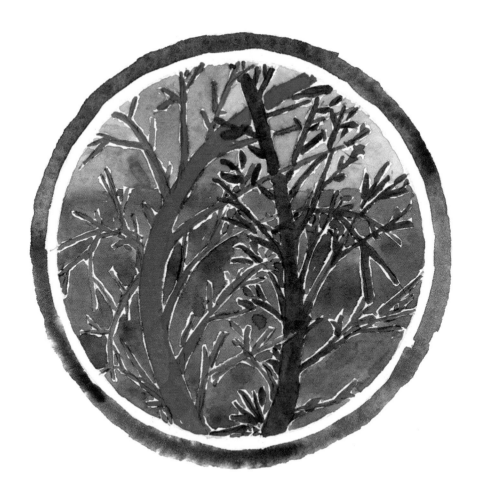

belatedly, for kit's 11th birthday
midnight, may 13th '80

this house this small house we three thrive in is
mostly wood, paper and words — i sd to myself as i looked all a-
round me. this small house heapt with worlds on paper invites
even more paper and words to help themselves to a place on our
already crowded shelves — i thought as the very paper under my hand
filled up with words. this un-bored wood, paper and breath a-
bode beside a creek with a tall pear tree has no beginning middle
or ending — i caught myself saying to the wind as row on row of
perpendicular worlds tilted their paginations at my small feat.
built of wood breath and a thimbleful of words: this small house
simply, abides simply us

ڼ

these words seem to be rehearsing —

the unquantifiable extinction of all similitudes ...
i thot i heard a bitten pear say .
'stuff and nonsense' hisst a stern verb tossing
love's pomposity higher than an april kite

o dancè a jig on the pear tree's midden heapt
with divers wonderments . language is a fool's fruit
fool-proof pear trees bear the laughter of .
put your ear to its forkt-trunk — hear its sap thrum

&

in my day-break dream:
somebody in a fool's green vestment was seen waving
2 luminous syllables by their
golden stems — shouting, P E A R S ! P-E-A-R-S !

— how come 'you' turned out to be
the green fool with slender phosphorescent fingers
and 'i' — the golden stems? how
does a pear tree circumvent mistaken-identities ?

&

dear wallace stevens

 not til i got this far which is as far as a handful of
dried pear stems have brought me ... did i feel the 'pips' of
your two pears implode in the loam of my pear tree's
midden heap . long before i ever thought to write 'them' your
pears composted the night air . — if these 'auguries' to
an old pear tree veer too far in the wind of a disembodied
wit ... i'm almost certain that you of all the poets i
read in my young manhood will indulge me with a passing nod
if not a handshake . i'll take a twang of your 'blue guitar'
anyday of the week over reams of semiotic-nonsense .
language overload that obstructs the rush of an intent speech
bores the pear i also be . permit it this small screech

 yours, complete with worm holes

&

how to shake a ripe pear down

hop up and down on the branch it dangles from
til it drops. get fat-assed 'cause mean
winter's comin' with sodden rain. whoever steps
on a fallen pear steps on a small bird's dessert.
this is an old bird mockin' the pecking order
of local politics: it's about all the stale white bread
& baloney sandwiches no pear tree bird in its
right mind would stoop to eat. it's about the absence
of love among these glistening towers and all the
inhospitable machines. 'have a bite on me,' sd
the providential pear tree to a migrant bird breasting
an unseasonable squalor.
 'holler if you need me'

214

&

— if on a cold winter morning you
fill up on a bowlful of ripe pears say 'grace'
and 'praise' the perennial mating of sol
and chlorophyll — this is the indigenous voice
of an old crow cawing up a commotion —

pears struck from the spoilage of a man's will often
emit a quantum of unalloyed noise

pears : persimmons : & pumpkins all got
their p's and s's loopt together into a sibilance
even if nothing else clings to them : this
is their contingency-plan their unplanned mandate
— this is the hiss of personification
listen — a dangling pear spinning a winter Omen says
"let your own fruit drop ... and fast, again"

&

thinking about all the eavesdroppers

eg: the poets / the birds up in the pear tree monitoring
the daily round-of-awe for a small pome's sake.

thinking about a 'you' i once knew and your preserved pears
thinking about a small 'me' and my pitiless fruit
thinking about all the frost-bitten pears hugging its hearth

the old midden in unsurpassing rhetorick proclaimed —
"I COMPOST THE LANGUAGE-TREE :

 TAKE YOUR CLUES FROM ME!"

&
what i have been given to do will bear

its own felicities an ancient midden i've dreamt about
utterly enfolds . otherwise silences abound —
& the bounty is this hissing rain this whining midnight siren
& these my twice emptied-out clay hands . i would
write a cantata for a harp & a small bronze bell if i could
sound the unpeel'd silence when the last pear falls ...

moment-
arily air
borne

another
mottled pear
slides —

down
an unseen
draft

to touch
earth
home – free

&

there are no words left for how i feel

towards you : no words that haven't returned to
the well-of-silences ... if i told you that
my feelings are grounded in the still waters of
my own body — would you have believed me ?
would you have placed your ear to my chest and
listened ? the brilliant october air laves
the back-alley . the pear tree lets its last fruit
bruise the ground ... there are no words left
bearing the seasons of a once fruitful tree ...

 can you hear me ?

&

there must be at least one pome to a pear tree in all

the divers tongues of the morning world pear trees thrive in.
i am simple — i want to believe that a sapling planted in
the loam of a pome will one day flower into a tall pear tree
bearing a basket full of fruit, indigent birds, and diligent
lovers-of-the-marvellous. i want to consort with all the
bruised pears pitting the dew-lappt grass. in all the diverse
tongues scoured by its first flowering: there's a scented
nomenclature breathing a votive "YES!" amongst its graven leaves.
o st. francis! look! there's a full moon lighting up its thatch!

&

the morning sun emblazons

the photograph of a family i once had
past-tense : past all pretence —
it shines in upon a once thriving nest

fate is a lengthening shadow an unwept
tear glistening — a granular silver
bromide print : what 'i' beheld i became

&

in this our
one thousand nine hundred
eighty-second
 summer a.d.

in this our summer of pitiless animosities
the chinese anglican church of the good shepherd choir
is singing — "onward christian soldiers
marching as to war ... " in this our summer of nuclear

218

fallout and ekonomic depletion: in these
and other acts of "ideological terrorism" — teach us
o wrathful one! how to tend a small garden
and in its daily tending learn (again) how to nurture
our dire impoverishment.

 will you forgive me for
 seeming to make light of a bright
 sunday morning service —
 but the very hum of my typewriter
 depends upon the sunne's
 electro-magnetic aplomb! and if i
 may say so — so does your
 gone-to-seed gone-awry-garden
 full of pungent verbs

 like the golden hub of
 an ancient chinese chariot wheel
 the spokes the branchings
 of the fabled pear tree
 radiate out
 over the roof-tops of
 my 'pacifica'
 hooping
 water earth air wood metal & fire

 like the endless
 column constantin brancusi sculpted
 to point a finger at the bestial
 sun these brine-words wave towards
 the pear tree's trunk full of
 intricate divinations

 say 'pear tree' twice if
 you want a turn on a tall sky-wheel
 say 'pear tree' thrice if
 you want a ride on an eagle's back with
 a breath-taking view of
 the whole turning / burning
 Dream Wheel

&

a capricorn pear tree

up / side / down
its calligraphic-branches twist in
the fist of a winter-wind —
into an uproaring of knarled hands
shaking — a skyfull of dread
in the face of a wan winter moon

what i am given to tell dwells intact
in a raven's eye

&

'the body i am is the purest instrumentation of desire i know'

 sing —
 the unslaked
 heft
 of hunger

 the
 midden's
 trove
 of wonder-
 ments
sing —
its
riddled
love-
song

220

say
i love you
midden
heap of my
being

almost
'me'

&
who knows if i'll be around
when they come to chop my pear tree down
to build another condominium

 magpie! magpie!
 swayin' on a high silverbranch!
 will you caw me —
if you catch a glimpse of the axe-man
 comin' down the alley
'cause i've got a petition signed by all
 the neighborhood kids
who haven't had a chance to skin their
 knees let alone laugh &
 sneeze up in its leafy corridors
 and there's a young
couple i know who want to build their 1st
 nest up in its forkt-branches

 magpie! magpie!
 will you be my unpaid informer?
 my unimpeachable i

&
long after the pear tree's final surge of sap ...

these spare words shapt from a handful of dried pear stems
will re-birth (again) in a remote corner of your mind :
where the unnamed 'breath' blew an unnamed 'terror' into
the pith of a hapless 'verb' and thus 'death' got born

how many dawns stalk the pages of the book of etymologies ?
how many nights has 'it' used my addlepated tongue ...

&

heapt with leaves the midden hides my mirth

mother
i am nothing but this pod-of-breath caressing
the midden's heapt-up exuberance/s
nothing if not all the mud twig & spittle consonants
the whole air-borne extravaganza !

mother the nests we feather at
speech's behest

&

pied
pear

i love
you

pith
stem

seed
un-

voiced
sun

&

dear pear tree

it's taken me 56 winters to cry real tears ...
how long do you think it'll take me to learn to die, clear-eyed?

written between august '82 and march '85

the persistent question seems to be
"how many ways are there for calibrating the bounty of each day"
— bearing in mind there'll never be
another quite like this one. bearing our derelictions
in mind: be kind to yourself

(with special thanks to wallace stevens and rainer maria rilke)

Gotenyama

Gotenyama
is especially for
Syuzo / Satchiko / & Kana
otherwise it's for a
Host of Friends scattered
in Southern Nippon

why—
i am prone to ask
myself
why does this midnight
Litany
of All your Voices
enthrall
the yet-to-be-born
Thronging/s
in my
'umeiboshi-throat'

listening

to takeo hail
an autumn gust / these motley
words shed their
end-of-winter torpor to
ride piggy-back
on a billowing blue paper carp
as my 58th spring
curlsup the flue of his
october reed

listening

to takeo tail
a frost-bite leaf / my aggrieved
throat rehearses a
plain-chant of
its own (acerbic) winnowings

&

why the seemingly
insignificant lump underneath
his adam's apple began
to swell by the time he alighted
from the 747 in narita
and how it swoll into an unsightly
purple protuberance
by the time he got to Gotenyama
left him, panic-riven

&

at the top of his list
of 'things' he hadn't developed more
than a rudimentary taste
for were both 'olives' & 'umeiboshi'

if only i had had them on
the fabled kitchen table of my duplicitous
childhood i might have grown
into manhood speaking 'greco-roman'
while speaking 'japanese'

divining exactly how
his pucker'd throat felt on the back of
his tied-tongue & wanting
to nickname it—he promptly named it
his 'umeiboshi-throat'

&

'hubris' dwells like an infidel
in the twilight-zone of my purple-throat

and all my flagrant days kaleido-
scope into each other: every/which/way

 pre-emptive
 silences
 /

 perpendicular
 disarray

&

throat

throat
of no-meaning
throat

of an ancient
throng
take
this awful
thirst
this poor throat's
alms

&
while
i was thinking
of you
doing your daily ~~round~~
~~of~~ things
a small bird glanced off the
window ~~pane~~
and
catching a sudden
updraft
neath its startled wings
swoopt
up a round the overhanging
eavetrough
~~out of~~
~~site~~

&
can you hear Gotenyama
rehearsing the
equinoctial-overture

can you see a giant 'tanoki'
stompin' about bare-
arst in the pale moonlight

&
there's nothing left but
the long insomniac-night ahead…
i wrap myself up in my futon
and lightup another 'echo' cigarette
don't tell me this spring rain
drains into the foul well of
my own abject solicitudes . tonight
Gotenyama is nothing but a
wind-swept knoll in the bowels of
my 'umeiboshi-throat'
i daub tiger balm under my sere nose.

inexplicably—all the things i
took for granted, begin, un-ravelling

these words herald
an unleavened world-of-things

&
out of
hitherto (unrecognized) grit
shredded paper
scurrying ants pushing pebbles
twigs dew & leafy
runnels
 an
 ancient site:
 all the
 seemingly haphazard
 alignments
 un
 conceal
 self
o

underfoot

Gotenyama's Imprimatura

overhead its aged
cypresses sweep Spring clouds awry

&
bird

bird
of profligate
plumage

bird
of my scarified
throat

baste
this lapidary
song

Dr. O'Hara's Admonition

doku—
means something noxious
most of all it means
poison—like your coagulated
blood. therefore no
pleasure domes & no public ofuros
the last thing we need
is a thoughtless infection due
to your derelictions

and by all means take your
anti-biotic pills as prescribed if
you want to hasten health

&
blithely

billowing
azure & crimson paper carp
tethered
to a sky-high pole

tassels

this roundabout
saunter
thru Gotenyama backstreets
re sound-
ing inside the shell
of a child's
syntax

(an 'echo'
of a distant echo...

my mother
taught me on the sunday morning
back porch
of a long ago East Calgary
circa 1930s

these
thrasht blossoms clinging to my sleeve

 this mid-morning
 reprieve

Gotenyama Spring

this
unflinching
mirror
this
poor throat's
psalm

this
resplendent
gift

this
keening spring
air

i am heir to

🚲
mother:
i seem to be minding
all these sights & sounds that
abound in Gotenyama—
for the sake of an unfound 'numen'
embracing 'alphabet'
and 'kanji' . i seem to me
to be *all eyes all ears*
a reptile with an uncouth mouth

mother:
i have had to cross midnight waters
Lethe's bottomless well)
i can't remember the last time i cried...
shredded on its own foul shoals
this throat savours an April silence

mother:
this Summer is all in all:
let 'it' loft—
our heart's coruscations
let it 'echo'
a venerable 'innocence'
let it singe us

&

who would have thought
that Gotenyama would one day play
host to a foul prosody:
this vile throat chockful of syn-
tactical divertimentos
 this wan mote

&

when i think of you—
which is usually in the early morning with
my first 'echo' and late
at night with my last puff... i am wont to ask
"how could 2 small villages
be so close (as the crow flies) and yet like
'sun' and 'moon'—so far apart?"
how come these words have to travel such appalling
distances to tongue your ear...

can you hear them arouse a Hosanna?
can you see them commingle with the air?

&

that irresistible
raga-of-longing that droned through me
riddling my psyche...
had to be lanced before i could begin to sing
°
lattices-of-summer
lustra is nothing if not the sheen of
our care-worn bodies:
laughter its tonic sunrise & twilight augury

&

now the lengthening
summer days begin their magisterial
ascent Gotenyama lies a
scented pillow under my riddledhead
and my small foam bed
turns into a flying tongue winging me
home to the throne in my
own fraught-throat

 throat
 of no-meaning
 throat
 of an ancient song

o

what i have to dwell in
rides a sudden updraft across
the bright tail of that
sparrow's gist of riddled-air

&

as casually offered
as their own good health one
or another of the three
of them would peer intently
at his impaired throat
and in a single voice exclaim
that both the swelling
and the awful purple coloring
was definitely receding.
anyday now—you'll be capable
of swallowing a whole sushi
and even laugh outloud.

it was in amongst the clatter
and chatter of their daily
rounds that his throat healed
itself. whereupon—a Psalm
of halt-breath blesst the blue
tile roof tops in Gotenyama

&

when i think of all
the tiger balm i dabbed
under my nostrils...
i dab one last dollop under
my prose to give it
a lift into surpassing song

&

bird

bird
of my unbridled
foreboding

bird
of precipitous
flight

build
a mud & wattle
nest
in my
allegretto
become

my healing
air

&
when i
hear you breathing
my name

when i
catch myself hollering
yours

&
my rung-
throat will praise
us

&
to
solicit the Kami of
Gotenyama
sing-your-heart-out at
Eventide...
chirpt an underbrushful
of cicadas

cicada...
cicada...
cicada...
with lotsa *reverb*

&
it had never mattered
which shore of the Pacific they
hailed each other from:
their friendship had nothing to do
with punctiliousness &
even less with each other's ego.
from the very beginning
they spoke to each other through the
divers tools they shared

shaping ellipsoid-sculptures—it
was as if nothing counted
but the purity of their hand/eye-
movements: scented by heaps
of aromatic cedar-shavings . how
'each' divines the arc/s of
their whole body's prowesses but
nonetheless goes on tempting
'fate' with baited breath...

&

'beggar-worlds / upbeat selves'
i thought—thinking of Syuzo Fujimoto
of Gotenyama (16 years, later...

being
the unsung
Psalm
of my umeiboshi
throat

and

the
erstwhile
sequel
to my
Kyoto Airs

composed (piecemeal
in the manner of a lyric-narrative
e.g. a true story verging
on song : call them a haiku / blues
between April 1984 & December
1985 in both Gotenyama & Vancouver
& printed on a Canon Copier
at 648 Keefer Street Vancouver BC
in an Xmas edition of 26
plus 9 under the BLUE MULE logos

an April Fool Divertimento

"i am dancing a jig on an upturned bowl"

by Heironymus Bosch & Heir

upon being interrogated by the local clerics

concerning the alembic of his heretical work

"i come to my 'painting' as I awaken to 'morning'
incubated during the night: both hold up a chalice of light
then—i go to sleep cradled in day-glo colors... "

&
the days do flit bye. march, sodden march almost past-tense
& 'We' have had enough more than enough of this un quenchable drench.
we want nothing less than the aplomb of a bright blue sky & a be-
dazzlement of atavistic sunlight on our jowls & our fetid feet .
lotus-eaters have been known to cultivate a variegated moss & lichen
in their crude beards 'cause the wan winter sun attenuated them
i, for instance—look at my pallid bod & want to laugh out loud—
but a delinquent arctic gust outwits my blessed lopsidedness .

anyday now—the first vile crocus will buttonhole my lenten suit

these words all got upturned mouths

the pallor i bear like a wound has its own blush

&
they quarried a mirabilia-stone to sculpt gods
& goddesses who worshipped a divine Helio-trope & having
achieved a hitherto untold 'meta-physic' take an
afternoon siesta in the shadows of a sun-drencht colonnade
before... the pristine Aegean lauded & ravaged them

'i' on the distaff side of the precipitous Alps have
often beheld—an intransigent 'gunnysack' beauty stumbling
along on a dirt embankment, shouting—obscene sermons
the stave in her wizened hand & the crookt-finger inscribing
an Omen, on the offal air, depict, a gaunt perspective

&

their sun, i'm told—hallowed, the rotund:
thus the cylindrical column & the fulsome heroine got aplomb
our northern sun flattens light & flatters noone
'beauty' is a dollop of color staining her gunnysack skirt

in the Netherworld: both of us are purblind:
she with an owl on her ragged shoulder & i with my pouch full
of hog bristles. the owl & the brush i'll shape
speak—a gallows and tallow dialect that reeks superstition

&

enthralled by
an un earthly stratagem

of Hues 'i' paint
the taint of the 'beast' stalking polis

i gloss its neanderthal
concatenation/ s

fissures in
a lobotomized head

swallowing
buckets full of anon contaminants

darken my lintel
& belittle my coffin/bed

Adam hailed—
the un named Thrall

before falling
headlong into a ring-of-fire

i, a halt traveller
deprecate his

pyro-technic fall from grace
with a mercurial
stylus

&

meditation in a zealot's hell

"night's libations plunder my daylight feats"

234

these are 'figures' you have seen
they are said to grow on
everybody's
tree

"anima"
———

"metamorpho"

"humanoid"
————————

"beast"

 "the 'landscape' i like best
consists of
 a seething
 /
 crustacean

 mobile
 /
 mass

 —a riddled
 plenum"

 "i pluck both
 the garden of delight
 and a season
 in hell—
 out of my abdomen"

 "human
 blunderbuss"
 ————————

 "midnight staves
 to heaven"

&
four-legged: 'i'
stand upright on my thick tail

my claws tear at—
the throat of unvoiced tarantulan fear

this is a profile
of my phosphorescent entrails

these are my
distinguished credentials

&
in my female guise—
i incubate a golden egg

in an ashen thicket
to hatch—a vile wonderment!

april's unalloyed
'epiphanies' drench my foetal nest

&
... if I hadn't crossed the precipitous Alps in my youth
i might have missed—the mytho-logician's precipices

... if i hadn't come to manhood on the flatlands
i might well have pissed on the sheer homeliness around me

... if i didn't get to lave her calloused feet i at least
got the burden of depicting the heaving midden she stood on

&
beyond the grasp of copyright/s–

Beauty is a ring-of-fire burning encaustic
behind glaucous eye-balls: an

inflammable 'figure' of Bequeathments
dancing on a midnight pyre

&
every moment

the NEWS
leaks out of toxic
catacombs

penetrant

i, envisage
its serendipitous
fractures...

'i' am the anon-caller who knockt
on your bolted door

———————

'death'
in the garb of a crocus

caresses the labia
of 'breath' &

all my frugal-litanies sprout
leviathan-wings

ȡ

going out into the wide world comprised of innumerable 'others'

How implacably each Face looms up out of their anima despite all
the proprieties that obtain viz, the un gratified ego—the alibi
of a self-sufficient 'individuality'. 'i' felt a stress even
appalled by all the conundrums each face salvaged from a heretical
text... it was as if the painter i be had turned into a gross
caricature. hear me, i felt the hulk of an un named fear leaning to
wards me & a gargantuan thyroid stalk my vernacular. these words
lie curled up like a leaf in a fist of dread, un read. it's
the implacable face of the other you find your own face among that
feeds an omnivorous narrative... the very next face looming up
in front of you could be your own un born profile. let's play dead

ȡ
v-o-i-l-a

clamorously
amorously / inchoate
prehensile

thing/s
permeable
de-sacralized
vestigial

dream/s

resurrect
insight: a scoop
of breath

v-o-i-l-a

&

gallows & tallow humours: a conjuring up of a host
of anthropo-grotesques legions of once libidinous bipeds
intoxicated, lovers of gothic curses & lucent hearsay—
you name the 'dread' & i'll wager my last curse that i have
o i know the gallows are obsolete & death a happenstance
when the very air you breathe begets offal malignancies...
but if i may add one last trope, i'd say that 3 Mile Island
is nonetheless an indivisible part of all the excrement
embedded in the very body of our sacrilegious hearth .

&

child

of
syntactical
leaps
i stammer
after
your unbeknown
smile
your
simian grief
reeks

&

these 'diaboli-figures' tempting saint anthony temper
the fledgling poet 'i' be : up from the brine, out of the
primal slither & the pomp of reasonable facsimiles—
these meta-morpho 'critters' agog in the groin of a nightmare
appall—even as they match wits with The Ace of Swords.
if i have known any surcease from all such bedevil-meant, it
it must be 'cause the 'Owl' i swallowed is avidly waiting
to lift-off into the roseate dawn of April—the Aspirant's
spring-board into the bowers of summer. April petals my stamen

an April Fool Sortilege salvaged from a post-Medieval midden

———————

for Sheila & Wilfred
these heraldic Consternations upon having another look
at Hieronymus Bosch in the pall of our nuclear blight

march 31st
——————— *'86*
june 7th

printed on a canon copier at 648-keefer street, vancouver b.c.
in an edition of 30 under the sign of The Blue Mule, june '86

All Amazed
in the Runnels
of His 60
Winters

all amazed
in the runnels of his
60 winters

including
the untellable seasons
in a labialcave

an
intrepid
fog
sonata

 a
 monstrance
 brim
 full of
 aqua

for
all
those
who
cover
the
waterfront
waitin'

for
their
silver
ship
to
sail
in
to
the
port
of
the
flying
angel

match your wits up with
the vectors of a porous december fog
let it sodden your lair

parlay midnight's roseate-
bifurcations into an uproar of bears
dancing on a blue mountain

this sprig-of-breath is also
also in its pellucid-keeping: praise
its freckled concatenation/s

bead
on
bead
a-
biding
the
rutted-
syll-
ables
un-
furling
dis-
taff
laughter

this
my neighborhood:
(blight
on the ramparts of urban

renewal
these
seemingly unbequeathed
streets
reeking an erstaz
inglish
this clapboard cul-de-sac
wedged-in
between the railhead
and the
strait of georgia

these
gulls with their beaks
in a sky-trough
these
slant-vernaculars

all the
perdurable epiphanies
merging—
into a providential
syntax

 this
 december
 wears
 a billowing
 porous
 vestment

and
the wan
sun
never
topped
the
tall
telephone
wires

&
splicing
sullen
solstice
skies

i too

turn
away from
its
promiscuities
its
anon
dissipations
pitted
in gloom
and
imprudent
lust

o parlay!
your midnight dream
into a galley
of un-repentent pie-
eyed Ghost/s

 ghosts of
 forlorn alacrity
 ghosts of
 gnomic history
 ghosts of
 sere friendships
 ghosts of
 atavistic love

ghosts of
wolf bear and raven
disbursing
quotidian-thoughts

this fog
waylays a mountain
capt with
un-sung

 memorabilia
 ——————

 embroidering

 the marge
 of the new year

this
cloud-bank
reeks
anon)
prodigality

 bead
 on
 bead

 ambergris
 these
 soothsayer
 beads
 this plant
 aqua

 bead
on beast

 thanks
 to our host

the
illimitable
sea

 this
 awfulfog sucks
 up all
 the
 old
 colonial
 scold/s
 o lord
 strathcona!

 verdure's
 prosaic
 nurture

 these
 tallow words
 turn in-
 side a crypt
 of mirth

this my
appropriate abode
me thinks)
wears a capricorn's
lineament /
s

40 copies
printed
at 648 keefer st.
vancouver
b.c. V6A 1Y4
january 18th, '87

244

Excerpts from the Long Autumn Scroll

(Written in the Manner of a Chinese Scholar's Autumnal Journal)

Here, the mountain air is already frost-laden:
'neath sun-dog moon, scarlet leaves and pine needles glisten.
in the morning i shall sweep the floor and tidy up.
Then i'll stash all the empty sake bottles under the back porch
and in the early afternoon I'll close the shutters
and catch the ferry back to Vancouver. It's the sustaining 'Chi'
of my okinawa summer that keeps me warm these chilbain nights...
　　　　　all summer long i forgot 'your' name.
my own name died, twice: once in 'nihongo' and once on
your bruised lips. all summer long — you rang the clapper in
your broken dome. "forgive me" you said, "i can't stand
this living/death."
　　　　　all summer long my small bell clapped
to the tidal swells in a distant okinawa. all autumn long
i've been inhabited by a nameless thronging. "love," the hangman
said, "un-knots love & all things forged in the belly of a
gone-awry-dream."
　　　　　laced with arboreal-light — this writing
ignites the music laving your ashen trove. sleep howard
sleep let your hassidic-boat cradle these scintillant silences...

"kai" my second grandson a class of '86 tiger has fair hair
and blue eyes. i "kenjiro" a class of '26 tiger have dark brown eyes
and once thick black hair. — o listen to our startled outcry!
our myriad-mirth. this unbecoming cloud-burst laves our fidelity.
ask old mother pacific who truly keeps the family archives...

　　　howard: since you left your marimba behind
i've fallen by hawks street — to re-kindle their afro-latin
rythmns/rhthmns that had you under their spell.
like a number of our friends you declined to take up more
space than you needed to stretchout that big frame —
but as it turned out even that was more than you could handle...
so you let your mournful ol' soul drift across those
black keys one last time... before a pall of dust hushed their
bequeathments...
　　　　　this day onto day syntax
unfurls in the heart of your sad accomplice. when i'm alone
i strum each syllable as if it alone entuned my dulcimer.
ah! the moon-crazed viola-notes among the purple hyacinth:

well-springs of a thronging crazing the abrasures of my
startled-strings. now that the endless winter brushes an un-
requited hush across my plectrum... the first snow
clasping the pine branches sings the plum-colored eventide

umagi-mura interlude)
down the well-worn path barefeet share with civic ants
orange tiger lilies abut calligraphic roots & tendrils.
down the herbaceous incline towards the unrevealed but
not unheard plaintive mutterings of ol' mother pacific —
i strode thinking i would find myself a place in the sun and
let the ol' crone harp me all afternoon. but, need I say,
i was wronged: hide your tuberous bod under a huge boulder:
wedge yourself into its seaweed armpit and watch the
pummelled tide ride the black pebbles up the foreshore to-
wards your unwebbed feet. beat a hasty retreat...

> shikoku no aoi yama
> kaigan no osoroshi kaminari
> otosun no hosoi koe

skim-of-downward flowing run-off lave my incredulous feet
while overhead — the whole bamboo grove dripped on my
tousled head. leaning into another sun-dappled slope i'm suddenly
above the tree-tops and my feet know there's just one more
slope to go before — the whole sky opens up and the blue pacific
brims the horizon. "it's just a big flick of an errant monsoon's
tail — just enough rain to tell rice fields to tough it out," saychun
said, as i came up over the rise, incomparably sun-dried. on
a hot summer night you can hear the pacific crooning all the stars
in its keep to sleep... while you lie awake listening to your
own heart-beat monitor the odds

... "kenjiro" my namesake & first cousin got pinned beneath
his toppled backhoe, setsuko told me, moments after i arrived
in kochi city. beside the slope that crumbled under the weight
of his backhoe. beside the dank stone slope that sheered upwards
from the road below. beside all the family tombstones he had
so recently refurbished i wept for his undeserving fate. the only
photo i have of my childhood visit in umagi-mura is with him

"everyone has to make their own covenant with death..." setsuko
wept as we looked at a photo of the backhoe he had so recently
bought to shore-up the retaining walls around the old family home.

go, dumbfound, song
go lie under his bruised head
be his dream pillow.
gleam his unsung breath

246

a june skylark for kai's air

&
old proverb sez:

it all start / les
with a common cry and a
colic chortle and
given its fair-share of
spunk (plus) toil—
all the nascent-nouns
and agile-verbs
conflate a home-made
vernacular...

adding—
the proverb concluded:

another 'i' to
the babel-of-vernaculars
falling—forever
out off our hapless aplomb!
into the realms of

our peregrine mirth our
daily Orbit / s

&

o loom a lattice of summer airs!

trace the sun and moon upsidedown
on our carapaces: 'be' unfathomable
Sky: midnight's galactic-ranger

&

o by the by

has anybody seen
little you-i
who stood on a green
hill and threw
his wish at blue

asks
e.e.cummings

&

Inscription
on an autumn leaf :

 the child is the father of
 the scribe

&

abide!
abide!

the ledgerdemain
of tides

the cantankerous
polis

&

kai: my 2nd grandson all
onto himself a class '86 tiger
has merry blue eyes . 'i'
kenjiro a once fierce brown eyed
showa '26 tiger and this
bright ides-of-may window: my
twice-told 'pear tree' once
enlivened with its white blossoms
and bird-enchanted leaves.
we who have always known how to
fly and surely would if we
had been given wings instead of
arms and hands... together

watch the heraldic-sky for... is
it, songs of our hidden agenda

involuntarily i enclose
his mite-of-a-fist in my own
mutilated hand...as if i
could foresee an awed portent...

&
sticks
and stones break
bones but
names and faces can't
unless...
they too hurl them
selves at
'us'

o

hands
inscribe / hands
defile

hands
shake / clasp
smiles

&
meaning—

falls pixilated!
out off my
grandson's perfectly
shaped mouth

 beads of
 opulent nouns...
 beads of
 profligate verbs...

&
o!
the small
foot
lifteth
and
falleth

on the
very vertigo of

walking—
and talking a blue
streak—

o

child
of the pacific
littoral

you apparel
stars

o

if i hadn't beheld you with
my own brown eyes i wouldn't have
believed in your blue ones...

the scribe sighed—walking a thin
line between unredeemed dreams
and the fear of genetic engineering

how all-of-this came about was
without a syllibant doubt more than he
ever thought he could conjugate

❧

 paging aesopian
 parables...

what did the old tiger tell
the youngest-whiskers on the block
with 7 lives to live out?

keep your antenna up, kid—
attend to guardian angels with wit
be your own shit-detector

o

what did the tiger cub tell
old tom cat with at least 3 lives
left to measure a veldt with?

i know you love my purr and
my bold stripes but Look! i already
got 2 more teeth than you do

&
kai:

the summer sky has
the color of your surmise. mine
the color of the earth:

we'll both re-learn—
as if *it* were our heart's context

 beads of
 opulent nouns...

 beads of
 profligate verbs...

&
meanwhile
2 spiffy tigers
one older than a scold
the other bolder
than punning prowl—
the dune-colored carpet

growling—for
their afternoon cat-nip

&
an unprinted Obit from
the files of the vancouver sun:

at exactly 12.38 am on May 18th
a much beloved Pear Tree was toppled by
repeated gusts of alacritous wind...
its once splendid crown splintered
and impaled upon a hitherto unvisited
lawn. we all stood at our bedroom
windows in our assorted nightgowns Awed!
to see its shattered trunk and a—
hitherto unperceived hole in the sky!
let all the birds without perch or
umbrella tell you about its unquiet feasts.
'pied pear / i love you / pith / stem /
seed / —un voiced / Sun...' the
poet cried: something in him had to die
that night to release the stars .

ॐ
kai: that 'once' splendid
pear tree you slept your 1st summer
under has left its Inscription
on your grand-pa's own gnarled trunk.
that shining stump i showed you
marks the place where i'll plant an-
other tree perhaps a cherry tree
to scent all of your unborn springs.
kai: your great-grand-father who
died before you were pledged planted
a willow sapling one sunday after
the world war that soared above our
roof-top by the time i left home
for good. kai: let's you and i go stand
under the towering maple out front
til the new tree is as tall as us

ॐ
tiger!
in a space
missive!

tiger!
in a cloak
closet!

tiger!
of appalling epi-
phanies!

is there
an uncontaminated
heaven

left—
for the 'likes'
of us...

ॐ
in 'these' my end-
of-May Felicitations i
surmise my 1st Cry—
if not my penultimate
Chortle...how tell
the simple beatitudes of
being a 'twice-born'
tiger in the year of the
chinese hare?

252

&
who
knows if
the
Moon approves
of its
image since
we be-
smircht
it

&
watch
our grin / catch
our leer

hear *our*
startled Outcry—
kai

your
mouth encircles
world /s

&
the great learning:

grinding the corn in the head's
own mortar to fit for use)

takes root in clarifying the way
intelligence increases
through the process of looking—
straight into one's own heart
and acting forthrightly on
the results . 'it' is surely rooted
in watching with affection
the divers ways people grow .

 confucius
 via ezra pound

&
may
all the children in
the universe
born on the 1st of june
take a bow—
 signed
 the cat's meow

.

mother 91
me 61
mariko 31
kai 1

.

composed and printed at 648-keefer st. vancouver b.c.
with special thanks to rachel greenaway for the hand-
some cover. e.e. cummings william blake and confucius via
ezra pound for borrowings and ingrid klassen for company
and carefulcollating may 1st thru 30th 1987.

Three Nippon Weathervanes

K u m o / C l o u d / s

i have never looked up—
to behold a cloud that said, hey!
do i remind you of that
peerlesscloud etched on the glass
of the observation deck?

no 2 syllables hiss alike
in their aleatory divertimentos
no 2 clouds quilted alike
in their multifarious libation/s

it'll always take 2 to tango i tell
myself—dancing on a cloud
with Ginger Rogers—it'll always
take 2 to cast a bronze spell

&

cloud/s of
laser probity

cloud/s of
acidic fallout

cloud/s of
carcinogenbirds

cloud of a
lover's ear lobe

a cloud of
fistula Omen/s

uncanny...
unaggrieved...
unplumed...

&

... O i wouldn't speak of any part of your faire anatomy
as being especially cloud-like, unless i allow myself a
euphemism or two, for the sake of baiting your petulant
breath. Come to think of it, your breath, as i remember
encountering it, was as often as not a porous cloud: i
mean that the globules-of-air you ensnared and secreted
had a way of squeezing mine in mid-air and letting all
the hot air out. O Mistress of my Distresses! Midas of
my carnal taunts! i wouldn't think of speaking your
body let alone name its amplitudes and amphibian folds
without naming the corresponding parts of my own
body's hard-won alacrity. To wit: tummies tits elbows
kneecaps fingers and toes plus several orifices are com-
mon to both of us but what both delights and unhinges
me is unbeholden to diplomacy. O swallow cloud! Let
me pluck my lute at her walk-up apartment window
before i go off to the Holy Wars for her good Lord and
my hard task-master.

for Paul Blackburn
now among his favorite tin-pan
alley troubadour/s

256

&

ah!
midnight's
petite
whitepillow
cloud
rocking

all night
between
my thighs

the grass
widow who lifted
her big tits
up to the moon and sat
with aplomb
on my startled
cock

and i
played deaf and dumb

when i wake
i'm sucking my thumb

&

the
severed
umbil-
icus of
shy
syllables

the hoot of
tatterdemalion
consonants

this
aqua/
brine to
lave
stitched
lid/s

lip-synch
drench

the
chittering
wind's
lapidarian
swoop

&
impenetrably
dense (nonsensical) granitecloud:
lifted entire out of a black bowler hat
by none other than Rene Magritte the
avid pundit of the imprudent Surrealist/s.
see how deftly he plucks an eagle out
of the mountain's precipitous shoulders...
and daubs a ruff of whiteclouds round
its majestic neck!
 signed Rene Levesque

&
ah! yesterday's humblepiecloud unleasht
my doppleganger's signature—

and
scoured
the
portals
of a
once
sagacious
lower-
case
homo-faber

ah!
yesterday's
cloud of
unknowing

&
cloaking
the Confluences
under the
tall palms along
the banks
of the windless
Nile

cloaking
the Ikon/s of a vast
lunar desert
presided over by the mute
stone sphinx

oasis
o mirage/ migraine
mirror

this
phantasmalcloud
embalms
a mad pharaoh's
unimpeach
able
 grimace

these nihil
crocodiles shed
all the un-
appeasable 'sand'
similitude/s...

this almsless sunday
wind in the land
of the burning dune
unwinds a caustic
spasm

&
tomorrow's
borrowedcloud is
the wind's
spendthriftchild

thief
of serpent
sleep
indiscretion's
upkeep

the
futuristic
tout

count sheep
dream a chalice full
of light/ sleep
without a flotation
system
dream outloud

೫

in the Golden Tribunal to
our everlasting "future without travail"
all the lofted rhetoric of
anonclouds reign over the seething rivers
of the penitential flood...

Babylon took forked-tongue
and trident tail with it into oblivion

೫

you
crazyquilt
cloud

i wear like
a sieve
instead of a
shroud
i'm
your
taciturn
groom
your
immaculate
bride

sweeping
up the
alacritous
hive

೫

i filled 3 notebooks full of
an oftimes indecipherable 'romaji' alternating
with pages of cluttered 'inglish'

all summer long i caught myself sifting long agog
syllables—as if i were beholden to
their 'topos' if not their oftimes libellous wit:

all the things i held in my hands—
that were once 'rotund' in either tongue
dissolved into oceanic silences...

&

these words hatch their own syllibant cloud/s
'grief' they murmur is a hiss of the utmost brevity
among crustacean/s "i" mean i heard nothing
cry out of the burrows of the living coral... where
i've been the very body's forensic bodings sing
a porpoise's siren song

 dreadnoughts anchored
 in the san juan straight-jacket
 my sere syntax...

 terra firma
 terra incognito

&

yesterday's
childhoodcloud
capping the
awed-summit and
variegated
slopes of Scotch
man's hill...

laps up my
feral presentiment/s

cloud

kono ko mai	Kono Komai	このこまい
kumo	Kumo	くも
wa natsu kashii	wa natsu kashii	は　なつかしい
to omo	to	と思う
kumo	Kumo o mē	（くも）

ki noono o ki　　Kinō no ōkii　　きのう　の　大きい
ku mo　　　　　　Kumo　　　　　くも
wa zu i bun　　　wa zuibun　　　は　ずいぶん
o so ra shi kata　　osoroshikatta　　怖しかった

clouds　　　clouds　　（クラウド）

asu no ku mo　　asu no kumo　　あすのくも
wa do chi kara　wa docchikara (dokokara)　は　どっちから
ton dei kuru　　ton de kurun　　飛んで来るん
da ro　　　　　darō　(TO OMOU)　だろう

ku mo　　　　Kumo　　　　（くも）

shi kata ni　　shikatanai　　しかたがない
kum o wa kaze no ko　Kumo wa KAZE no KO　くもは風の子
ma ku ra no　makura no　　枕の
do ru bo　　dorobō　　　どろぼー

clou/ds　　clouds　　（クラウド）

e ma no kumo　Imano kumo　　いまのくも
wa nun ben shi bo tachii　wa nun ben shibotachii　は　なんべん絞ったっち
asu no umei　asu no ume　　あすの夢
ni wa oitsu kun　niwa oitsukan　　には追っかん

kumo　　Kumo　　（くも）

ko rei wa　　KORE WA　　これは
kan shin no kagami　"Kanshin" no Kagami　"かんしん" の 鏡
ko rei wa　　KO RE WA　　これは
ka gami　　KAGAMI　　かがみ

No cloud　　no cloud　　（のくも）

櫓井 清岡
増谷 松樹
昭和六十年五月二十八日
1985　MAY　28th　Vancouver

kumo

i
think –

this

small
cloud
is

love-
ly

kumo

yesterday's
beggar-cloud an un-
diminished

n-i-g-h-t-m-a-r-e –

kumo

no
telling
which
way
tomorrow's
cloud
will
blow

us

kumo

too bad but
cloud is the wind's child

burglar of sleep
pillow

kumo

no matter –
how often i wring this out

tomorrow's
dream lies – unfettered

kumo

this
mirror's
sheen:
its
perfect
cloud

awakens

(translated into english
the night after Matsuka-san & i

translated my roma-ji in-
to plausible japanese & sang it)

May 29th, 1985

for Kumo's Cast

ॐ
no matter
how often i wring
it out its
dream lies beyond
i's orison

afterword:

1st notated
in 'romaji' & adapted
by Matsuki-san
into a corresponding
'nihongo' then
into my kind of 'inglish'
and sung to a harp
accompaniment—
as an introduction to
'kumo'/'clouds'
a 16mm film about the
A-Bomb & its
aftermath by Scott Haynes
and Fumiko Kiyooka.
Premiered at
The Firehall Theatre
June 2nd '85.

further
improvizations with
Isamu Akino
and family under the
banyan trees
on Kohama Island
Okinawa '86

Toksuka Topiaries

summer-time layabout

naked i lie in the green glade
of summer too lazy to
wave my white feather fan too aggrieved
to want an insolent tan i hang
my hat on a snag-tooth and
bare my head to the wind blowing through
the pine branch eaves

> ... if this isn't bliss
> it's got to be the sigh-of-death
> all senses, alerted

re-shaped
from memory after Li Po)

&

helio-copter—
brushing the tree-top Esplanade

the 'tambo' you tend—
i sit facing the burgeoning hill-top garden
with the about to be fired kiln—
the heaps of cord wood behind my back the whole sky
about to swallow up my stammer—
while hiro bends over his work table trimming
the spout of another tea-pot—
mayumi under a wide straw brim bends to weed
another ah! newly-seeded plot

a venue of hot summer days
overlooking the runnelled 'yama' roads
waylays harbinger-breath . o pray
if you have a need to—for unfouled skies—
clay / thumb / tambo vision/s

ॐ

 all the cloud-eaters and all
the salutory grateful-dead clasp waxen hands
 circle-within-circle-a-whirl of
bright kimonas and flying shirt tails around
 the tall / drum / tower o see how
they all clap their hands and stamp their feet
 to the throbbing taiko-beat tolling
their mid-summer night *Bewitchments* all
 the festooned pater-familias tables
under the linden trees all the fly-by-night
 dipsy-doodle fast-noodles nickleodeon
vendor/s all the unmitigated bystanders all
 able bodies without exception tallied
by the old curmudgeon gate-keeper with his end-
 less lists of our earthly trespasses...
dead or *alive*! o see how all all the
 cloud-eating "grateful-dead" and all the
shit-eating "avidly-alive" fall—into
 a flaming Heap a round the skirt of
the tall drum tower on O b o n D a y !

 o the old Soul-Catcher with her
 invisible net—
 cavorting among the guileless
 reveller/s

ॐ

mayumi:
 ... i remember you asking me when i arrived
on your door-step from kochi city if i had by chance
come upon "harimayabashi" and did i know its
famous folksong. i of course don't recall what i may
have said but i was surely both deaf and dumb
'cause all the bridges i came upon and often walked
across didn't have 'names' i could read let alone
write down. it was only after i got home i
discovered its piquant-song on a cassette tape i
bought to delight my old mother's ears: she of
course knew both bridge and song, intimately. now
—given who i be and what i'm mostly about and
given who you be and what you hiro and rae are all
about in faraway totsuka... i'm sending you a
sprightly tin flute instead of the fabled hair pin of
the harimayabashi legend.

266

there are impoverisht bridges
in totsuka that want to claim your ardent
foot-steps... walk them if you
have the mind and time to do so with our
love. o my *ouma*, with much
affection from *junshin*'s 'hungry-ghost'

 may "ashitaba" thrive

ॐ
hiro:
 in their daily usage—
your oblong tea pot and thick-walled
lump of a bowl are with me to
scold if i don't attend to the dance
of the particular things to hand:
even this gist-of-words has had to locate
the center of their own comeliness...

 all my potter friends measure
the shapeliness of the thing they've turned
by the 'emptiness' it contains... i
would measure the duration of my sentences
by the silent intervals... it exudes

 that last evening we got stoned to
make music, together—
 goes on making sense

ॐ
hey rae:
 any one of these days
you'll get a catch-in-your-throat
and an 'inglish' word will come
tumblin' out and all the things it
'once upon a time' meant—will
surely tickle your funny-bone—
 and riddle your pliant 'nihongo'

 mine will have to lie dormant
til i'm with the 3 of you, soon

ॐ
tane dear
how small breathing
you do...

 seed to seed
 let me lie beside you
let earth-worm runnels rune
our burdened trove

 (when the light merges
 into shade...
 (when the shadows meld
 into dawn...

i sprout green wings
chlorophyll brims my throat

 o bloom! when you will
 but do so beside me—
 together we'll scent a
 summer morning and
 ascend into nectar-air

ॐ
dear tane
i'm about to sprout—how about you?

... that late-night drive along
winding back-streets—to the reaches of the
'other' pacific pounding the pitted
rampart/s of the littered holiday beaches
of sleepy "kamakura"... riddles my coral ears
all the plummeting black-waves
spuming around your ankles—your drencht
to-the-skin Whoops and Cries while
i hunker down my back to the bleak sea wall—
listening to the grating pcbblc-voices...
and to simply spin this paean over
to your side of all these mountains and all this
formidable brine—that windows down
stuck-to-each-other insouciant drive back to
your walk-up flat in 'bed city' totsuka

'that' o it's too hot to sleep midnight plunge
plumes 'these' frost-bite world/s

anyday now—
the kiwi on its entwined vine
overlooking your back-
stoop will ripen into green
succulence…

i thought, thinking of
'another' summer in the middle
of another sodden july

&
woke-up at dawn—
sat bolt upright with my
eyes wide open
but—the Dream persisted
from—a bower of
purple hoar-frost shadows
"imperturbable"—
he thought—thinking of
R.C.'s 3 old women
up in a tree and 'other'
litanies coming in
through 'other'
 window/s

 touch
 mind's enplacements

 sweep-up
 the littered floor

Kohama Skies

on my back on the warm sand
my gimlet-eyes gleam epic light-years...
laughter welling-up inside my
coral ears abides the lapping tide... the
crackling tako fire igniting our
strangers-in-paradise Consanguinities—

shooting stars & satellites falling
thru an endless sky-chasm...

 the myriad-names of
CELESTIAL CREATURES cited by
anon-astral navigator/s:
this swarming lustrum the star's
own polis. "i's" teleo-kin

 my "billy goat" grazing an alpine meadow
has a shiner on his pewter horns and cloven toes
his bushido eyebrows hide an intrepid cornea
all the legends of his unfleeced gold his habitual
 butts inscribed in a scintillant vernacular

 oji-san!
 oji-san!

 where are you hiding!
 we can't spy you

 "agnes" the radiant maid of the milky way
alters the ratios between soi-distant constellations
everytime she dips her star-filled pitcher. ask
agnes what comprises the protein elements of a starry-
eyed paramour. ask agnes who isn't laved by a
billion streaming udders... redoubtable agnes

oji-san!
oji-san!

where are you!
the tako's
sizzling! & the
sake's hot!

 "max" the consummate master of the whirling
target wears a pair of dazzling star nebulae on the slopes
of his himalayan shoulders. the stars cinching his
spangled cummerbund are a billion times brighter than our
earthling sun. it'll take max a lot longer than i can
bear to think about—to unsheath a sapphire-tipped arrow
and drawing a bead on a galactic outlaw bring the
bastard down. max the heavenly gods' centurion: his starry
visage the night sky's cenotaph to the fallen archers...

oji-san!
oji-san!

show us your hiding place!
holler out!

"giant backhoe" hoisting buckets bigger than saskatchewan full
of galactic tailings to plug up the latest black hole. if i ever get my teeth into
that sky mole's tail i'll cleave it into such tiny bits you
could hide it under a thin dime. —i'll pare its nasty toe nails down to their
original stumps. g.b. roared, lifting its enormous fist. meanwhile
the "kinky kid" alias "little dipthong" scoopt molten meteors into celestial
pin holes—to fire up the "world's oldest light-show" for
a command performance by dolly parton at the hollywood bowl.

... & when i heard
their creaturely-voices echo
"Ojisan" "Ojisan"
across the shadowed sand &
turned towards their
scuttling-movements... my
voice un-ravelled
light-years to ignite a WHOOP!
in their anima ears

terra
firma

———

terra
incognito

netted inside
the fulsome universe "i"
an "anon navigator"
invent the names of stars
and measure my
place in the furling universe
by their position
in the burning
 firmament

 wrought
 inside
 a sidereal
 hearth:

 moon's
 wash basin
 earth-
 ling mirth
 star of
 wonder/ star
 of light
 pagany's

 heavenly
 delight

grilled tako & fish on
splintered sticks/ bowls
of solstice laughter/
cups of scalding sake &
midnight galaxies/
leaping shadows around
the blazing fire/ the
shadowed sea stretching
off into its own
immensity/ our unseen "i"
perforating heaven:

 stars' own wash basin
 skies' star/fish pool

&

a small "i" wants to sing but
will it be in 'inglish' or shitamichi 'kochi-ben'

ah hibiscus the hue of my 'lumo'
felt tip pen i'm nothing if not your green stem
when i chose you to adorn the kitchen
maid's plaited black hair you made her blush and
tilt her cup of tea on my startled lap
these palm-size black butterflies pollinating
the hibiscus thicket quickens pulse

> this coral ledge called 'kohama'
> the brilliant red hibiscus in her black hair
> this morning tea beside the sea:
> all burnisht by the providential sunne!

&

Natsu no Umi no Matsuri

It was after all the weekend divers had left for the coral diving grounds and
all the dishes had been washed that Kaiko the proprietress came up to me
with a cup of tea to invite me on a family picnic. So Toshiyake the husband,
Kaiko the dutiful wife, their two sons plus a burly Okinawan boatman and i
set out on the coral sea in a swift boat provisioned with a bouquet of
flowers two bags full of fruits & vegies plus a food hamper and a cooler full
of sake beer and soda pop. ah! the jade green coral sea and all the fin and
gill inhabitants beneath our swift boat's wake and high over our tousled
heads the blue okinawan sky—as the "isle of the gods" a mere dot
momentarily appears on our portside heading through the coralless corridor
towards the open pacific. Now we're passing through the wide strait
between giant Iriomote & tiny Kohama with the "isle of wild horses" a mere
nod on our starboard side and as a core of other islands dot the horizon our
burly boatman navigates the swift boat parallel to Iriomote's verdant slopes
while the blue Pacific laps the westerly horizon. A couple of hours out—we
idle into a crescent-shaped cove wreathed in bracken & seaweed. moments
after our burly boatman tosses the three-pronged anchor overboard... we
hear the trill of Iriomote's jungle birds and all the plopping fish all around
us. Looking down we saw the startled fish darting in and out of the coral
labyrinth. Beyond the coral-shaped cove the Pacific lay like an immense
sheet of translucent glass.

Pausing long enough to enable the becalmed Pacific to instill itself in us
Toshiyake began the solstice rites. He began by tossing the fruit vegies and
flowers one by one overboard as Kaiko passed them to him. Then he opened
the sake bottles and poured their contents overboard—saying that the great
sea has a big thirst to quench. Whereupon Kaiko torched the incense and

passed it to Toshiyake who held the pungent slab aloft before tossing it into the great sea's maw.

Then the six of us lined up on the starboard side and clapping our hands three times we bowed our heads for the great Sea's plenitude. And because it was such a becalmed afternoon every earthly thing given to the sea formed a brine flotilla drifting sea-ward for our i's delight as we ate our obentos and quencht our own small thirst. Homeward bound—the curved flanks of a pod of porpoises loop our eyes while scuba divers in their fish-like regalia lounge on passing cruisers. All the mid-summer Hullabaloo... "i" an honored guest in the House of Higa inscribe this Solstice Rite on your pallid eyelids.

The House of Higa has had a blind child since i was last here. Now she's two years old and her proud parents' privilege and private sorrow... down the wide swoop of white sand the waves lave i heard a dulcet outcry as i came up over the rise but it was only the shadowless wind inscribing a brine hieroglyph upon a foam scroll—or so i thot til i heard that cry again—and looking up towards the wind-break trees i beheld the blind child's trill of flight as her mother held her aloft like a fledgling bird—before letting the awed-child swoop down to the nest between her ample breasts. I swear it was the becalmed sea burnisht by the infidel sun that honed an aleatory-chamber for her trill of flight. I wish i knew the name of the daytime star that shone for her eyes alone. It'll take a lot more illumination than i can bear to think about before all these cloud-syllables brush a 'haiku' across her translucent eyelids. "star of wonder... star of light... whose eyes will you shine through, tonight... "

down the long swoop of white sand high above the reaches of
the solstice tide—i came upon a marmalade cat napping in
the shade of a heap of sun-bleacht debris. or so it seemed til i
looked more intently into that burning shade and was taken
aback by all the uncanny maggots that had already emptied-out
an eye socket and were boring under its harried fur. days later
when i peered into the heapt debris—there was nothing left of
a once proud marmalade cat but wisps of orange hair and bits
of undigested bone lying in a shallow bowl. as for all the fervent
maggots they didn't leave a trace of their bloated whereabouts.
what Kohama's sun hallows belongs to a marmalade cat's nine
lives as well as the swarming maggots' magisterial appetite.
these astonishments suck up the ocean's amatory divertimento...
 love its foam cuff

—sighting down the carapace of my own rib-cage
"i" behold a furrowed mollusc floating in a pool of sea
weed & pubic hair. o procreation's limpid jester!

274

it was upon this very beach this warm pool full of algae
i lay long ago in an incomparable heat with Donna
la belle Donna: 'we' were to all intents & purposes Adam
and Eve but if the truth be told la belle Donna was
in another room: it was her ebullient-laughter ringing
down the long corridor of an apartment in monreale
that posited an LSD coupling. and it was on this sun-laved/
moon-stroked beach that the 'mermaid' he was wedded
 o brine-born thing.

⅋
t o u c h e ! for Li Po:

who purportedly drowned—reaching out to embrace
the full moon's reflection

... it was the day after a bunch of renegades broke
into your mountain hermitage and made off with the last
of your rice and plum wine—i swept up to your front
stoop at the foot of Cloud Mountain. What a mess! i
tidied up as best i could. all night long i listened for your
foot-fall... a lone wolf howled through the falling
snow but i slept well. forgive me for trashing your straw
hat but it looked so delectable hanging on the wall
i couldn't help myself. let's just say that your pal the old
'blue mule' fell by on his way to Lao Tse's hideaway.
... laughter ain't anything but Heaven's unpluckt fruit Ha!

 unsung aplomb on the evening ferry

 ah! this
 smooth speckled
 pincered-critter's abandoned
 dome boat—afloat
 on the shoals of a pocketful
 of silver coins

 my encapsulated sun
 my finger's labia

o it's a long long time from spring until autumn and
all the unaggrieved moments that filled my votive-summer
dwindle down and almost sedately it's a wheelbarrow
full of frost-bite leaves and high overhead the clarion call
of canada geese. now i'm ambling past the clapboard
houses fronting Hawks—the huge MAPLE LEAF on the Expo
site unfurling over my shoulder crossing Prior past all

the empty softball bleachers the puddled base-lines towards
the tall maple trees with their mounds of scarlet leaves
and as i lean upon a maple to scuff the mud off my runners
and catch my breath... i hear a barking dog and its master
from the direction of the empty bleachers... but when i
look up towards them another dog and its master ran across
my autumnal vision/s

 unequivocably
 all the unnamed appalling thing/s
 scented his intransigence
 & named their Gift... o rehearse
 the peregrine soul's
 midnight nuptia

 partly to assuage the pain of
 your leave-taking trudi rhoda and i
 have begun to play 'our' music
 again and wanting to ring in all the
 changes descant a no-name raga
 to re-kindle the thrall
 it held for you

 sleep howard sleep
 let your doom-felled hassidic blues
 rock our bardo boat

October's Piebald Skies & Other Lacunae

subtle,
as a breathing
compost...

october tolls
the dank
hibernaculum

&
is this Indian Summer's promissory
note to that old scapegoat, 'body'... does this
flask of heat anneal the long downward
spiral into the forebodings of our winter estate...

&
o little bird! chirpin' on a telephone line

grant me this bounty of plain thoughts —
the whole unsung realm of the common noun
and all its agglutinated peregrination/s

as i live and breathe my breath is beholden
to our uncommonly commendable origins. o
little bird! i meant to be as brief as you

but your chirp posits a syntactical hullabaloo

&
this comma preening itself
in mid-air conjugates its own vernacular

bp gone
and left an unfettered
alphabet

birds
molt and die
the sky
presides
over their clay
effigies

bp gone
and left an open-ended
discourse

this verb
prostrating itself
in verse
praises the realm
of mirth

&

an old man sits minding his perfervid p's and q's. he is nothing if
not a simple-minded poet practising a bread and butter journalism:
his specialty insofar as special 'isms' gripped him had a lot to do
with the activist's sense of "vigilance at the ramparts of ideology."
as for his own heart's circumlocutions: of all the distraught buried in
the pages of the Book-of-Desire, he knew virtually nothing, nothing
but the grasp etymology had on him: thus claspt all the clandestine-
syllables lifted him up by the seat of his pants into the realm of
their wakeful morning estate and sat the alphabet upright on his head.

&

ghosts of manic...
ghosts of alacritous visage...
ghostly pronouns...

want to topple over into song
instead, i catch them veering headlong into oblivion

runic hosts...
runnelled epidermus...
rime's footfall...

haunt their drenched pedigree
my bitten-summer lies in october's rain trough

&

with concentration he could posit their residual-presences
but he couldn't for the life in him recall their once palpable scent.
all of his disinterred heartless stratagems had lead to this,
this abject, nuptial vanquishment. to wit: all that was vestal if not bestial in
him got embedded in his uncouth vernacular. toucht
at last with a dollop of grace each syllable issued out of its own pungency.
Hurrah! he said, thinking of other untidy nostrums.

&

"i" under my breath said
"my what a prodigious downpour —

278

not a single bird in sight"
to which, syntax chortled,
"what a mouthful of nonsense — they're
under the eaves of noah's ark"

&

3 whole days of rain and a tonic gust later — there's a
fingernail moon trembling in my parched larynx:
there's a vixen, half-woman / half-beast reaching out
to clasp its silver horn. it isn't just the dead in
us who are forlorn — a madman's ravings are no less
pronounced when the full moon wanes and all the
uncanny things withdraw into the shadow of their un-
bespoke visages. beneath a cowl of scarlet leaves
my crocuses dream of Spring and all that thaw

&

... as my fingers tap the keys
to a hostage-of-laughter and a pinch-of-swart
some dude i know by hearsay is plunkin'
out "tea for two and two for tea" and other golden
oldies. old bowler hat fats waller — be
my fleet-fingered midnight marauder! tease
these friable nouns into an impudent blues —
wherein all the woebegone syllables taunt that
old gigalo, mista death... before they too
succumb to his godawful blandishment/s

a bird in the throat of the old year dragon
for nobby kubota

&

sometimes words ignore judicial entreaties
other times they pounce, unannounced —

bereft-of-meaning, they conjugate hapless verbs
imagine a lexicon full of idiot-babble...

gaps in time, whole continents could topple into
imagine an ebullient epistemology a whole

hierophant of auric-colors surrounding each body
imagine a polis without its nature-morte...

&

if the propensity of language is a veering towards 'fiction'
it's surely a slither down the trough of translation —

"i" suspect i'm a sheer product of all such linguistic-
transaction/s: an intransitive noun at best i translate myself

❧

Somewhere near to my hand an old man draws the blind back from his
street-level window. Pouring a cup of tea and lighting a player he pulls a
worn blanket up around his stooped shoulders and stares out onto the
October Morning street. Underneath the table his able-bodied dog lies
curledup against his ankles. Somewhere close to my hand the alexander st.
alley-cat saint with a brown bag full of dry cat food in one gloved hand
and a tin cup for water in the other hand is doling out the alley cats' daily
rations. Between cat-stops she pauses to look up at the blue sky and says,
lord, it would sure help if you would deign to serve up some rain. I miss
the burly old guy with his red toque and crackt smile who stood just
around the corner of the New World Grocery with his baleful shopping bag
of oddments. The last time i saw him he was looking up at all the starlings
in the topmost branches of the tall maples fronting powell st. with an ice
cream cone in his hand. I too paused to look up and lent an ear to their
ebullient chatter — while all around us the mid-morning traffic cancelled
out our "HUR RAHS!"

Nearer to my hand than any imaginable embrace there are sagacious old
men and women not to mention alley cats who are the past-masters of the
art of the pitiless silences and they've never had their pictures taken. All
these pigeons circling the waterfront from their vertiginous perch on top of
the tall grain elevator fronting the 2nd Narrows. These precisely arraigned
gulls on the soggy softball field. All all these unflinching "I's."

... nearer to my hand than any imagined clasp an old
man lifts his window to scatter crumbs on his lintel...

keen wind off georgia strait thrums an unalloyed october zeal

❧

laved by a wan winter sun
a lone gull stands aloof on top of margaret
moon's georgia street apartment
incomparably quiet... given
the proximity to hastings & prior together
with all the waterfront racket —

adding an unsound ping! to our parenthetical
silence/s...

&

autumn briefing/s:

in the pisst-up against entrance
to my powell st. studio — a swirl of crispen
leaves half obscuring a heap of shit.
"is this a sign of our acrimonious ekonomy?"
i ask myself — stooping to scoop it
up in a handful of leaves and depositing it in
the gutter between two trucks. then
i head upstairs to fetch a bucketful of water
to flush out my
 october exegesis

do the soi-distant stars really care 'who'
shits in anybody's doorway?

&

looking down on a perambulatory powell street

... i wish i could spell out how it truly felt to be 16 in '42.
i wish that spunky kid would talk a blue streak without
the intervention of 46 intrepid winters. i mean i wish that
spunky "yellow kid" welled-up in me utterly unsolicited.
But if the truth be known that kid died twice before he came
to manhood. The first time it happened his whole back got
crispt when his nightgown caught on fire as he & his brother
jostled for the warm place in front of the open gas flame
on a cold winter morning. The second time it happened when
the A Bomb got dropped on Hiroshima and Nagasaki. Hoping
against hope I'll hear his unabashed voice — i keep repeating
my own peevish biography: My grade 10 teacher fought with
the British at Vimy Ridge and taught us History as if "he" had
in deed, co-authored it. "I" never got to finish high school
and kept that fact from myself and others longer than i care to
recount. Don't ask me how it felt working night-shift on the
killing floor of the swift canadian plant during those thwart
war years. Don't ask him how it felt to be "finger-printed" &
registered as an "enemy alien." Ask if you can locate him, that
dumbfound "yellow kid."
 Ask his imperturbable mother.

&

 whereas: 'we' japanese-canadians who
are, to all intents and purposes, rather recent immigrants
have had our Grievances tabled, tallied, and in
no uncertain terms, dispatched: all the peoples comprising

the far-flung 'dene nations' keep having their
entitlement/s shoved under the bureaucratic red carpet
after the latest round of talk/s. — if History
can be said to 'mean' anything for the likes-of-us, it
must surely mean that 'those' who in every way
preceded us and thus possess a vivid sense of their original
entitlement/s have a claim upon those of us who
were, to all intents and purposes, so recently dispossessed:
or, it doesn't mean but — all the abrogations
of power — History keeps on sucking up to. according to
h.w. longfellow and his "transcendental companions" —
"hiawatha" was, to all intents and purposes, the very embodi-
ment of the "noble Savage" with unmined gold, not
to mention other trophies under his supple feet. etcetera.
i'm sick of 'ideologies' and 'genres'. perhaps
our next act-of-intransigence will consist in our taking
a stand beside them, for holy reparation's sake.
ask a norival morrisseau how fire water burned the angel
out of his throat, ask a noel wuttunee about epithets...

ও

what about their heartless immolation on reservations?
what about all their aboriginal entitlements?

what about all the gone indians in a computer megalopolis?
what about the unimpeachable "indian" in ourselves?

ও

I see the whole Pedagogy of the '80s as beset by our technological /
ekonomic / ideological befoulment/s ad nauseam. Hopefully, the wholesale
implantation of high-tech computers throughout the entire school system
won't supplant all the pre-Socratic verities achieved with a plumb-line and
an agile thumb. Pedagogy in the '80s has been largely persuaded to mid-
wife a secular / specular ideology — that will shaft itself on its own
enpowerment /s. All the technocrats shaping their paradigms under the
skyscraper's meagre shade. All the furbelows of the Free Trade Dialecticians
add little to diminish our plethora. Democracy's uplift denigrates the Third
World lying awake in all of us. Out of the 'agora' of Native Cultures — the
only meaningful dissent.

ও

... is it any wonder that the heart of "japtown" goes on being pisst and shat
upon. Is it any of our business as erstwhile Canadians that the unsigned
bottom-line belongs to all those we just brushed past with downcast eyes
waiting in the drizzle for their meagre sandwich. Those who unlike us have
very little to be dispossessed of: those to whom our "Redress" isn't even a
bread and butter issue. Is it any wonder when I think of the eko/logical

ravages wrought by our vociferous use of petro/chemicals I tend to think of our Redress as a token, political stratagem: like, let's get this "minority" off our backs so we can get on with the establishment's business. Is it to mend our own disaffected loyalties that we nikkei have had to undergo such abasements... i ask myself as i walk down the steep flight of stairs to alight on rainy Powell Street. Through the open door of the Japanese Deli sushi and sashimi fill a variety of bellies.

This October gutter swills with — it must be our own vagrant thirsts...

&

henceforth: We Japanese Canadians will go on being opened out by the vast multicultural, linguistic, gene-pool... til there's nothing left for "racism" to plunder because we will all have become the original colour of that "face" predicated on the myriad-coloured faces preceding each of us. Already my children, and now their children, bear the lineaments of other no less kindred physiognomies. "i" am despite these permutations and all the genetic-engineering going on in the laboratories, nothing if not my Kochi mother's beloved son. We always speak "kochi-ben" when we're together. Otherwise, we speak inglish in the white man's world. When it comes right down to the heart's own politics — we all speak in our mother tongue.

"the dream of justice achieved" is perhaps the end of one transgression and the beginnings of yet another no less tyrannical real-estate —
one in which our very colour and idiomatic speech will be oppressed by an utterly desacralized judiciary of multi-national ideologues. but,
i'll be damned if i'll let the word "shikataganai" fall from my lips again
i thought, thinking of all the hostages of other malevolences...

&

THE ALPHABET CLIMBS THE WALLS OF TIME
THE ALPHABET DECLINES TIME'S HALLOWED CORRIDORS

The 1st Wall was built out of air
The 2nd Wall was a buffer-zone from the merciless wind
The 3rd Wall was a mountain range
The 4th Wall was built of stone with crenellated turrets
The 5th Wall had labyrinthian passages:
Passages for the comings & goings of the living / dead
The 6th Wall enclosed a forbidden city
The 7th Wall forestalled the derelict heart's passage
The 8th Wall was inscribed with chaos
The 9th Wall toppled over with the death of ideology
The 10th is the un-climbed Tree of Fate

Walls that plunder midnight's roseate dreams
Walls that benumb our bestial hearts

Walls that startle us Walls that sleep us
Walls haunted by twigs mud timber uncut stone
Walls of Lascaux's birds beasts & hunters

The Alphabet climbs the distaff walls of timbrel-time
The Alphabet declines time's hallowed conjurations

Walls of perdurable eternity
Walls of our acrimonious estate

Walls of compacted mud
Walls of scorched mirth

Walls of abomination
Walls of putrefaction

Walls of unsurpassing black
Walls of blinding whiteness

Walls of unnamed abstentions
Walls of cauterized syntax

Walls of perfidious vernaculars
Walls of paradisiacal intent

Walls of our dumbfound abundance
Walls of our penurious estate

O can you hear Time's absconded Psalm —
ringing through the spend-thrift walls of your ardour?

The Alphabet climbs the Walls of Time
The Sunne scribbles a plangent song on my epidermus

In a Vision I was given under the tall fir tree in
Charmain's garden: The walls of the Holy City were built of
Bricks, each clay brick shaped and placed by hand.
Each brick bearing a fabled Signature. Let the Dead turn into
Mortar. Let the Living inscribe their Names on the
Pentecostal wall. In that fiery Vision I was given the walls
Of the Holy City were built on top of catacombs. Now
All you can trace of its earthen remains is the handiwork of
A forlorn God caressing an armful of syllibant stones.
Moan moan to your heart's content, the wind said, burnishing
A thicket full of broken bricks. In my sleeplessness
I've been haunted by a vision I'd been given under a fiery tree
In that unmitigated nightmare — all the clay bricks

284

We built the walls of our Holy City with turned in a tumultuous
Wind into a vast encampment of squatters' shacks.
And there layer by layer all the bricks bearing our signature/s
Re-enact a hazardous C o v e n a n t .

Text for Bart Uchida's "4 Notations" performed Sunday afternoon
July 31st 1988 at the Powell Street Festival

&

nothing
doubted/ nothing
gained
. . .
nothing
tallied/ nothing
blamed
. . .
remorse —
runs in pitiless
circuits
. . .
til nothing
parts us but a luminous
membrane
. . .
"what in heaven's name are you getting at?"

"o nothing —
to write home about nothing
i can name..."

&

october's
full-moon pledged
on top of
the maclean block,
englobes —
my petite kitchen
window

light of my nightlife:
illumine my
hubris

vincent van gogh and the bird of poetry

unbequeathed to
night's conjugal felicitations the white
heron divulges a perilous silver
bromide eucharist. in its solemn flight across
embossed white pages — inside
the least typographical trope it illumines
a mad artist's obituary
this altogether unintended 'flareup' of singed
white wings heralds the pent-up
soul's galactic betrothal
out of the bounds of sovereign sight his once
mutilated ear rejoices in its
haunting, windward outcry
at the very end of vincent's implacable fervour —
you alighted on an unruffled
midnight march — the world didn't end until
your incredible swoop lifted —
off the unread, pagination/s... the englobed light
inside the sleeping child's abdomen,
adored the white heron's magisterial flight.
unkempt vincent slept beyond —
the dream's recall

Longing is nothing if not a disembodied absence —
a concordance of all that's abysmal when i think of my
body as its own source of impoverishment: to wit,
I can't recall the last time I had a hug, let alone slept
with a woman — until la belle donna came up to me
after bp's wake and said, o hold me. hold me close. I did
and she, holding on, cried, I thought for the three of
us. some hugs keep holding onto — it must be our first
heartfelt embrace. to fall away from the realms of
mirth into an utter blackness is to hug a penitential loss.
"what thou lov'st well remains, the rest is dross"
the aged poet intoned as night fell all onto itself into an
october puddle. an old man minding his gone-awry
syntax journeys moonwards

&

... i never imagined such a lucent white

two
white toadstools
startle
the mourning
grass

an arc
of white jet trail
stencils
the october
sky

Omen/s
often come pair'd:
bp died
in the fall of '88
almost 44

&

 'i' see my own grimace in
both highlights and surrounding shade a faint
trace of one of my fugitive smiles —
creased their lucent lips. every 'face' i print up
looks clear through me — through its
own death-mask: every portrait a memento-mori

 'we' are the twin faces of
the bromide-beast stalking a ruined garden for the
utterly beclouded face, the one that
hasn't found its own reflection. every face i print
throws a pall across my own apparencies...
it's always solstice in the darkroom: imago-
images of, a gone-world, riddling, encaustic-light

&

let
firecrackers
frisk
the piebald
sky

freaks turn
into
flamboyant
saints

let
the unruly
dragon
whip
its scalar
tail
one more
time

mischief
inter-
rogate
numbskulls
let

a
pumpkin
gild
thy tallow
Fall

... i hear the preemptive hiss-of-dread:
the uneffaceable lineaments of old age mock my midnight mirth

&
i'm just a tattered scarecrow propt-up on crossed staves
my sex a shorn bundle of threshed straw. it's a good thing some
body with their wits about them stitched my floppy hat on
my straw hat on my straw head. otherwise, i'd be a heap of shit
an inhospitable swallow's nest. older men ought to mind
their tercets... and let the young women tend their perfumed
gardens. the hubris embedded on the guts of an erstwhile
'homily' is to all intents and purposes — a compliant lover's
epitaph. everything else belongs to — the long night's un-
fathomable exegesis

&
unharried... the old year sucks up the scold
while the new year standing on tip-toe blows it away
7 black specks percht on the topmost wire —

toby maclennan singing an aria composed of stars seen
through a musical stave held up to the night sky. o solo meo!

now there's 9 black specks in 2 discrete series
informing the bottom wire — call 'em 'twittering commas'
a slant-cadence nipt with frost punctilious, dots

&
the small
insistent rain spooked my front door — &
all the would-be halloween
reveller/s stayed in-doors watching a sit-com as
a few plaintive firecrackers fizzled
in the ongoing drizzle i put the candies back in the jar
peel an apple and — under my breath pray
that next october's alacritous faces will repeal
the weatherman's retort
let
baited-breath
reign

&
unharried...
the old year sucks up the scold
while the new year standing on tip-toe blows it out
7 black specks on the topmost wire —
toby maclennan singing an aria
composed of stars seen through a musical stave held
up to the night sky o solo mio!
now there's 9 black specks in 2 discrete series
informing the bottom wire — call 'em
twittering-commas, a slant cadence nipt with frost
punctilious, black dot/s

&
o little sparrow bird, beyond probate
will you tap on my window pane —
when it's time to bear, brutus winter

&

parchment epiphanies

yuki
and koto
raga —

each
crystal
flake

each
scintillant
mote

loops
of pellucid
white

verb/s
mantling
gorgon

throat

*written & printed
at 648 - keefer street, vancouver bc
in an edition of 40 of which
no two are alike: to commemorate our
redress & the memory of
bpNichol. september/october '88*

A February Postscript: to October's Piebald Skies & Other Lacunae

... i suppose you've heard i'll be goin' into surgery soon, bp said, under the sun-dappled september trees in front of the old coach house. he had come by with his pear-shaped daughter sarah to use the old laser copy machine... well, books 7 & 8 have almost compiled themselves, ha! ha!, bp piped up. i notice the sheaf of papers along with the sturdy cane caught in the crook of his arm and wonder at his unflinching prodigality. some texts could be said to be voracious. others i'd call lambent but at the very least bp's *martyrology* is both. we parted, bp, sarah, & i, as casually as we had come together. the agile squirrels with their bushy black tails cavorted around our feet, for — it must be, their own stake in the scheme-of-things... there's an unbidden, metrical omen monitoring all my waking hours. t.s. eliot's *wasteland*, a bramble-patch laced with p.c.b. in the out-reaches of *the martyrology* — up, in the volatile air or under our sodden feet... the contagious environment pummels us

the *lin-gua fran-ca* belongs
first and foremost to the whole intricate kinship-
of-vowel/s (lodged) in a man's throat:
its exact notation on a piece of paper or in the air —
of which bp had a mastery — heralds
all the sobriety and siftings of an impassioned Speech
each uplifted-syllable a lodestone

omens
breviaries
salve
heart-balm

grief

— punctilious death laid claim to bp's
burdened body. barely 44: *the martyrology* to all
intents compiled, his big body caved in.
post-modern medicine with all its scientific knowhow
couldn't put bp back on his feet. 20 years
younger than me bp was from the beginning the
prodigious "kid brother" who almost single-handedly
lifted our common speech into the thrall
of incantation. let 'annaliviaplurabelle' whisper
a lullaby in your ransacked ear. sleep bp
sleep in the fallow antechambers of a plangent

martyrology

captain poetry beckons
each unaggrieved thing to enlist in
poetry's hall-of-fame

— the air surrounding
his lower-case signature bears the imprint of
a piebald saskatchewan sky

bruce chatwin's *Songlines* —

the australian aborigine's way of hailing all
the divers things whilst walking
bare-foot, across, a seemingly, bleak terrain:
sing each thing, come upon, string it
and it on — an un-ravelling line and let your
feet carry you to your destination. all
the cross+roads of a vast nomansland held up
to scrutiny and a measured pace.
"songlines" aptly designates the tracking/s

of one of our own kind of aborigine:
call 'em cartographers of the-spirit-world —
the wide-eyed, wundrous-world of bp's
homespun 'saints' — grace a vertiginous world

(read at a Gathering in honor of bp late fall, '88

&

bruce chatwin's
patagonian feet have re-traced
their step/s to
their primeval/nomadic haunt/s

history ravages us...
hug mirth kiss the holy ground

isamu noguchi —
turned into an un-hewn boulder
his last words:
pebbles in my parched-throat

history ravages us...
kiss the holy ground hug mirth

emperor hirohito
inaugurated the 'showa' dynasty
the year i'm born.
the queen and i are all one age

history ravages us...
hug mirth kiss the holy ground

(inscribed in snow with a stick
stones were used to mark asterisks dots and periods:
one false spring day in february, '89

&

ken, mike and i dined one night in early september. the talk over dinner had
been desultory at best but we all agreed that the greek food was first-rate.
we went back to mike's for a nightcap, thinking that our fitful conversation
might still renew itself. the cupboard was bare, we settled for a beer. ken
was, insofar as he spoke of it, still immersed in don delillo's brilliant
portrayal of all the intrigues of the kennedy era: how all the salient facts got
twinned with all that had to be made-up in the retort of one man's fictive-
imagination, gripped him. ken wondered why japanese/canadian writers
didn't seem to have a nose for fiction. he wondered why we couldn't, as it
were, transform our lives into the big story. i got the gut feeling that other
men's fictions, particularly american fiction, had long ago taken over and,
in its many guises, bestowed on him the mantle of a big-city, literary
journalist. — it was the long windin' narrative with lots of street-wise talk
that really held him: poetry, in its brevity, didn't grip him. we said virtually
nothing about the "redress" and, as always, even less about ourselves. we
were afterall, despite our common fall from grace, almost perfect strangers.
ken left me with the feeling that it was afterall — too little/too late: like the
rest of us ken had paid the price of an unwarranted humiliation, and under

that awful shade in the throes of the post-war years, he sat down and wrote a trenchant chapter of our silent despair. one thing seemed certain — neither of us could go on blaming the harrowing past for, it must be, our own ineptitudes. i had already been in the east too long for my own good. i had slept in strange yet familiar beds and often lulled myself to sleep by walking the crenulated foreshore of long beach in my bare feet... nearly everybody i met seemed, despite themselves, caught-up in a chemical fall-out. "welcome — to the inner circuits of Hell, incorporated..." was in retrospect a characteristic salutation, in toronto the good that summer.

&

when 'i' think of all the hands and mouths and all the feet, the metrically-inclined oftimes meritricious feet and all the palimpsests and oracular bones that have to all intents and purposes left their decalcomania impressed on these duplicitous words. when i think of all the augustinian confessions and all the riven stream-of-consciousness and all the parsimonious epithets, together with all the low-down backcountry speech positing an epicurean nomenclature. when i think of my small portion of the o.e.d. with its intricate proprieties and hierarchies and all the labyrinthine ways i'm inflected and thus inflect, all the fiction i've read. when i think of all the sahara deserts and all the amazonian forests and all the monstrous bull-dozers ransacking the face of mother earth and all the mad-cap 'characters' i turned unwittingly into for the sake of another man's narrative... it isn't too difficult for the likes of 'me' to believe that an otherwise exacting author could — under the pressures of copulating with a deadline — turn, without intending malice, into an unprepossessing, two-bit plagiarist. to wit, one who, with a prick of his pen, quarries another author's logos. some have been heard to say that it wouldn't have happened if he had listened to his doppleganger's silent approbations. others who know the heft of a memorable phrase and have themselves been tempted to appropriate it say — that a self-inflicted death was an exorbitant price to pay. etcetera.plagiarism/s are always waiting to leap into the gap inside a torn-syntax... if i might add a nonetheless salutary foot-note: — i'd begin by reaffirming an old platitude which says that the act-of-plagiarism is nothing if not an un(conscious Homage to the impeccable tropes of its original scribe. an awful lot of what writing incorporates into its own commotion/s flows in and out of all the anuses and mouths of once fallen-angels... what occurs and re-occurs within the confines of a clandestine-syntax acts inside the awful plethora of our post-modern volubility. 'who' in their right minds had the foresight to see that the real author of *the enemy that never was* had, like the rest of us, an invisible enemy in the pit of his abdomen. pity — all the small words he'll never rub together...

<p style="text-align:center">pity their lost glint.</p>

("shikataganai"
i caught myself saying 'cause no other
word came to mind...

&

 mantling green-shoots
a tumulous line of bruised automobiles
their lobotomized part/s
heapt-up; mounds, of bent chrome/ retread
condoms — the last pit-stop
all these snow-capt/ back-stoops/ the grove
of bowed-over bamboo all the
school children's gum-boot tracks skirting
the puddled alley. for the 100
th time i ask myself, "who the hell is Tom
Delvecchio... ?" all these —
will surely vanish with the same inexorable
ease as these words will... into
 a pelt of un-contaminated whiteness

 — this music without fortissimo
this uncompromising Psalm:

 — to winter's vicissitude/s

'who' wouldn't want to lie beneath
a burgeoning white mound, with all the petite
crocuses — to anoint another 'Spring' —
who wouldn't embrace such Gladness... sleep
ken, sleep with your ear pressed against
the mouth of the Language/Beast its white-noise
 an impeccable, anarchic-Mantra. sleep

 bequeathed

(the day it snowed all day long
and most of the night: the day it snowed
more than all the snows-of-winter

&

BELITTLED BY THE TURBULENCES OF AN OMNIVOROUS FICTION —
the harassed 'lyric' faulters in a world of genetic-engineering and multi-
national take-overs. an unremittingly, desacralized, human/bio/sphere
trembles within its transparent skin. australian aborigine painter/shaman
those with x-ray vision will tell you that all living creatures have that kind of
see-through-skin and that's why they're depicted with their entrails hanging
out. long before i said a single intelligible thing that could be quoted a
lullabye cradled a delinquent fear sequestered in the coil of my pillowed ear.
— i couldn't imagine 'anybody' in the world but mother and i. some of us
move from place to place in search of that person with whom we can
re-enact that first intimacy and as often as not never find her equivalent.

others more fortunate never seem to have misplaced that initial covenant.
— if i cup my ear i can almost hear my grandson murmuring at his mother's
breast. she is singing him to sleep with a lullabye she enbibed with her own
mother's milk: language begins with a suckling child. the first time i really
hollered my lungs out — i wanted 'her' and 'anybody' else within earshot
to know, how utterly bereft i felt penned-up in my crib without a tit to
suck. now that i know how her bitten-words came to crease my own
vernacular... the small voice, some would call 'pipsqueak', lifts itself up by
an act of incomparable lightness. let its 'etudes' season us with a pinch of
salt. let even a flawed lyric speak out, against all that seems, furiously-fated.
let a bountiful harvest of sea-weed apparel our naked genitalia. henceforth:
the Gods on high will have to save their own faces from our conceits and
indiscretion/s... un-diminished; the fine thread of an ancient lullabye weaves
its way through, my own small thronging/s

(salman rushdie 'reading' at the arts club, february 26th, '89

ॐ

read — un-read — barely-perused — long-dead
Letters legislate my waking hours and monitor my sleep
from their unquiet haunts: but, when i'm
apperceptively-inclined 'they' keep nothing not even
my own pallid prose hidden from me. it's
as if i couldn't commit a foul crime or give my time to
charity, let alone fall in love at 60 plus
without their filial approbations: sandwiched be-tween
all-of-them and little-me there's an unspoke
Compact — to wit, We-are-all-branches of "The Singing Tree"!
the very trill of all these starlings
perched on my outstretched limbs a sibling's foot-note —
to G-L-O-S-S-O-L-A-L-I-A the Gift-of-Tongues

written, copied, & collated at 648- keefer street, vancouver in an edition of 21
copies feb./march, '89 the snake's year

296

Pacific Windows

Like the rain-spattered pages of a Romance novel left behind on a holiday beach: All the photographs of windows and doors, all the lintels, ledges, unspoke captions, no longer belonged to him. He looked at each passing face with its own thatch, its half-shuttered windows and closely-guarded door; he had seen that facade impress itself on his own face and had turned away from it, his beard half-trimmed. Lately, he was appalled at how often a barely audible scream issued from an unknown throat. All that summer his own windows cast their attenuated shadow on his every footstep. His own throat often felt parchment dry. With nothing but the unillumined images of his own mind to abide, but too wrought up to sleep he opened the "Book of Books" and read a seraphic passage that told how all the tears shed in the name of an omniscient God — almost drowned the hitherto thirstless earth. Everywhere he walked that Fall pages out of his past spoke of inchoate presentiments. His mother turned ninety-four that summer. In former years she would sit and knit thick woolen slippers in an array of colors for members of the family

while she kept an eye on her favourite soap opera, but this year she did one or the other and as often as not nodded off with the unknit slipper on her lap. They spent long summer evenings together remembering distant 'names' and 'faces' and they recounted all the kindred and alien time-warps. Each summer she cited the names of those she knew who had recently passed away, and in her obits she would cite how each of them passed their presciences onto those who were alive and kicking: Her many great grandchildren not the least amongst them. Thus for a month each summer since the early seventies she flew over the mountains to be with him: And though it was never enough to simply sit and knit she would finish a vest for a son or a pair of slippers for a daughter, and when she felt like talking she invariably talked about all the family ties they had on both sides of the pacific, and though she never mentioned it, they both knew she was the last link to the sad and glad tidings of the floating world. When they had talked at length and had little but silences to add to the tally of their summer days they sat and watched television: One night it would be The Bill Cosby Show, another night Rashomon. And all through the summer her grandchildren and great grandchildren came and went: She would remark on how tall each had grown since she saw them last and how they looked more like one or the other parent, and even as she gave each of them a gift and talked to them in broken-english, she knew that even the smallest grandchild was too heavy to lift let alone take on her small lap, a once ample lap all her children had long ago curled up on. And every morning, just before he got up, he wondered if her eyes would gleam the bright morning sun and for the ten thousand times with faultless but frail gestures would dress herself before she slowly made her way downstairs, and just as she turned the corner and placed a tiny foot firmly on the livingroom floor, would say, "good morning," and the pleasure of it was in her voice. So they had breakfast together each morning and together got another day on its way. For many summers he didn't acknowledge to her how a mother and a son enacted the role of a peerless seer and a faithful acolyte, but now in her dwindling years it all came home to him with a dumbfound clarity. He took another long look at all the old photos they had perused together: Except for the minute accretion of dust laving every photo, all the stories surrounding their ambiences remained virtually intact. In the end it was the casually taken photos sandwiched between Pearl Harbour and Hiroshima that had a special poignancy for both of them, though they agreed that even *these* couldn't foretell what the post-war years had in store for them. Each summer they peeled away layers of dross and became more and more their essential selves; even their roles as a mother and son had a portent. To die if need be penurious but full-hearted was after all the very hallmark of a meiji samurai's beloved daughter: Thus, this past summer he had plainly seen and heard how all that had befallen her in a country too vast to imagine let alone put a name to had composted an indigenous pan-pacific midden. And each evening after she said "goodnight" and went upstairs to her small bed he would look in on her... if it hadn't been for her intermittent breathing, the sheer abandonment of her

sleeping posture would have daunted him. Some old people tell her they lie awake every night terrified that if they shut their eyes they will never wake up. Others like her close their eyes one night and die into their longest sleep. Take care of yourself I'll phone as soon as I'm safely home... in that moment before the tall stewardess took over and gently wheeled her through the check-point, his broken-syntax collapsed into the airport din. Peripatetic images haunt his waking hours: Hastings and Main Street Bodhisattvas, Mary's plum tree, her purple mums and tiger lilies, all the unflappable gulls on top of asphalt roofs high above the guerilla alley cats prowling the runnelled asphalt, all the flagrant back-alley garbage pickers, the fiercely-proud poor taunting him for a hand-out, all the sodden east-end bread lines and hand-me-down thrift stores, all the untethered dogs large and small taking their early morning promenade in the Sunday morning school yard, all the cruise ships flat-bed freighters rusty russian trawlers, all the yankee dreadnoughts at anchor off ballantyne pier, all the protean artists hatching their eko-logical visions in nooks and crannies, all the la chinoise aromas and smells, all the asian vernaculars, the bruised bodies of teen-age hookers with delicate tattoos on their winsome arms and legs, all the condom-strewn back alleys the turn-coat policies of our bread-and-butter erotic life, all the simulated glamour of our paltry urban desires, all the phases of the moon inflecting the oceanic tide, all the tumultuous brine inflecting 'the ten thousand things' that lie unbidden under the photographer's black cloth. While he was printing the photos he found himself leafing through, he habitually revisited the site of their initial disclosure. But now as each photo fell diffidently into its place in the narrative, their prefigurements disclosed the unspoken symbiosis between each thing and its facsimile: It all had something inexplicable to do with genuflections, replications and gross representation: Thus, each photo enacted the perdurable blessings of light. Now, with the first dappled leaf cutting capers on the Fall air and the last year of his idiosyncratic pedagogy already lofted he had a hunch that the gift of sight simply augmented all the ripe pears his once-upon-a-time 'pear tree' yielded each summer, without stint. And, because she had often spoken of her late husband, particularly their early years in Kanada after the first world war, he felt gladful that the last snap he had taken of him got included in Pacific Windows. Then, as each darkening page reassumed its silences the book fell out of his hands. Closing his eyes the first rain in weeks came through the open window and laved his eyelids.

"to see is to forget the name of the thing one sees":
to dream is to redeem its unspoke sacral meaning

Acknowledgements

The editorial work for *Pacific Windows* has benefited from the generous contribution of many people. I want to express my appreciation to the Estate of Roy Kiyooka, especially Kiyo Kiyooka and Fumiko Kiyooka, for their encouragement and for their hospitality when I needed to see material in the Roy Kiyooka Papers. Thanks to Katie Ohe and Harry Kiyooka for their recollections of RK during my visits to Calgary. The Japanese Canadian Redress Foundation assisted with a publication grant. In the early stage of my research, Mark Nakada shared with me his work on the index to the RK Papers and also provided helpful feedback on RK's poems. Linda Gilbert readily made available a typescript of the "Pacific Rim Letters," an indispensable resource for me, and David Bolduc gave his permission to reproduce his drawings for *Pear Tree Pomes*. I have had the privilege of consulting, from time to time, with George Bowering and Fred Wah, poets very familiar with RK's work over the years. In the final phase of editing, Irene Niechoda provided invaluable assistance in proofreading the manuscript. Finally, special thanks to Michael Barnholden for taking on the difficult job of layout and design, a process that took longer than anticipated and that required patience, creativity, and resourcefulness on his part. Throughout the editorial process, I also welcomed our discussions—often late into the night—of textual questions and the friendship that grew out of our mutual delight in RK's poetry.

And for Roy Kiyooka who taught me the astonishment of the syllable and whose tongue-tied vernacular hails a resonant inglish—

scattered
a gain

RM
October 31, 1997
Vancouver BC

AFTERWORD

Coruscations, Plangencies, and the Syllibant: After Words to Roy Kiyooka's *Pacific Windows*

Prefacing

"my inclinations tend towards the beatitudes of the mundane, the mutabilities"[1]

The prospect of carrying out the editorial work for this collected poems outside the collaborative potential envisioned with Roy Kiyooka has been daunting—haunted as it is by the disrupted process of dialogue and interchange. This editor's "confession," if it can be termed as such, is not meant to detract, or subtract, in any way from the crisis of responsibility in what lay ahead after the sudden and unexpected death of Roy Kiyooka early in January 1994, in his Keefer Street home in Vancouver's Chinatown. Roy was apparently at his computer working on what would have become this "collected poems," this *Pacific Windows*. Disentangling my own sorrow, as a friend, from the editorial task spawned a trepidation calling for the passage of time during which the decision to resume the "project" was made—with the resolve that Roy Kiyooka's poems needed to be published. I say this in the awareness that my editing has been inflected by the anxiousness of representing a poet whose work bears such indelible signs of an utter specificity. It was, nevertheless (these eyes), in the minutiae of the poems themselves—their remarkable accomplishments—that the editorial process became a gift of procedure.

Some history I hope can fill in the transition to this *Pacific Windows*, the title on the incomplete "computer version."[2] In spring 1993, during one of several conversations about his writing, I urged RK to put together his "collected poems," and he laughed at this seemingly outrageous concept. For most of a decade previous, he had decided to forgo what he considered the overly prolonged and often frustrating experience of seeing a book through the publication process of trade books. Drawing on a delight in the material details of artistically-designed texts, he produced limited edition chapbooks of his own poems. As he explains in a note, dated July 1, 1987: "since the early 80's i've ventured into self-publishing as a way of getting my words out under the logos of the 'blue mule' which is or was, the name of a photography gallery i had for a few years on powell street. the artist in me likes to attend to the whole appearance of a book as though it were an integral part of the process by which books come to be in the wide world. all these have been printed in editions of 26 plus 10 and have no further editions in mind. i write the passages of time i mind the starlings chattering on the telephone line i hold in mind an actual world of kinship/s and the books are meant to return to all those i've been touched by and would, in turn, touch. this is, needless to add, an ongoing enterprise" (RK Papers). Not all were printed in runs of "26 plus 10," but the principle of limited (under 50) held true. The texts were normally set on an IBM selectric typewriter, designed by Kiyooka, and printed in his Keefer Street home on a Canon copier. Kiyooka followed an earlier cut-and-paste method familiar to him from small press work during the 1960s and 1970s. It was only at the time of his death that he was beginning to be attracted to computer layout designs.

Speculation on the varied reasons why RK turned to self-produced chapbooks requires further research, but at a more straightforward level it would appear the move coincided with a strategic localization of his writing/artistic stance—the desire to be attentive to the mundane particulars of daily life and the simultaneous rejection of the commodification of books subject to market ideology. Underlining this positioning was the realization that his own poems—despite the recognition given to *Pear Tree Pomes* in being nominated (but not chosen) for the Governor General's Award for Poetry—would not receive serious critical attention outside a small sphere of readers. The thought of a "collected poems" from a mainstream literary publisher seemed an impossibility. No one had even sought a "selected poems." And besides, how could he handle the conundrum of re-reading all the poems? It seemed an apparently overwhelming task for RK, a writer whose practice of revision inevitably became a re/vision in which a new text was produced. Simply preparing the "collected" could easily become a self-consuming disappearance into the "past." The intervention of an editor—I intervened—could offer a methodology in which the assembling of texts could take on a collaborative form with more finite boundaries.

When we tossed around some ways to proceed, we were aware of the humour implicit in what would be an "involved" production process. Our mutual projection of the text-to-be included the likelihood of those rills and rivulets that would no doubt tempt linearity off its customary paths. While we talked off and on, I approached Karl Siegler at Talonbooks. Since, for RK, a text is never completed, but finally "abandoned,"[3] a publication agreement would establish a necessary limit. Siegler was taken by the range, power, and cultural significance of RK's writing. He encouraged us to continue. By the fall of 1993, Talonbooks had agreed to publication in the fall of 1994. Work then began in earnest.

For the sake of computer compatibility—and despite a resistance to what he considered the deceptive ease of on-screen writing—RK acquired a Macintosh computer so that we could edit and make changes on the same word-processing and page-layout programs. Although his knowledge of style and formatting on a Macintosh was "rudimentary," to use his own word, he seemed eager to explore all the design possibilities that would be available to us as our collaborative work would unfold. He began inserting texts. By December, he was deep into the "project." The plan was to begin meeting regularly in January 1994.

Sketching

> "everything on earth has its moment of testimony: its valorous presence as a witness to mutability. 'i' am no different..." ("Pacific Rim Letters" 389)

Roy Kenzie Kiyooka was born in Moose Jaw, Saskatchewan, on January 18, 1926, "during a January blizzard," as his mother recalled.[4] He was the third child of Harry Shigekiyo and Mary Kiyoshi Kiyooka. Two brothers, Harry and Frank, and two sisters, Joyce and Irene, came after him. His older brother George had been born in Victoria, British Columbia, and his sister Mariko in Kochi, on the island of Shikoku, Japan, while Kiyoshi returned to her home town. The two young children remained there—not an unusual cultural practice at the time: George in his father's home town, Umagi-mura, and Mariko in Kochi. Kiyoshi's father, Masaji Oe, was a former samurai whose livelihood had been disrupted in the dismantling of the old social order in the modernizing expansionist fervour of the Meiji era. His social stature, however, did not

suffer the same decline. His renown as a former samurai and in the art of swordsman-ship "as the last great master of the Hasegawa school of Iai" (*Mothertalk* 15) are recognized in a large stone monument erected in his honour by Kochi City. The inter-section of Oe's death in April 1926—at the end of the Taisho period—with RK's birth—the beginning of the Showa period—forms an auspicious moment recalled in *Mothertalk* (74). The awesome presence of his grandfather would remain large in RK's imagina-tion of familial origins. (A photograph of Masaji Oe with Mary Kiyoshi appears as a frontispiece to *Transcanada Letters*.) George returned to Canada in 1931, 13 years old; Mariko remained, finishing high school in Kyoto under the care of Kiyoshi's aunt and uncle. The breaking of the family circle, and the image of Mariko stranded in Japan, alone, during the horrendous years of war, produced in RK a troubled and often ambivalent attachment to a distant "Japan," a country that would preoccupy his otherwise Canadianized perceptions as a kid growing up in the inner city neighorhoods of Calgary during the lean Depression 30s.[5]

If the reader of RK could gaze through a temporal telescope, there would be a restless and inquisitive kid with glasses intently taking in the social scenes of a migrant heteroglossia in the working-class localities of Calgary where his parents ran a vegetable stand. "There, thats me. I'm sittin' halfway up the stairs at 1008 - 3rd Street East in my pee-stain'd bathrobe. I'm waitin' for Mr. Kinoshita to finish his Sunday morning ablutions. And *look*, look at *that*, the stain-of-colour suffusing the narrow staircase."[6] A plenitude of images—a veritable archive in the making for a future photographer—belied the economic struggles of his "immigrant" parents. Already the artist who could transform the mundane into the marvellous, RK was nurtured by the protective care of loving family relations in the "clapboard house" (*Mothertalk* 98) in Calgary—a place reified as a memory matrix in *Pear Tree Pomes*:

> i loved the whole smell of the morning world from the back
> porch of 1008 third street east when i was a foothills' child
> i thought, thinking of all the spells i had before i could spell (220)[7]

The practice of art, a specific kind of spell-casting, was there too, as far back as early childhood, so that by grade six the urge to create had already become a passion: "...i'm sittin' on my fold-up stool, my head bobbin' up and down. I'm drawing an endless procession of milk bottles as they clink past and around the shiny hooded bottling and capping machine and come out all white and gleaming. That drawing got entered in the annual public school art exhibition at the local stampede" ("Intersec-tions"). In a note, RK recalls his school days at Victoria Public School as a period when his "small hand guided by my already near-sighted eyes kept filling the margins of my scribblers with all sorts of graven images" (RK Papers).

In the winnowing of early memories, among the many sign-posts of identity formation are two that approach the status of "touchstones." Of course, the bounda-ries of "identity" are always shifting in both time and space, as the changing—and desiring—"i" negotiates its position in the conflicts, contradictions, and multiple forces that shape the nuances of its movements. The evocation of "touchstones," then, is not a recourse to a more closed discourse of causal explanations, but rather the recognition of a biographical configuration of values evident in the poems themselves. Here, too, I follow RK's lead in *October's Piebald Skies and Other Lacunae*, a poem initiated by the accidental conjunction of the Japanese Canadian Redress Settlement (September 22, 1988) and the death of poet bpNichol at the young age of 44 (September 25,

1988). The political achievement of "redress" for the wartime injustices so many decades before and the sudden death of a kindred poet whose work was infused with so much promise led RK to face, again, the two "deaths" which happened to him. The first event, from early childhood, would subsequently provide a touchstone for physical and emotional pain. In the brief instant of an accident, RK says, "his whole back got crispt when his nightgown caught on fire" from an "open gas flame on a cold december morning" (281).[8] The period of recovery was wholly dominated by the relentlessness of sheer physical pain, but also required confinement in the house for one year, a period of isolation and emotional trauma which would come to represent, for the artist/writer RK, a threshold of human suffering. On the other hand, the tender treatment by his mother who devoted herself completely to his care for the year became the measure of maternal love. It was in the intimacy of the bond between mother and child that RK would also come to inhabit the imagination of his "mother tongue" which would shape the parameters of poetic language—the "inglish" with the lower-case "i" which he distinguished from "English," the dominant language of what was for him an anglocentric norm.

The second "death" came upon RK, on December 7, 1941: "I was three months into my tenth grade at Western Canada High School. I heard of Pearl Harbor, after we had been playing hockey down at the city dump, and the bunch of us had come back to our house and gone to a corner grocery store called Switzer's. It was a soda bar, and sold fruits, vegetables and things on the side. We sat there and had Coke, and they had their radio on with this sputtering voice, hysterical almost" ("Inter-Face" 43-44). In quick succession, RK was immediately removed from school, his father and brother George lost their jobs, and to survive the family moved away from Calgary, to Opal, Alberta, a small Ukrainian town where they became farmers. Overnight, the transparent signs of childhood became the opaque space of state control, a machinery that homogenized his "Kiyooka" name in a system of codes in which the "i" of his consciousness became a body "of the Japanese race"—the nomenclature used to register, finger-print, and revoke the rights of innocent people. Overnight, the young Calgary school kid who never thought of himself as different from the other kids found himself classified as "enemy alien"—the "jap" whose racialized subject status would, from that instant on, bedevil the seams of his personal and social identities.

On March 4, 1942, the BC Security Commission was established to forcibly remove all persons classified as "of the Japanese race" from the BC coast, regardless of citizenship. In 1942, the Kiyookas were among the small population of Japanese Canadians living outside of BC and, though they lived well outside the "protected zone,"[9] they too were subject to the loss of rights, registration and finger-printing, and the stigmata of the term "enemy alien." This mark of racialization cast an ominous shadow over the life of his family and rendered them brutally "other" in a place they had taken as their own. The young RK was profoundly disturbed by this radical estrangement from place. From 1942 to 1945, he would undergo a period of crisis in which the family's survival depended on his labour. In Opal, the urban-bred kid learned to cope with the nitty-gritty of farm life: "I milked the cows churned the cream fed groomed and harnessed the horses rode the plough walked behind the disc and harrow cut each winter's supply of wood and hauled it home from the govt. wood lot. I helped birth pigs and calves and I helped the hired stallion hump our mares each spring. With an old carpenter's manual I built the two-room log farm house we dwelled in for many seasons."[10] At this time, RK also found work during the winters in a slaughterhouse in Edmonton,

the "killing floor" (*Transcanada Letters*) in his own words, and every summer he flew up north, to Gros Cap, NWT on Great Slave Lake, to work at a fish plant.[11]

It was during this prolonged period of restrictions as "enemy alien" that RK grew from a naive boy of 16 to the resilient, resourceful, conscious young man of 20. What may have appeared, on the surface, to be a remove from overt racial violence, had also prepared the pragmatic ground for an intelligence much more attuned to conditions of outsiderness, ostracization, and the "modality of power" ("Inter-face" 48) residing in language. The persistence of familial instability was made all the more painful because his older sister in Japan, Mariko, had written them "to tell about her appalling hardships. And I clearly recall how those precious letters had been slit and the contents scrutinized and stamped by a nameless Censor" ("Dear Lucy Fumi" 125).

The internalized conflicts of the war years would never stray from the immediate reach of memory, though the artist RK remained wary of using its personal and historical specificities as subject-matter of his visual art—a use that the formal / modernist artist in himself saw as extraneous to the contemporary practice of art. The memories would announce themselves in his writing, even more insistently in his poems, as the desire for articulation grew. One such textual "occasion" erupts in the journal/journey enacted in *Wheels*, a poetic sequence that tracks a train trip with his father in 1969. While the "nisei" (Canadian-born Japanese Canadian) photographer scans and shoots the museumized evidence of the bombing of Hiroshima—click, click, click—the shutters open on the 1940s and he is himself momentarily caught in his own frame:

> i remember the RCMP finger-printing me:
> i was 15 and lofting hay that cold winter day
> what did i know about treason?
> i learned to speak a good textbook English
> i seldom spoke anything else.
> i never saw the 'yellow peril' in myself
> (Mackenzie King did) (170)

Four decades later, in what is perhaps the clearest account of his own emotional state during the 1940s—a letter to the Japanese Canadian Secretariat in Ottawa—RK would write: "In and through all the ideological strife we avidly attended via the local paper and the radio a small 'i' felt as if a punitive fist kept clenching and unclenching behind my back but each time I turned to catch it flexing it would disappear into the unlit corners of our small log house" ("Dear Lucy Fumi" 125).[12]

Japanese Canadians were not free to return to the BC coast until April 1, 1949. From 1946 on, though, some restrictions were eased to implement the government's "second uprooting"—a "dispersal" policy intended to prevent Japanese Canadians from re-settling in BC. The administrative plan was explicit: assimilation until there would be no "visible" presence of Japanese Canadians in the country ever again. For young nisei, this manoeuvre by the state meant the possibility of getting on with their lives; for RK, this new condition meant the chance to pursue his dream of becoming a "Canadian" artist.

Four years after being pulled from school, RK entered the Alberta College of Arts and embarked on an extended period of self-education, apprenticeship, and travel—but he would never continue with his formal academic education again. In a curious but revealing publisher's note loosely inserted in his second book of poems, *Nevertheless These Eyes* (1967), RK himself sets out in shorthand five phases of his life, beginning

when he entered art school in 1946: "1st: the discovery of Art as an activity & commitment during my art-school days [in Calgary, at the Institute of Technology and Art; now the Alberta College of Art] (46-49)...2nd: the year in Mexico [55-56] when I was high all the time and did my first real paintings. 3rd: the five years in Regina [56-60]...Some of the best students ever; and a sense of community with painters who recognized common concerns despite differences. 4th: Vancouver (61-65) when Poetry was high-frequency-soundings and the ocean moved to its own rhythms. Even now I cup my ears to catch the sound of both. 5th: the short, all too short, summer in Japan [1963] leading to my first book of poems, *Kyoto Airs*." During the 1950s the first two of three daughters were born to RK and his wife Monica (Barker): Mariko Laura in 1955 and Fumiko Jan in 1959. A third daughter, Kiyo Sara, would be born in Vancouver in 1960. The recognition of RK's artistic power came in 1955 when he and fellow artist, Jim Pinto, received a scholarship to study for one year in Mexico at the Instituto Allende, San Miguel de Allende. He would return to an influential teaching position at the School of Art, the University of Regina, where he established himself as a young Canadian artist at the forefront of his generation. The move to the west coast, to the very geography that had been "home" to the displaced Japanese Canadian community, would lead to the most radical change in his artistic life.

RK threw himself into the ferment of artistic events in the Vancouver of the early 1960s. On faculty at the downtown campus of the Vancouver School of Art (now Emily Carr College of Art and Design), he encountered a generation of artists and writers who also rejected traditional aesthetic forms. He was able to shed the constraints of his art school education as he interacted with the local scene by organizing readings and positioning himself as an artist in touch with the pulse of contemporary urgencies. Then, during the summer of 1963, he finally found the opportunity to connect with his older sister, Mariko, for him the long absent sibling who only existed in his imagination of wartime poverty and deprivation.

In the poems of *Kyoto Airs* written later from notes, the self-identified "Canadian artist" listens with intense care to his sister Mariko's wartime stories. He finds himself immersed in her "Japanese" suffering, all the while wandering the streets taking in the signs of modernization and change. Despite the geographical, cultural, and linguistic distances, their lives have followed parallel tracks, and now they are brought together as "Japanese" - "Canadian" siblings. Mariko's gift of the sash for the poet's yukata, the image that opens the sequence, functions to bind and unravel their separate but interconnected lives: "how else tell...?" (7)

෴

It is worthwhile to pause briefly on this first book of poems. *Kyoto Airs* is inaugural. How to tell? "For years," RK said, "i couldn't bring myself to tell anyone" about the termination of his education after grade 9, "as if in that very act my appalling ignorance would show. It took until my 30s when i began to claim my own ground as an artist to see the actual gain. And it took at least that long to be able to laugh out loud" ("Intersections"). The term "gain" attaches to a narrative of personal transformation and the power of artistic practice to translate pain and suffering into an articulation of the real. Laughter, too, is part of the liberatory process.

The poems of *Kyoto Airs* unfold syllable by syllable, word by word, line by line, each particle of language weighed in the tension of line breaks, in the tentative shifts— the poet's imagination rigorously attuned to the action around him, almost as if he were seeking permission to be a "poet":

myriad colours
reflected
on each cut
glass surface
shimmer to
the sound

of voices
clattering
cups, the music,
all sounds
other than
my own. (13)

Inside touristic eyes, the "Canadian painter" poet weaves in and out of the historical and cultural signs of what he thought might be his lineage. It is in the midst of this commotion that he conjures—the gift of Kyoto's "air"—an "i" silenced, an outsider: "I am among / them a tongue- / twisted alien" (12). The doubled effects of alien-nation, the displaced in "kanada" mirrored in a displacement in "nippon," calls forth the language of the poetic text. Like the art-full stones placed at Ryoanji Temple in Kyoto, the word by word articulation of the "i" comes into appearance. Sauntering then becomes a mode of attentiveness through which the poet gains access to the semiotics of sexual desires/transactions in "nippon." Or he decodes the audibility of silences as he gazes at "Higashiyama" through the window frame of his room. Or he re-enacts his sister's wartime memories as he discovers how she overcame her suffering—the "moments of despair shaped / by fire into something / rare, something rare" (21).

In the composition of *Kyoto Airs*, RK literally "claimed" an identity as a writer/poet. This act of coming into language was painstaking because, as he recalled, "It's as though you found yourself, despite yourself, having to do everything the most difficult way imaginable because you had to explore the whole terrain before you got a purchase on it." The exploration of that "whole terrain" was the struggle to find a way to renegotiate his personal and social contract with the "English" of his upbringing, the language that had spoken his identity, but which now was called upon to become, for him, a medium of articulation. The task was—and would remain—arduous: "Despite the brevity of the poems, there were thousands of hours of work in those poems, you know, because it wasn't as though the poem was just given in that lovely sense of inspiration or anything like that. To me it was an act of retrieval in terms of the detritus of my language, just the shit of it. I had to go over and over and over again." But then again: "That was a lovely time for me, 1963...thirty-seven years of age, but I went through that whole thing as just the most eager-beaver kind of undergraduate, oh sure."[13]

&

RK would meet poets Allen Ginsberg and Philip Whalen in Japan, and soon after they would all attend the historic Vancouver Poetry Conference of 1963, organized by the late Warren Tallman, a professor in the English Department at the University of British Columbia. Warren and Ellen Tallman came to Vancouver from Seattle in the mid-1950s and quickly became the conduits through which the "New American"[14] poets arrived in Vancouver. Charles Olson, Robert Duncan, Robert Creeley, Denise Levertov,

Allen Ginsberg, and the lone Canadian poet of the group, Margaret Avison, participated in a series of talks, readings, and social events that influenced a generation of Vancouver-based Canadian poets. RK was there, and so was his friend Phyllis Webb, and they absorbed the talk of an "open form" poetics announced in Olson's now canonic "Projective Verse" essay. And the term "composition by field"[15] held out possibilities for approaching the poem as an enactment of the unfolding spaces of the text.

RK would compose *Kyoto Airs* soon after, and the following year the sequence would appear in a series of finely designed poetry books by fellow Japanese Canadian artist, Takeo Tanabe, at Periwinkle Press (Vancouver). Tanabe also designed and printed John Newlove's *Elephants Mothers & Others* (1963), Gerry Gilbert's *White Lunch* (1964), and Phyllis Webb's *Naked Poems* (1965). In a letter to Webb decades later (c. 1992), RK looked back on the 1963 conference as "a turning point for both of us: your Naked Poems and my Kyoto Airs were in part borne of that memorable occasion" (RK Papers).

The Vancouver years would give the push RK needed to begin writing poems in all seriousness. *Kyoto Airs* was followed by "the 4th avenue poems," a farewell to Vancouver before moving to Montreal where he would teach (1965-69) in the Fine Arts Department of Sir George Williams University (now Concordia University) and co-ordinate major literary events which brought to the city many of the leading American and Canadian poets of the time. *Nevertheless These Eyes*, RK's second book of poems, was the outcome of a subjective immersion in the letters and visual art of the eccentric British artist Stanley Spencer. While the content departs from the perceptual concerns of *Kyoto Airs*, the gain is an emergent consciousness of passion and obsession, in this sense a permission to address the complications of (male) desire through the practices of another artist/writer. Through the eyes of Spencer and in the found texts excerpted from his letters to his wife Hilda, RK was able to plumb the emotional depths of his own manhood.[16] His wounded sister re-appears, this time transfigured as a muse figure— a maternal figure of suffering who takes on the suffering of others—his own mother perhaps concealed in the memory of his own childhood pain.

Nevertheless These Eyes incorporates, for the first time, visual art by RK. This development prefigures a major turning point, in the summer of 1969, announced in the unexpected invitation by the Canadian government to "represent" his country in a sculpture for the Canada pavilion at Expo 70 in Osaka, Japan. The departure from Montreal was swift, and by September RK was living in Kyoto. He thought he would return to Montreal.

The four months in Kyoto, with daily trips to Osaka to work on the sculpture, "Abu Ben Adam's Vinyl Dream,"[17] was perhaps the most fortuitous period in RK's growth as a poet/artist. As if by accident, while wandering the Expo site, his attention was drawn to the numerous workmen's gloves discarded and left intact wherever they had fallen. It was the immaculate specificity of their random shapes and forms, the detritus of their materiality made present by the absence of function—the gloves in themselves now seemingly outside the realm of representation. The urge to track these gloves through photo sequences took over. RK began shooting images daily, then returning to Kyoto to develop the film, and slowly an archive of prints accumulated. RK describes his activities in a letter to Phyllis Webb in *Transcanada Letters*, October 26, 1969:

> been going abt taking lots of photos.
> i just keep looking under-foot or

to left and right, back and front with
in say a 10 meter circumference:
FOCUS viz yr camera/ eye must then be
'locus' or even Olson's 'polis'

no matter—the evidence of whats there
(underfoot) accumulates[18]

Alongside the photo process were notes and journal entries that would later be translated into poetic texts. That interplay between image and text—that "interface" between art and writing—led to the remarkable sequence, *StoneDGloves*, a poetry book doubling as a catalogue for his first major photo exhibit which opened at the National Gallery of Canada in 1970.

The Kyoto sojourn also yielded another remarkable sequence of poems, one that RK would circle and re-write many times over in the years ahead. The basis of *Wheels: A Trip Through Honshu's Back Country* (initially titled "Backcountry Trip" in *Transcanada Letters*) is a tour around a section of Honshu, the largest of the four islands making up Japan, with his father visiting from Canada. Structured as a journal/journey—echoes of the travel narratives by the Japanese poets Basho and Issa—a Japanese Canadian poet/photographer, his issei (first generation Japanese Canadian) father, and their "intrepid" Japanese guide, Syuzo,[19] move through the landscape on the train, stopping here and there to take in the sites/sights. As they sojourn the poet-narrator explores his relations with his father and his hybrid identity as "Japanese" and "Canadian." The writing of *Wheels* would itself become its own journey. Many years later, in March 1977, RK wrote to Gerry Shikatani that the poem that he had been writing "a draft a year for a decade" posed the problem of both "getting a canadian-japanese voice in there" and composing a "homage to my father. & what he spawned. what, therefore, i also, am" ("Pacific Rim Letters" 57). RK's father had died in 1974 at the age of 86.

After four productive months in Japan, RK moved back to Vancouver in 1970, but only temporarily. He moved to Halifax in 1971 to teach at the Halifax School of Art and Design, a period of his life recorded in *Transcanada Letters*, the indispensable text for understanding RK's geographical movements from the mid-1960s to 1974. He settled more permanently on the west coast in 1972 when he began teaching in the Fine Arts Department at the University of British Columbia, a position he retained until he retired in 1991.

&

In 1975, the Vancouver Art Gallery mounted a major retrospective exhibit of RK's art to mark his 50th birthday and published an accompanying catalogue, *Roy K. Kiyooka: 25 Years.* By then, ironically, he no longer thought of himself as a painter, but more a photographer and poet. Over the next 10 years, he published three more books of poetry. *The Fontainebleau Dream Machine* (1977), like *StoneDGloves*, composes an interface between poem-texts ("frames") and a series of meticulously constructed collages which together propose the "dream machine" as a textual discourse, a "rhetorick." From this vantage the sequence critiques art practices that contain rather than release desire—becoming, in this way, RK's "re-taking of / Art History . its awesome oft / imes comic verities" ("Pacific Rim Letters" 59).[20] *of seasonal pleasures and small hindrances* (1978) is a serial text ("marginalia") that tracks the daily consciousness of the poet who measures fragments of public news—"viz the watergate follies" (98)—

against mundane particulars. In this rubbing of language memories arise, including the wartime racism informing his past. Then, in the early 1980s, came the altogether absorbing composition of *Pear Tree Pomes* (1987). Here the magic of words would fold the specificities of the personal into the immediacy of the compositional process. In this sequence the aging poet, enrapt by the quotidian phases of the backyard pear tree, translates the pain of a broken relationship into an affirmation of language—the "inglish" that enacts the gift of mother tongue.

The public record of RK publications would nominate *Pear Tree Pomes* as the singular achievement of the 1980s. Much less is known, except to a handful of readers, of the proliferation of the limited edition chapbooks produced under the Blue Mule and distributed without charge. In the 1980s, as well, RK made much more overt gestures towards the imagined "Japan" he had been courting ever since *Kyoto Airs*, taking trips to see friends and relatives, even locating himself as a kind of "sojourner" figure in three places that assumed heightened poetic importance: Kohama, an island in Okinawa, Toksuka in Yokohama, and Gotenyama, just outside of Osaka. The opening of this expansive cultural space, in turn, led to a more comprehensive awareness of his own hybrid cultural formation. Coming to maturity in that interstitial space between language and place, he began to understand his "i" in the wily figure of the "Japanese / Canadian."[21] The more familiar connections with Japan drew him closer to his mother's past, and in the early 1990s he took on his last major writing project, the composition of Mary's stories into a life narrative, the text of which became *Mothertalk*. A companion text, the narrative line written to accompany a series of photographs for the "photoglyphic" text, *Pacific Windows*, stands as a compelling homage to Mary and a statement of poetics that reverberates throughout this *Pacific Windows*. RK's mother would outlive her son by two years. She died in 1996 at age 100.

Editing

> "let each detail of the least thing be a pre-figuration of its own narrative in time" (RK Papers)

When RK began inserting his poems on his Macintosh, we had agreed that the "collected" would be a gathering of texts already published, not an occasion for substantial revisions—which for a poet with the propensities of RK would have led to a process of rewritings that would be all-consuming. Our project would perhaps never get completed—or we would grow long white beards before the revisions exhausted themselves. As mentioned already, we thought that the collaborative act would prevent such a turn. So, ok, no changes, other than the minimal and, ok, the "collected" would be finished in time for publication in the fall of 1994.

I first saw the poems on RK's "computer version" after his death. Despite our agreement, RK could not resist the temptation to make changes as the words appeared on the computer screen. Since we were to go over each text together, it is difficult to say with certainty the extent to which RK was trying out certain changes for our conversations to come. As an editor attempting to carry on the collaborative process we had envisioned, while obviously now one-sided, in making decisions I have tried to account for how I think RK would have responded. In a few instances, I consulted with knowledgeable readers of RK's poems. In the end, though, the responsibility for all the editorial changes made to create what I see as an editorially sound manuscript—changes, for instance, that include spacing, punctuation, spelling, and choice of variants—rests

in my hands. In all cases I have endeavoured to proceed on the assumption that RK would have agreed with my recommendations.

Of all the principles that had to be constructed, one stands out for establishing the overall shape of *Pacific Windows*. RK made a number of revisions to his first two books. After carefully weighing these—and recalling our conversation that they of all the texts should remain as published in their time—I decided to go with the first editions, incorporating only a few changes. For the other texts on the "computer version" I have followed RK's revisions. The one exception is *Wheels*, the text that posed the greatest editorial challenge. In my view the revisions made by RK at times did not serve the best interests of the work, so that the version in this collection reflects an amalgamation of a 1985 draft and the draft on the "computer version." For the poems not on the "computer version" but which would have been, I have used the chapbook publication. The revisions on the "computer versions," of course, means that RK in effect created new editions of the poems inserted. Despite this "fact," I have decided to include unrevised the detailed colophons that are characteristic of many of RK's publications, but especially so in the chapbooks. For RK, the colophon itself is part of the compositional process. If this procedure creates anomalies, let it be a tribute to RK's quixotic habits.

Noting

Kyoto Airs
Published in 1964 by Periwinkle Press, designed and printed by Takeo Tanabe.

the 4th avenue poems
Published in *Imago*, Number 11 (1969), a magazine devoted to long poems edited by George Bowering. RK's note in *Imago* says the sequence was written "winter 64 / spring 65" and "revised in Montreal winter 68." Further changes have been made on the "computer version" used as the basis for the text in *Pacific Windows*. In a note found in the RK Papers, dated May 1990, RK connects these poems to a series of collages, "The Zodiac Series" (Numbered 1-12), for George Bowering's book of poems, *The Man in Yellow Boots*, published as a special issue of *El Corno Emplumado* (1965). This series, RK writes, "together with 'the 4th avenue poems'...embodies my own cantankerous sixties' politics" (RK Papers).

Nevertheless These Eyes
Published by Coach House Press in 1967. *Pacific Windows* includes additional poems appearing in *Transcanada Letters*, "Later Draft/s of the Stanley Spencer pomes," with some changes in RK's "computer version." In the Coach House edition, the "found" texts by Stanley Spencer were printed in purple ink; in *Pacific Windows* these passages have been set in italics.

StoneDGloves
Published by Coach House Press in 1970 as a catalogue for RK's photo exhibit, "StoneDGloves: Alms for Soft Palms" (National Gallery of Canada, 1970). In *Transcanada Letters*, RK points to some errors in the publication, mentioning the "omission of the last line / 2nd Variation (for Victor!) and the omission of / the 3rd and 4th Variations entire. / as for the un-corrected poems and the meandering page / numbers that begin with a no. 4 and just wander— / no one will as they say in Grimm's

'know' / but US." He was eager to produce a new edition of this important work. The "computer version" restores the omissions and includes many changes. The poems placed on photos have been reproduced from the first edition. The page limits of *Pacific Windows*, regrettably, did not allow for the portfolio of photos following the poems.

of seasonal pleasures and small hindrances
This text appeared in *Transcanada Letters* (1975) and was later published in a much revised form as an issue of *BC Monthly* (November 1978), edited by Gerry Gilbert. Further changes were made on the "computer version." A bibliography in the RK Papers subtitles this sequence, "A Renga Country Suite."

the Fontainebleau Dream Machine
Published by Coach House Press in 1977. The 18 collages (32 x 17 inches) were printed in an edition of 126 copies by the Bau-Xi Gallery in Vancouver (January 1977). Writing to Louise Walters on March 8, 1977, RK says he finished the draft of the poems "abt 3am Sunday March 6th after nearly 4 months of an intense preoccupation with the un-ravelling of its Coruscations..." ("Pacific Rim Letters" 59). Writing to his daughter Mariko two days later, he refers to the poems as "a form of insanity a lustin' after the Husk of a Dream viz the Language" ("Pacific Rim Letters" 60). The sequence was reprinted in *The Long Poem Anthology*, edited by Michael Ondaatje (Coach House, 1979). RK's "computer version" contains revisions which have been incorporated.

Mutualities: A Packet of Word/s
Published in the Vancouver art magazine *Vanguard* (October 1977: 11-13). Some minor changes were made in RK's "computer version." Section titles, except for "2am, July 23rd, '77," are the titles of paintings by Richard Turner reproduced with RK's text.

Wheels
This text has a long and complex history. A brief excerpt, based on a journal begun in Japan during the fall of 1969, first appeared as "A Sequence from 'Seven Day Backcountry Trip'" in *Imago 20* (Talonbooks, 1974), edited by George Bowering, and a portion was published in *Transcanada Letters* (1975) as "Backcountry Trip." Longer sections appeared in *Paper Doors: An Anthology of Japanese-Canadian Poetry* (Coach House Press, 1981), edited by Gerry Shikatani, and in *Descant* (Numbers 44-45, 1984), edited by Karen Mulhallen. In July 1985, RK privately printed a handful of copies of *Wheels*, the final draft prior to the "computer version," primarily as a mock-up manuscript for what he hoped would be a Coach House publication—a companion work to *Pear Tree Pomes*.

Struck from the Heat of a Cold December Sun
Published in a limited edition of 11 copies, December 1983. While not identified on the colophon, this title was issued under the Blue Mule. This chapbook is not on the "computer version."

Pear Tree Pomes
Published by Coach House Press in 1987, though RK's textual note dates its composition between August 1982 and March 1985. In a letter to artist David Bolduc (February 22, 1985) whose drawings form an integral part of the book RK says he is hoping "to birth the P.T.P. this year with my 59th birthday behind me and 60 coming up" ("Pacific Rim

Letters" 378). This sequence was reprinted in *The New Long Poem Anthology* (Coach House, 1991), edited by Sharon Thesen. As a text that had already been revised meticulously for the Coach House edition, RK and I agreed that he would not make any changes. The "computer version" starts out by following the Coach House text, but past the midway point, changes appear, for the most part with line breaks. It is likely that RK, as he faithfully reproduced the Coach House text, was taken over by the urge to create new variations—new ways of reading his own poems. These revisions, then, allow readers to perform the Coach House version alongside this one and then recompose their own relationship to the changes.

Gotenyama
Published under the Blue Mule in a limited edition of 26 plus 9 copies, December 1985. This text is not on the "computer version."

an April Fool Divertimento
Published under the Blue Mule in an edition of 30 copies, June 1986. This sequence is not on the "computer version." RK made substantial changes in 1993, a version perhaps prompted by the request for material from Walter K. Lew, editor of *Premonitions: The Kaya Anthology of New Asian North American Poetry* (Kaya Productions, 1995). I have decided to use the chapbook version—a text that is more in tune with the style and energy of the RK chapbooks as a whole. Readers are encouraged to compare versions.

All Amazed in the Runnels of His 60 Winters
Published under the Blue Mule in an edition of 40 copies, January 1987. This text is not on the "computer version."

Excerpts from the Long Autumn Scroll
This excerpt comes from the text of a scroll work last shown in an exhibit mounted by the Or Gallery and Artspeak Gallery in Vancouver (1990), for which the catalogue *Roy Kiyooka* was published. RK comments at length on this work in an application for a Canada Council grant, dated October 6, 1991: "...in the mid-80s I put together a long horizontal scroll twenty-five feet long and twenty inches wide. First I gathered up a large paper bag full of crisp fall leaves and placed them variously on the platen plate of my canon copier and printed off 100 legal size sheets of variegated leaves. Then I ran the vertically typed Text through the copier onto sheets of transparent acetate and combining each page of text with a page of leaves I put the whole 100 sheets together in proper sequence and I had the whole scroll laminated to save it from wear and tear. This long saunter via the Long Scroll has its roots & flowering in the legends & the agendas of one man's asian roots" (RK Papers). The text in *Pacific Windows* is the section on the "computer version" that RK decided he wanted in his collected poems.

a june skylark for kai's air
Published in a limited edition, May 1987.

Three Nippon Weathervanes: Kumo/Cloud/s, Toksuka Topiaries, Kohama Skies
The title for this chapbook trilogy appears in a bibliography prepared by RK for *The Capilano Review* (Series 2, No. 2, Spring 1990). Of the three only *Kumo/Cloud/s* has a colophon. It was also published in *West Coast Line* (24.3, Number 3, Winter 1990), of which two pages, necessary for the sequence, have been reproduced. *Toksuka*

Topiaries and *Kohama Skies* were probably printed mid-to-late-1980s. Toksuka is in Yokohama, where RK stayed with his friends, Mayumi and Hiro Yoshihara. Kohama, in Okinawa, remained for RK the "idyllic" landscape of his friends Kazuko and Isamu Akino. These chapbooks are not on the "computer version."

October's Piebald Skies & Other Lacunae
Published under the Blue Mule in an edition of 40 copies, September-October 1988. RK's "computer version" is the basis for the text in *Pacific Windows*. This is the last text RK inserted.

A February Postscript: to October's Piebald Skies
Published under the Blue Mule in an edition of 21 copies, February-March 1989. This text is not on the "computer version."

Pacific Windows
This title poem was published as a special issue of *The Capilano Review* (Series 2, Number 3, Fall 1990). RK called it a photoglyphic text—a kind of visual novel—that works the interface between narrative and photographs. In a note slipped into the issue, RK explains: "A Photoglyphic Narrative of a Neighborhood with Autobiographical Images to add verisimilitude to one man's Polis. Printed on Sea Gull paper and endlessly re-combined to shape a kaleidoscopic narrative." An accompanying editorial note explains that the 96-page text which runs "as a continuous ribbon that reads from front to back, and repeats from back to front...offers two different experiences." Space limits did not allow for the inclusion of this accomplished work— but the text, which so richly informs the whole of *Pacific Windows,* became the inevitable moment to close this collection.

&

In another collection—perhaps a sequel to *Pacific Windows*—the photoglyphic text bearing the same title may be published in its entirety. Such an imagined extension could also bring together a scattering of "gatherings" that RK printed in limited editions, often for an occasion, such as a reading or performance. One of these, sent as a long letter to artist David Bolduc, has been published as a chapbook, *December / February 1987, 1988* (Coach House Books, 1995), with drawings by Bolduc. The RK Papers contain unpublished poems, though the precise extent of this material calls for further research. Meanwhile, the sequel waits in the wings.

Entering

> "Untolled hours of scrutiny and collating empowered, in, and by everything, diligently, attended to."[22]

I have refrained from commenting on the title of this afterword, hoping that the resonances of the three words—coruscations, plangencies, syllibant—could circulate in their own time, for a time, or for the time being. They were chosen, not quite at random but more by the accidence of editorial procedure. They stand as signs, for these ears in any case, of the care taken in the attention to the textures of language in RK's poems. Whatever alchemical ingredients were stirred into the making of his speech-writing, the localism of the words at hand—in hand—enact a present tense "i" that is

both affect and effect, both producer and produced, in the composition of form. It is the lexicon of RK's inglish that emits a sonic resonance exceeding the bounds of a pale face english. No, "I don't want to go on moanin' the old 'yellow peril' blues the rest of my days. Gawd save us all from that fate," so he writes in "We Asian North Americanos: An unhistorical 'take' on growing up yellow in a white world."[23]

So, then:

⊗

Coruscations: "coruscation," from the verb "coruscate": to give forth intermittent or vibratory flashes of light; to shine with a quivering light; to sparkle, glitter, flash. Hence "coruscations": the sudden appearance of figures in the darkness of language, often akin to the ebullience of the photographic image in process.

⊗

Plangencies: pluralization of "plangency," from "plangent": making the noise of waves breaking and beating on the shore; loud sounding, striking the ear powerfully; applied sometimes to a metallic, sometimes to a loud thrilling or plaintive sound. Hence "plangencies": the omnipresent sound of existence in the tied-tongue throat and in the transience of the imago-mundi.

⊗

Syllibant: "syllibant"? No known dictionary connection. Sounds like: "sibilant": having a hissing sound; of the nature of, characterized by, hissing; making a hissing or whistling sound; a speech-sound having a hissing effect; a sound of the nature of s. Or "sibyllant"? No known dictionary connection, but harbours shades of "sibyllic" and "sibylline." Or shares a syllable with "syllable" which gives "syllabling," "syllabled," "syllablize." Hence "syllibant": inglish for the alchemic transformation of "syllable," "sibilant," and "sibylline," articulating the oftimes unrecorded "earthen vernacular" (179) known as the tongue-tied syllabic speech of a canuck poet born into a home-grown nipponese.

In an end-of-term chapbook for his graduating students in the Department of Fine Arts at the University of British Columbia, RK advises: "Be indubitably an eye: by which i mean the least gesture of the least thing underfoot or up in the air ought to captivate your whole sensorium."[24] It is, again, the intensity of making art out of what one is given—given as both limit and gift. RK is remarkably consistent in his affirmation of the insistencies that motivate creativity. See, for instance, the whole of *Transcanada Letters* for prime evidence. His distance from formal education from grade 9, and his subsequent drive to educate himself through the negotiation of exigency itself, transformed him into an intellectual poet who respected the efficacy of language "diligently, attended to." His inglish straddles the productive spaces between a slanted "english" and an aural mother tongue "japanese," tongue-tied to his mother's Tosa-ben (the dialect spoken in her home town Kochi, Japan). He recognized this unusual relationship to language: "Everytime I find myself talking, talking about anything under or even above and beyond the sun, I feel the very pulse of my thots in a North American/ West Coast dialect of the English language with all its tenacious Indo-European roots, Now, concomitant with this recognition is the feeling that when I am most bereft, it's the nameless Jap in me who sings an unsolicited haiku in voluntary confinement" ("We Asian North Americanos" 117).

It is the aura of the "bereft" that becomes a constituting moment of liberation in *StoneDGloves*, a text that I would propose—along with *Wheels*[25]—opened up RK's inglish to new textual potencies. The advice that he gave his students literally fell from

the skies in Osaka: "I had the lovely experience walking the site one day—looking for gloves when from three stories up a grey tattered glove came tumbling down...plop against the side of my face."[26] The gesture of finding and being found through the medium of castaway gloves points—an instance of what RK called "astonishment"—to a future that breaks from the more eurocentric art world of the earlier painter he was. It was 1969, the year the gloves fell, that marks the beginning of the period when writing and photography, no long painting, assume centrality.[27]

In a lengthy interview published in *White Pelican*, edited by Sheila and Wilfred Watson, RK says that the "photos and words grew apart together. I mean I was working on this big sculpture for the Canadian Pavilion at Osaka and taking photographs of gloves at the same time. Then I would go home and make notes concerning the day's happenings and I would take the day's roll of film into the processors and pick up the previous day's photos and in that way just accumulate material—with then no thought of combining them. That came later, when I got back" ("Roy Kiyooka: Seen" 18). The precise phrasing, "grew apart together," implies the revelation of a poetics. What was one activity, words and photos gathered in a singular period of research, became a compositional act as the separation occurred to produce the tension of an interface. Photos and texts are then not governed by a referential mandate, which would introduce the hierarchy of source and illustration, but together (to gather) create a textual field of attention. The growing apart, in other words, becomes a twinning that opens the spaces "in between" where the principle of transience and chance is regained. The photos and the texts—the "stoneDGloves"—become allies in what is a "serial" process of composition.

RK had little patience with the lyric moment reified in the discrete poem. In a synopsis of his art work written for *Roy K. Kiyooka: 25 Years*, and inserted at the end of *Transcanada Letters*, he describes himself as an artist who produces in a series, then adding: "even my pomes tend to work serially." He explains in more detail this methodological practice in an interview: "I've always been a serial artist. My books are always whole entities. They're not made up of discrete things. That's how I photograph too. I can hardly claim to be the kind of photographer for whom each photographed moment is an exemplary moment, and you frame it, and say, this is like a beautiful poem. No, I'm not that kind of photographer. I need a number of images to articulate what it's about, so I tend to work in sequences. That's so deeply a part of my practice that I don't even think of it. I painted that way too" ("Inter-face" 52). The poems collected in *Pacific Windows* enact one variation or another of serial form, a sign that the poetic act always remained, for RK, the process of articulating the given—of finding out for himself, in the materiality of the syllable, the shape of the language narrative of any text underhand.[28]

Found among RK's papers is an application for a Canada Council grant to undertake a multidimensional art project in Japan, around his ancestral home in Kochi. He wants to "get in touch with the pulse of the place," he says, and admits to "a barely inscribed Pacific Rim Dialogue—one borne of the time immemorial impact of Asians of N.A. that 'i' go on lending my voice to til all the racial epithets disappear into the flux of our multi-national discourse." He then goes on to represent the trajectory of his artistic concerns, recalling the cultural ascendancy and power of US cultural forms in the 1950s, his formative years. His initial drive was to move beyond the "provincialisms" of his upbringing and to paint his "arse off" so that he could enter the emergent realm of abstract expressionism—"knowing that it was, for the likes of us, the only game in town." By the mid-1960s, with the west coast already infiltrating his imagination, the

316

European modernist framework of his art began to come apart. He soon realized that accomplishment in that mode would mean the continuing invisibilization of the personal. The movement away from painting to writing and photography had saved him from the temptation of the "fame game" which "as it pertained to a Japanese Kanadian artist was just another attenuated form of cultural alienation: I'd clobbered together a belated aspirant's modernist aesthetic, one that intrinsically denied my asian kanadian origins and those immediately around me. When all got said and done I wanted to be more immediate to the clamour and clangor of the real world. I wanted to shape things someone near to hand could share. Thus, I turned to writing and photography and later music—to plumb my unplummed self" (RK Papers).

In the broader figurative geography of culture and history, the poetics of *StoneDGloves* could offer a bridge between artistic practice and the mundane. The modernist artist/photographer of *Wheels* who composes his "i" through the frames of the camera is himself framed. The artist as insider, in control of the perspective, becomes the outsider, the stranger in a linguistic and social landscape that can be his own only through the reversed lens of childhood memory. *StoneDGloves* and *Wheels* give permission to translate the personal into the seriality of textual practice. RK himself alludes to this potential of writing in *of seasonal pleasures and small hindrances*:

> twice
> scarred
> three
> times as
> scared
>
> thank the Tao..."syllables" are the World's No. 1
> re-newable resource (103)

The syllibant returns "us," as readers, to the condition of composing (reading) in syllables, by syllables. Here/hear the inglish in the silences, like stones, (which) begin to speak. Lights, sounds, and the vernacular. Enter RK, the erstwhile poet of *Pacific Windows*:

> i filled 3 notebooks full of
> an oftimes indecipherable 'romaji' alternating
> with pages of cluttered 'inglish'
>
> all summer long i caught myself sifting long agog
> syllables—as if i were beholden to
> their 'topos' if not their oftimes libellous wit:
>
> all the things i held in my hands—
> that were once 'rotund' in either tongue
> dissolved into oceanic silences...
>
> &
> these words hatch their own syllibant cloud/s
> 'grief' they murmur is a hiss of the utmost brevity
> among crustaean/s "i" mean i heard nothing
> cry out of the burrows of the living coral... where

i've been the very body's forensic bodings sing
a porpoise's siren song

 dreadnoughts anchored
 in the san juan straight-jacket
 my sere syntax...

 terra firma
 terra incognito (260-61)

Notes

1. Roy Kiyooka, "Pacific Rim Letters" 158. At the time of his death, RK was working on this sequel to *Transcanada Letters* (Vancouver: Talonbooks, 1975), a collection that picks up where the former ended in 1975 and continues through to 1986, another decade of correspondence. The manuscript of "Pacific Rim Letters" was prepared by Kiyooka's friend, Linda Gilbert, and is part of the Roy Kiyooka Papers in the Estate of Roy Kiyooka. References to this manuscript and the Roy Kiyooka (RK) Papers are hereafter included in the body of the essay.

2. The term "computer version" refers to the texts inserted on the Macintosh computer by RK. This electronic text is part of the RK Papers in the Estate of Roy Kiyooka.

3. The term is RK's in Roy Miki, "Inter-Face: Roy Kiyooka's Writing, A Commentary/ Interview," *Roy Kiyooka* (Vancouver: Artspeak Gallery and Or Gallery, 1991), 53; he also says that sometimes a text "abandons" (54) him. Hereafter cited as "Inter-face."

4. Roy Kiyooka, *Mothertalk: Life Stories of Mary Kiyoshi Kiyooka*, edited by Daphne Marlatt (Edmonton: NeWest Press, 1997), 74. RK was at work on this book at the time of his death. Hereafter cited as *Mothertalk*.

5. RK's first trip to Japan (c. 1930) predated his conscious memory. He was taken to Umagi-mura by his father to meet his dying paternal grandfather. RK says in *Transcanada Letters* that his "father said I got sea-sick coming and going. And an old photograph shows me in Umagi with my cousin" (np). In *Mothertalk*, Mary notes that the "relatives were all astonished that Roy could speak both Japanese and English. They themselves had never seen or heard a whiteman" (124).

6. Chris Varley, "Intersections," *Roy K. Kiyooka: 25 Years* (Vancouver: Vancouver Art Gallery, 1975), np. Hereafter cited as "Intersections."

7. Unless otherwise noted, page references in parentheses refer to this volume.

318

8. See also *Mothertalk* where Mary recalls that the devastating accident occurred on New Year's morning (122).

9. This term was the government's for the designated area, 100 miles along the west coast, from which all persons categorized as "of the Japanese race" were expelled in 1942. Some 24,000 men, women and children, 75% of whom were either Canadian-born or naturalized citizens, were uprooted and dispossessed. The politics of racialization through which Japanese Canadians were interned has been studied at length during the past 25 years. See Ken Adachi, *The Enemy That Never Was: A History of the Japanese Canadians* (Toronto: McClelland and Stewart, 1976); Ann Sunahara, *The Politics of Racism: The Uprooting of Japanese Canadians during the Second World War* (Toronto: James Lorimer, 1981); W. Peter Ward, *White Canada Forever: Popular Attitudes and Public Policy Toward Orientals in British Columbia* (Montreal: McGill-Queens, 1990). See also by this writer: "Life and Times of Muriel Kitagawa," *This Is My Own: Letters to Wes & Other Writings on Japanese Canadians, 1941-1948*, by Muriel Kitagawa (Vancouver: Talonbooks, 1985); with Cassandra Kobayashi, *Justice in Our Time: The Japanese Canadian Redress Settlement* (Vancouver and Winnipeg: Talonbooks and National Association of Japanese Canadians, 1991).

10. Roy Kiyooka, "Dear Lucy Fumi: c/o Japanese Canadian Redress Secretariat," *West Coast Line* 24.3, Number 3 (Winter 1990): 125. This letter has been reprinted in the Appendices of *Mothertalk*, 187-190. Hereafter cited as "Dear Lucy Fumi."

11. Henry Shimizu writes about one summer with Roy Kiyooka at Gros Cap, 1950, in "Remembrances of Roy Kiyooka," *The Bulletin: A Journal for and about the Nikkei Community*, April 1994: 15-16.

12. Mary Kiyooka in *Mothertalk* remembers the trauma of being singled out as "Japs" in the newspapers. Friends started shunning her, but the "last straw was when our kids came running home from school with tear-filled eyes because all their buddies began turning away from them and they didn't know why" (136). The loss of freedom at the hands of her own government had lasting effects on her too: "Twenty-five years after coming to Canada and becoming citizens we were stripped of everything. Boy it's been a bitter pill to swallow" (137).

13. Roy Miki, "Roy Kiyooka: An Interview," *Inalienable Rice: A Chinese and Japanese Canadian Anthology* (Vancouver: Powell Street Revue and the Chinese Canadian Writers Workshop, 1979), 61, 62.

14. The term includes a generation of US poets associated with the defining anthology of the time, *The New American Poetry, 1945-1960*, ed. Donald M. Allen (New York: Grove Press, 1960). See also Warren Tallman's history of the impact of US poetics on Vancouver poets in "Wonder Merchants: Modernist Poetry in Vancouver during the 1960s," *Godawful Streets of Man, Open Letter* Third Series, No. 6 (Winter 1976-77): 175-207. In one of the few early comments on RK's poetry, Tallman points to Kiyooka's "penetrating eye" and argues that it is "his respect for all arrangements in his environment that causes him to let the arrangements be and yet see through to their inwardness" (205).

15. Charles Olson, "Projective Verse," *The Poetics of the New American Poetry*, ed. Donald M. Allen and Warren Tallman (New York: Grove Press, 1973), 148.

16. RK says in *Transcanada Letters* (Vancouver: Talonbooks, 1975) that he first came upon Spencer's work while he was an art student in Calgary, and that he re-discovered him through the biography, *Stanley Spencer*, by Maurice Collis (London: Harvill Press, 1962). It was, he says, Spencer's "intensely naive erotic-vision" that attracted him. RK may also have been attracted to Spencer's unrelenting desire to merge, in Collis' words, "the sacred and the profane" (70), a mode of consciousness that Spencer believed would counter social violence through sexual liberation. Spencer had an insatiable desire to write down the minute particulars of his daily life in journal entries; he poured his energy into a monumental collection of letters to Hilda, a woman he married, then divorced, but in whom he constructed an elaborate erotic fantasy of

adoration. The figure of "Hilda" embodied the bond that held the sacred and the profane together. Spencer maintained his obsession his letters to Hilda, many not even sent to her, and he continued doing so after her death in 1950, until his own death in 1959. In Collis' words, "Hilda is first real, then grows fictional and finally is vaporised into a supernatural presence" (14).

17. RK and his sculpture were the focus of two newspaper articles: Charlotte Townsend, "Kiyooka: Artist Returns to Vancouver after Starting His Pyramid Shapes at Expo 70," *The Vancouver Sun*, January 23, 1970; Joan Lowndes, "Roy, the Pyramid Builder," *The Province*, February 13, 1970.

18. *Transcanada Letters* is unpaginated.

19. Syuzo is the Japanese artist, Syuzo Fujimoto, who studied with RK and who remained one of his close friends in Japan.

20. This text has attracted more critical attention than other RK texts; see Eva-Marie Kröller, "Roy Kiyooka's *The Fontainebleau Dream Machine*: A Reading," *Canadian Literature* No. 113-114 (Summer-Fall 1987): 47-58; Christain Bök, "Oneiromechanics: Notes on the Dream Machines of Roy Kiyooka," *West Coast Line* 29.1, Number 16 (Spring-Summer 1995): 24-28.

21. The interface that RK created over time between his subjectivity and an imagined "Japan" comes out in a statement found in the RK Papers: "beginning with 'kyoto airs' in '64 i've tried to shape the fragmented images of nippon i've carried with me my whole life long. odd to say that i learned to speak nihongo well enough as a child and spoke it into adolescence: but, given the circumstances, i never learned to read and write it. alas and alack. nonetheless, i do believe that my kind of inglish bears the syntactical traces of my parent's kochi-ben: everytime i've gone back there and walked the streets of that lovely city on the pacific, i hear the cadences of my own native speech: both nihongo and inglish subtly transmuted into an undialectical syntax."

22. Roy Kiyooka, "Intersections: Interventions," *Roy Kiyooka* (Vancouver: Artspeak Gallery and Or Gallery, 1991), 7.

23. Roy Kiyooka, "We Asian North Americanos: An unhistorical 'take' on growing up yellow in a white world," *West Coast Line* 24.3, Number 3 (Winter 1990): 117. Hereafter cited as "We Asian North Americanos."

24. Roy Kiyooka, "Heironymus Bosch's Heretical April Fool Diverti-mementos & Other Protestations," dated March 1986.

25. For a reading of *Wheels* that addresses ambivalences in the poet's cultural and racialized identity, see Mark Tadao Nakada's "The 'Multiform Aesthetic': Reading the Poetry of Roy K. Kiyooka," the introductory essay for a catalogue of the RK Papers, Honors Thesis, Department of English, Simon Fraser University, 1995.

26. "Roy Kiyooka: Seen Through the Eye of Bernie Bloom's Camera," *White Pelican* 1.1 (Winter 1971): 26. Hereafter cited as "Roy Kiyooka: Seen."

27. Sculpture also entered RK's life through a series of cedar laminate sculptures done after he returned from Japan. In his interview with Chris Varley in *Roy K. Kiyooka: 25 Years*, he admits that by the late 1960s he had come to a "deadend viz painting" but that he still wanted to continue "making something" (np). The cedar laminates continue his work as a painter: "The cedar laminates take up the ellipses again and sandwich them in 3D. I wanted them to be of a size that would have an actual presence in a room. I wanted them to be of a size that could be handled, a *bulge*, if you want, in your line of sight. A presence you couldn't ignore" (np).

28. The importance of seriality in RK's work in poetry, visual art, and photography, which I can only allude to here, is a subject that calls out for further research and study.